GANGSTERS
&GRIFTERS

GANGSTERS & GRIFTERS

Classic crime photos FROM THE **Chicago Tribune**

MIDWAY

AN AGATE IMPRINT

CHICAGO

Chicago Tribune
Tony W. Hunter, Publisher
Gerould W. Kern, Editor
R. Bruce Dold, Editorial Page Editor
Bill Adee, Vice President/Digital
Jane Hirt, Managing Editor
Joycelyn Winnecke, Associate Editor
Peter Kendall, Deputy Managing Editor

Library of Congress Cataloging-in-Publication Data

Gangsters & grifters : classic crime photos from the Chicago Tribune.
 pages cm
 ISBN 978-1-57284-166-6 (hardback) -- ISBN 1-57284-166-4 (hard cover) -- ISBN 978-1-57284-744-6
(ebook)
1. Legal photography--Illinois--Chicago. 2. Crime--Illinois--Chicago--History--20th century--
Sources. 3. Crime--Illinois--Chicago--Pictorial works. 4. Criminals--Illinois--Chicago.--Pictorial
works. 5. Organized crime--Illinois--Chicago.--Pictorial works. I. Chicago tribune. II. Title:
Gangsters and grifters.
 TR822.G36 2014
 779'.9364--dc23
 2014027067

10 9 8 7 6 5 4 3 2 1

Midway is an imprint of Agate Publishing. Agate books are available in bulk at discount prices. For
more information visit agatepublishing.com.

ABOUT THIS BOOK VII

Foreword VIII

Notable CASES

STEVENS HOTEL SLAYER 26

LEOPOLD AND LOEB 40

William Heirens 54

JOHN DILLINGER 118

'MAD DOG' KILLER 140

Warren Lincoln 148

ST. VALENTINE'S
DAY MASSACRE 156

AL CAPONE 164

WANDA STOPA 168

DIAMOND JOE ESPOSITO 178

ABOUT THIS BOOK

We're very excited to share "Gangsters & Grifters," a collection of vintage Chicago crime photographs.

Tribune photo editors have been working their way through a massive archive of 4x5 glass-plate and acetate negatives housed five stories under the Tribune Tower. These photos were taken between the early 1900s and the 1950s, and many have gone unseen for generations. Some of these photos, having never been published before, reveal moments witnessed only by the photographers and police.

You'll see cracks, scratches, fingerprints and dust. But we've scanned the beautiful artifacts completely as we found them, as if the person who developed them all those years ago has just stepped away from his or her desk.

Be forewarned, there are graphic crime scenes, raw evidence and depictions of searing emotion. Some photos are shocking and disturbing, captured moments after a crime. Photographers worked alongside police back then, a kind of access that just doesn't exist anymore.

Each frame is a story, a trip back in time. We hope you enjoy the trip as much as we have.

The Dames of the Chicago Tribune Photo Department
Erin Mystkowski, Marianne Mather Morgan, Robin Daughtridge

Throughout this book, actual headlines from historical Chicago Tribune articles are displayed. These headlines have not been altered in any way. All information in the captions comes from historical newspaper articles.

Foreword

We have certainly had our share, haven't we?

There is no city on the planet that can boast more world-famous bad guys and bloody deeds than Chicago, and — in a mildly disturbing way — we relish the association. Despite the all-too-real modern city violence that annually claims hundreds of victims, many of them innocent children, tales of the past bloodshed and tears that have fallen on our streets have an eerie nostalgic glow.

Much of that is due to the glamorization of gangsters and other bad people (see "The Untouchables" TV series and film, as well as "The Sopranos" and, of more recent vintage, "Boardwalk Empire"). Please know we journalists are partly to blame for it. It was a former Chicago newspaperman named Ben Hecht who gave birth to this durable genre by creating what is generally regarded as the first-ever gangster film, "Underworld," in 1927.

Only two years later real life gave us a St. Valentine's Day bloodbath, and you will find here a photo of the carnage that took place that day at the SMC Cartage Co. The massacre started an ever-flowing stream of movies, songs and all manner of "entertainments" based fairly loosely on it.

On the following pages you will encounter Al Capone and John Dillinger, as famous as any gangsters have ever been. They both take over many pages here, while still alive and — in the latter's case — quite dead. In one of the book's oddest images, take note that among a crowd of people staring through glass at Dillinger's corpse at the Cook County Morgue are two women named Betty and Rosella. They are wearing bathing suits.

Also impressive, images of a pair of 21-year-old taxicab bandits, both of them dressed in the fashion of bankers or lawyers and noted for using water pistols.

These pages are filled with such curiosities but also with much blood and many bodies. But even in the most gruesome photos there is a compelling intimacy to the images, as photographers lugging their huge tools got up close, perhaps even convincing the police to delay their duties while they got the shots.

There is no shot more arresting than that of Edward J. O'Hare, a mobbed-up lawyer who worked for and later turned on Capone, slumped bullet-ridden behind the wheel of his car after a fatal chase in 1939. He was the father of Edward Henry "Butch" O'Hare, the U.S. Navy aviator and Medal of Honor winner for whom O'Hare International Airport is named.

There are a few femme fatales on these pages and some others who can be considered heroes, especially the cops who can be seen doing the dirty work. There is also a fellow named Leonarde Keeler, considered the father of the polygraph, administering an early test to a suspect.

We have come a long way and live now in a "CSI"/"Law & Order" world, in which all crimes are solved in a TV hour. But the real world is and always has been a messier place, and if you want (or need) to be reminded of that, just turn the page.

Rick Kogan

Born and raised and still living in Chicago, Rick Kogan has worked for the Chicago Daily News, the Chicago Sun-Times and the Chicago Tribune, where he is now a senior writer and columnist. He was inducted into the Chicago Journalism Hall of Fame in 2003, earned an Emmy Award for his broadcast work and is the author of a dozen books.

GANGSTERS & GRIFTERS

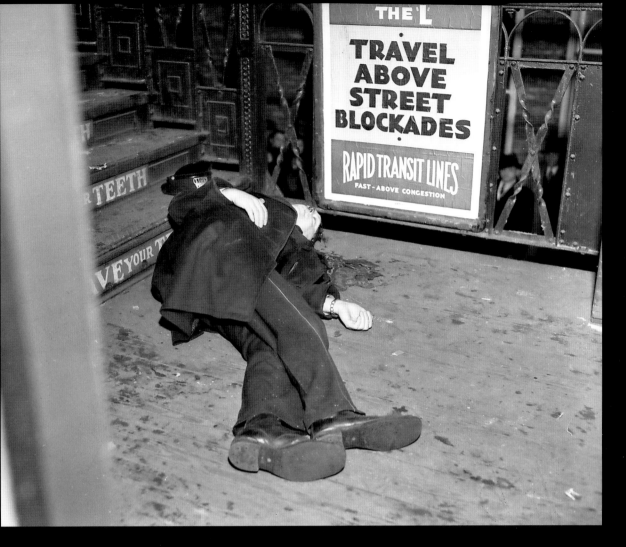

POLICEMAN OFF DUTY
IS SHOT TO DEATH BY
HIS BANDIT CAPTIVE

Policeman Arthur Sullivan, 38, of the Marquette station, was shot and killed at the Kedzie Avenue station of the Douglas Park "L" branch near 20th Street on Jan. 14, 1937. Sullivan, off duty, was on his way home when a clerk from a nearby pharmacy pointed out a man who had robbed him the day before. Sullivan trailed the man to the "L" station, where he confronted him. According to the Tribune, the suspect said, "Officer, I'm a law abiding citizen." As Sullivan marched the man down the stairs to the middle platform, the suspect grabbed a gun from a hidden left-shoulder holster and shot Sullivan in the head. Sullivan left a widow and four children. Paroled convict Joseph

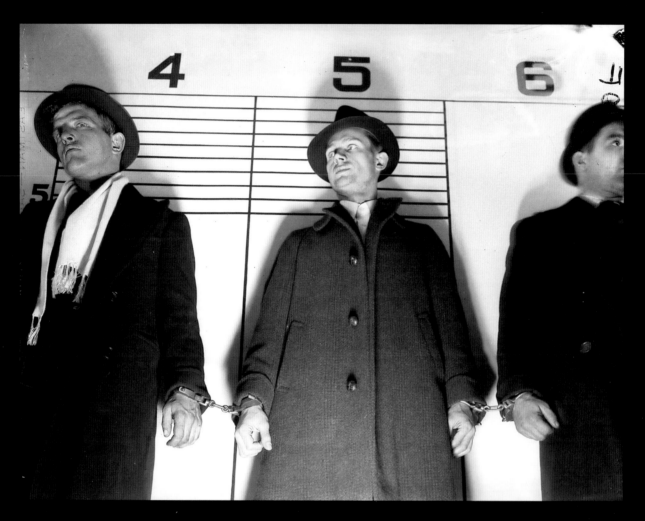

◄ CONTINUED Paroled convict Joseph Schuster, center, was identified by robbery victims as the killer of policeman Arthur Sullivan.

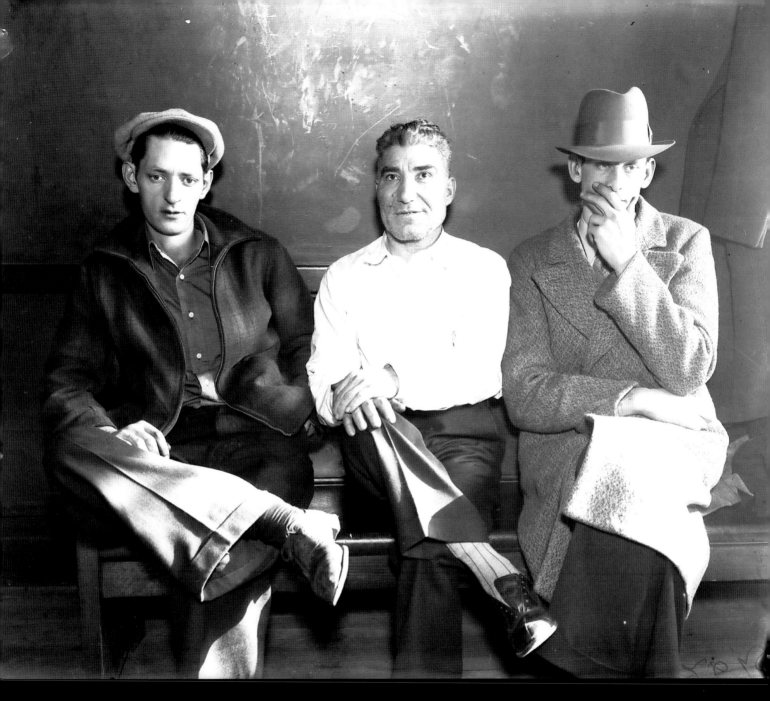

Others Linked to Police Killer's Gun

From left, Harry Cyranek, 25; Sam Circelli, 44; and escaped convict William Wrablik, 25, were three of the seven men arrested in a flat in the 2000 block of W. 18th Place on Jan. 26, 1937. In the flat, police found $500 worth of radios, fur coats and other stolen goods in addition to a sawed-off shotgun and a .44-caliber revolver. Circelli was said to be the original owner of the gun used by Joseph Schuster to kill policeman Arthur Sullivan. Circelli gave the gun to Cyranek, who hid it under a shed, where Schuster found it and used it against Sullivan.

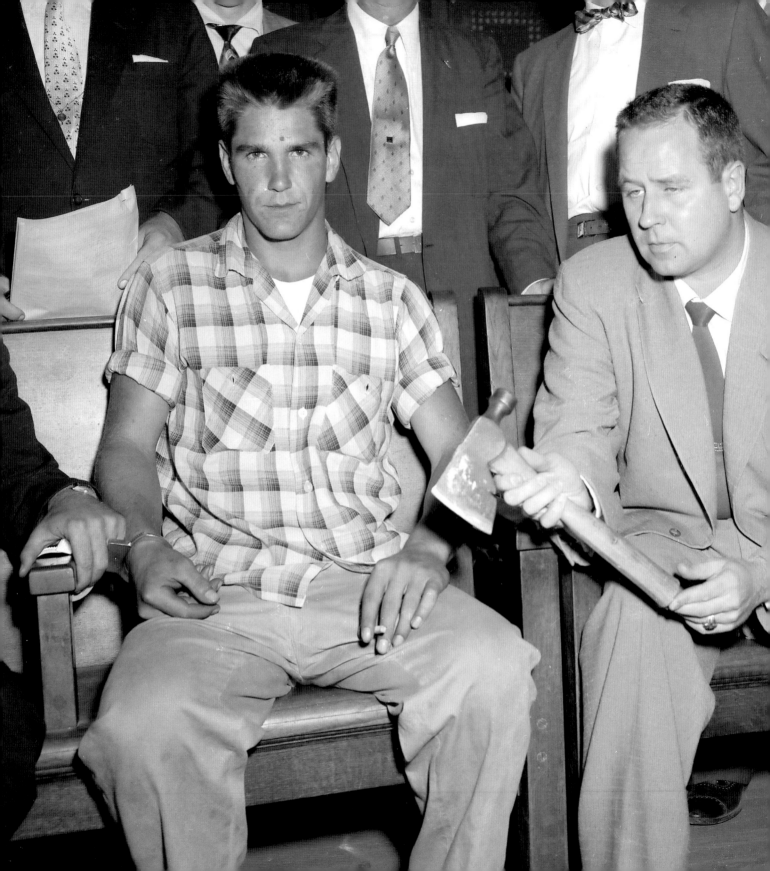

GIRL, 18, FOUND SLAIN BY BLOW ON SOUTH SIDE

The bludgeoned body of Rosemary McCarthy, 18, was found on Sept. 5, 1956, in the parking area behind a garage in the 5200 block of S. Halsted Street. The day McCarthy's body was found, Arthur Bauer, 21, confessed to killing her with his work hatchet when she resisted his advances. This photo, taken Sept. 14, 1956, shows Assistant State's Attorney Robert Cooney holding the hatchet used to kill McCarthy. According to the Tribune, Bauer explained, "I've been drinking since I was 15. I black out when I'm drinking. I don't know what's happened to me." Bauer was married with two small children.

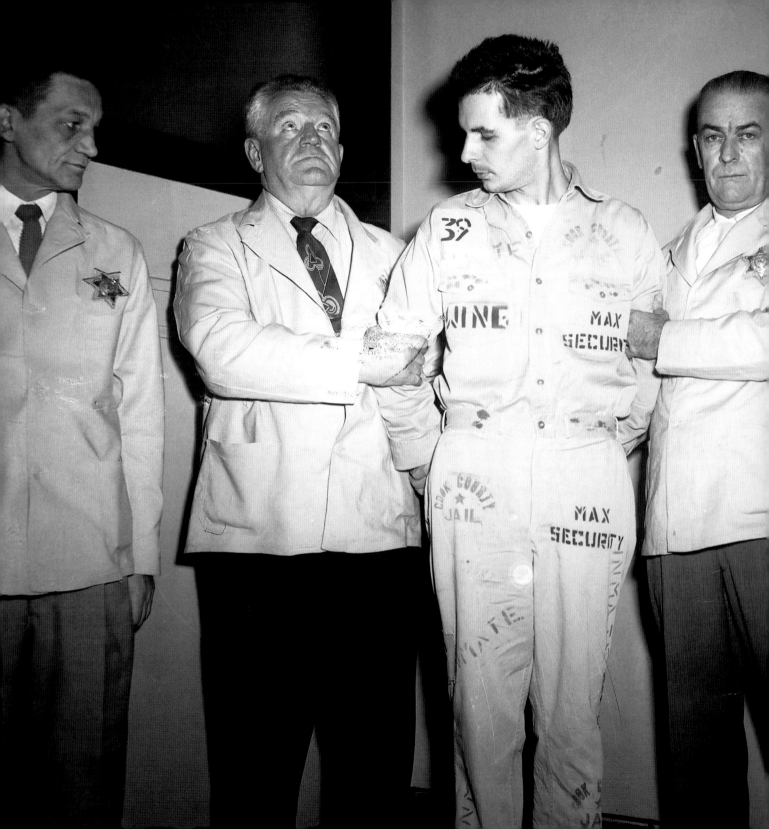

CARPENTER VERDICT: DEATH

JURY CONVICTS COP KILLER IN SPEEDY TRIAL

Deliberates Only 75 Minutes

Sheriff's Deputies Joseph Jacobsen and William Braun, from left, hold onto murderer Richard Carpenter, with help from fellow Deputy Jack Smietana during Carpenter's five-day trial, which began Nov. 7, 1955. According to the Tribune, Carpenter "refused to clean up or dress up and had to be dragged in handcuffs and leg irons to the courtroom." Carpenter confessed to more than 70 robberies in a two-year span, in addition to killing Detective William J. Murphy, 34, and seriously wounding Officer Clarence Kerr, 26, on Aug. 17, 1955. Carpenter, who was often uncooperative in the courtroom and jail, was found guilty and sentenced to die by the electric chair. He was executed on Dec. 19, 1958. CONTINUED ➡

KILLER SHOOTS SECOND COP!

Carpenter Wins Gun Battle in Theater

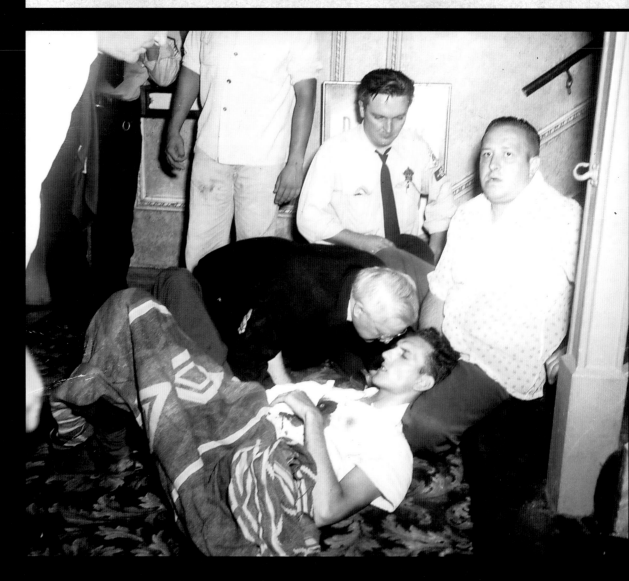

◄ CONTINUED Rookie patrolman Clarence Kerr is given his last rites in the Biltmore Theater lobby, in the 2000 block of W. Division Street, after being shot by fugitive Richard Carpenter. Kerr had finished watching a movie with his wife, Marion, when he noticed Carpenter sleeping in the back of the theater. After telling his wife to wait in the lobby, Kerr approached Carpenter and a gun battle ensued. Kerr was shot in the chest and, according to Tribune reporting, survived only because his heart was contracted when the bullet passed close by. Carpenter was captured the next day and executed for his crimes in 1958.

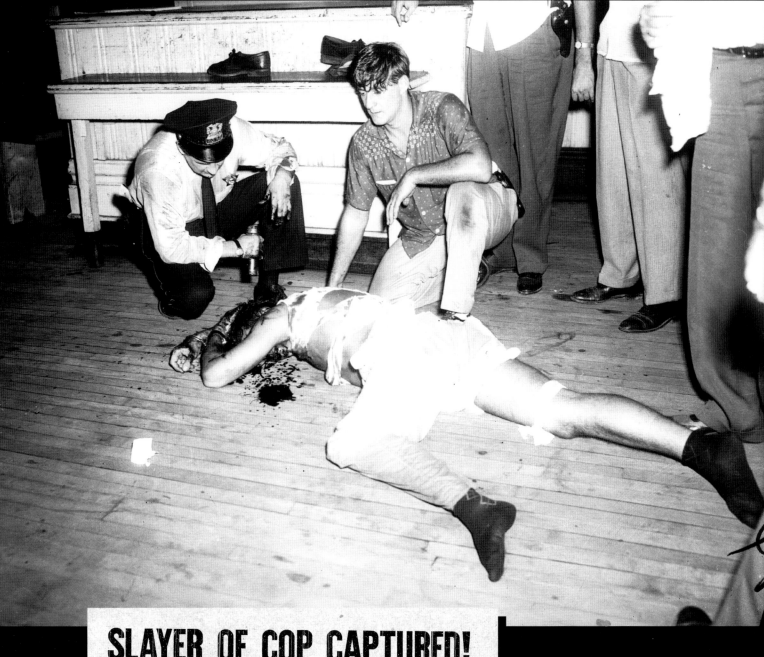

SLAYER OF COP CAPTURED!
30 SQUADS USE GUNS, GAS

Carpenter, in handcuffs on the floor of the W. North Avenue Police Station, was beaten by police during his capture on Aug. 18, 1955. Carpenter had fled to an apartment in the 2000 block of W. Potomac Avenue, where police attacked him with tear gas and shotguns. According to the Tribune, it took 30 responding police squads, and still Carpenter fought like a "vicious animal."

The Shooting
of Dion O'Banion

He Was the Gun-Crazy Glamor Boy of the Dry Law Days, and They Gave Him the First of the Big Gangland Funerals

Police remove the body of gangster Dean "Dion" O'Banion from his Schofield Co. florist shop in the 700 block of N. State Street, located across from Holy Name Cathedral, on Nov. 10, 1924. Three assassins entered the flower shop, talked with O'Banion and then opened fire, killing him with at least seven bullets. O'Banion's funeral was attended by 10,000 people, is said to have cost $100,000 and was replete with 26 truckloads of flowers. O'Banion's main rivals were Johnny Torrio and Al Capone.

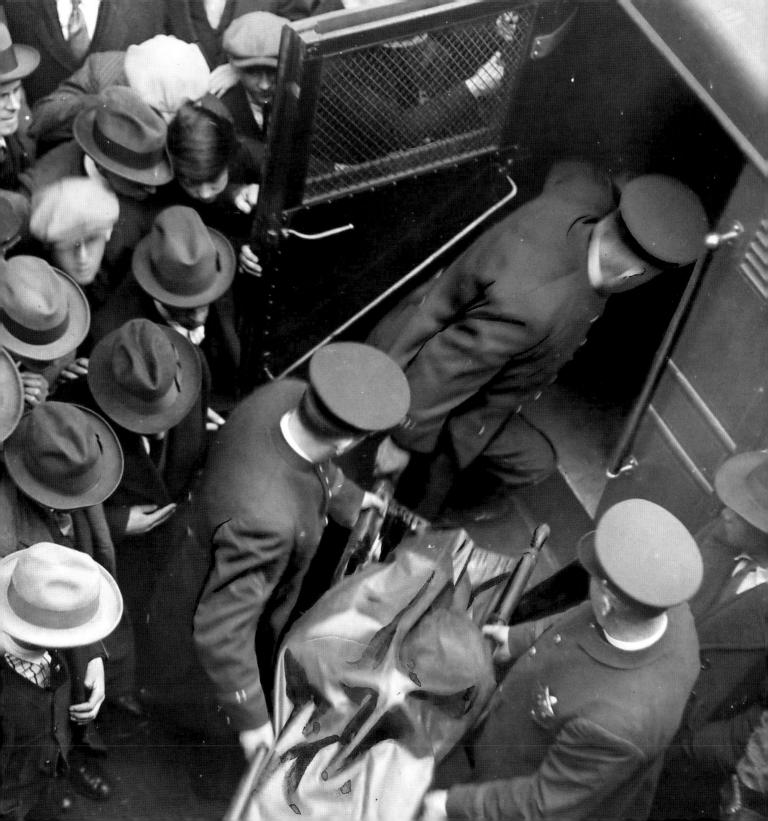

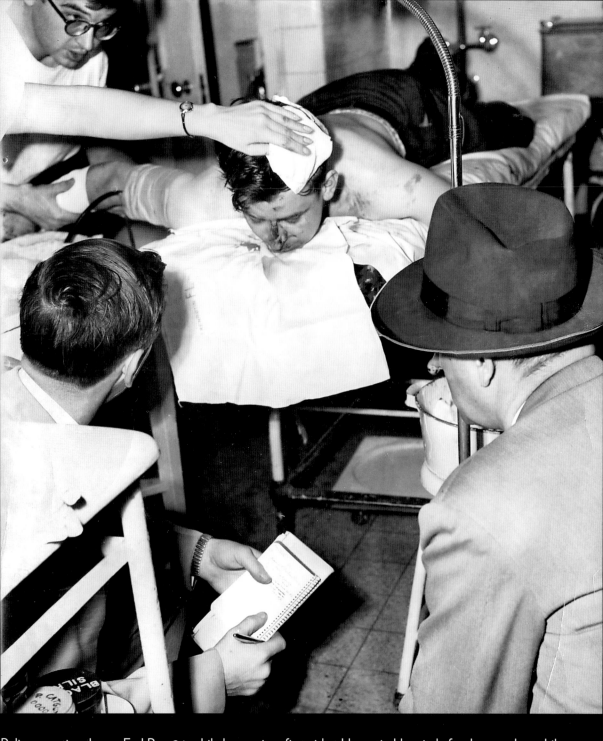

Police question James Earl Ray, 24, while he receives first aid at Henrotin Hospital after he was shot while trying to elude police on May 6, 1952. Ray used a gun to rob a Red Top taxicab of $11. In 1952, Ray vowed to a Chicago judge that if he were given probation for the armed robbery he would "never become involved with the law again," according to the Tribune. He was given a two-year sentence. Ray would go on to assassinate Martin Luther King Jr. in 1968.

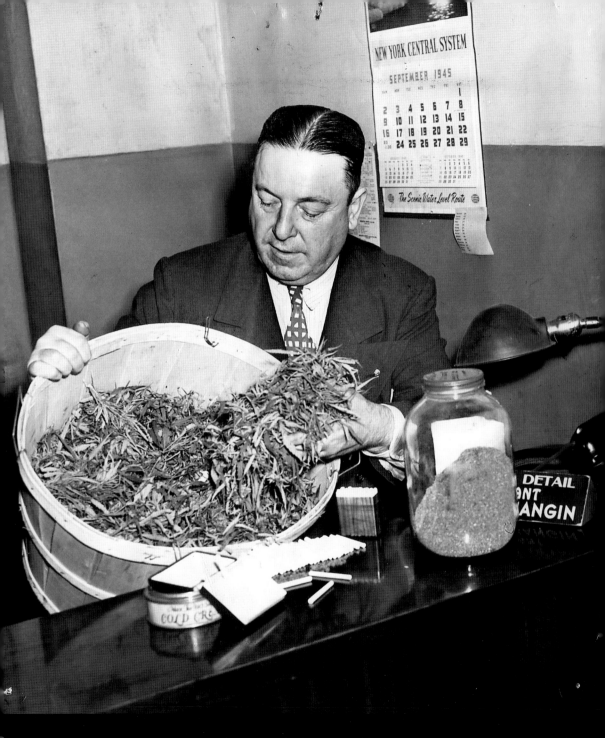

Sgt. John F. Mangin shows off marijuana leaves in a basket, ground leaves in a jar and 200 cigarettes made of the drug, which were seized during a raid on Sept. 28, 1945. Mangin and Sgt. Frank Sheahan of the police

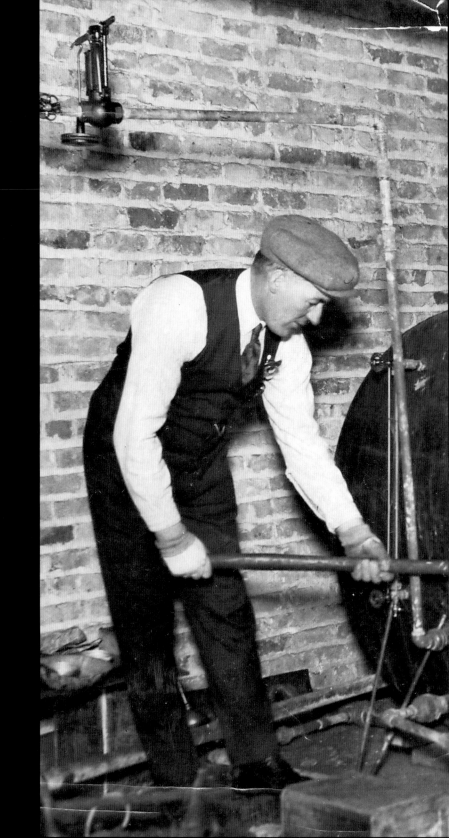

Police officers Thomas Roach
and Patrick Bourke raid an alcohol
processing facility on W. Randolph
Street during the Prohibition-era, circa
1929. The two patrolmen were known
raiders of "wet" parties and breweries.

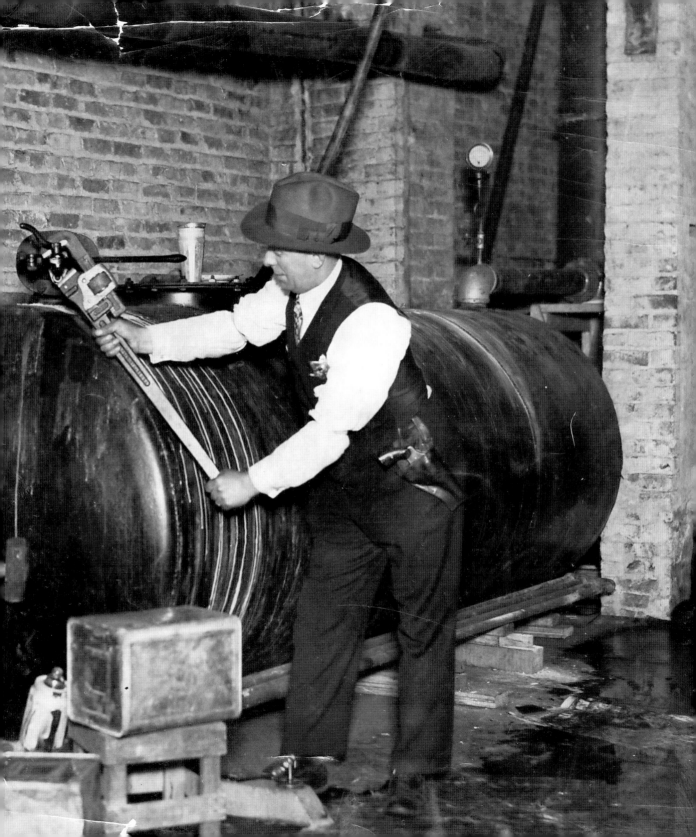

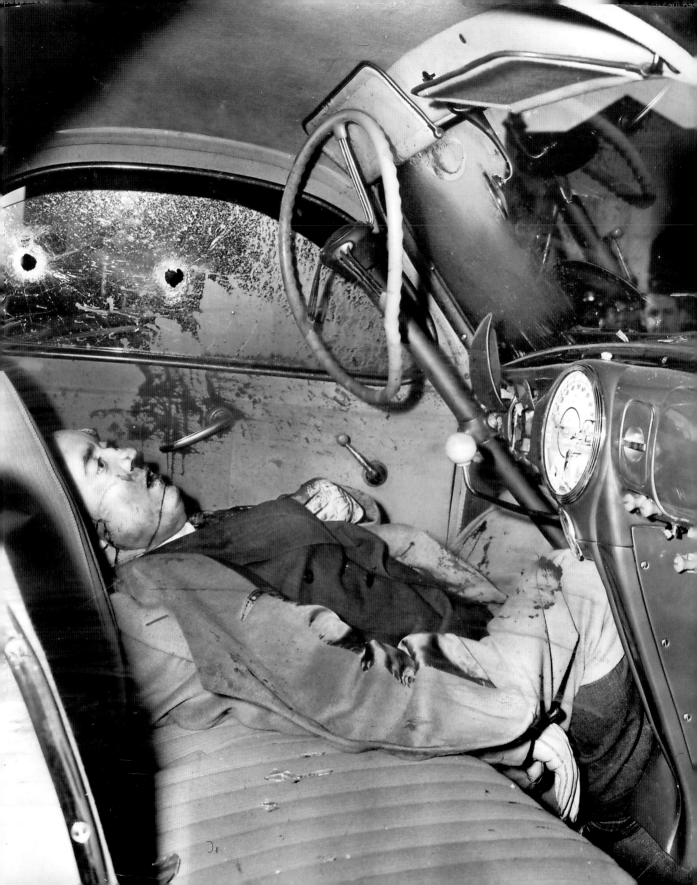

E. J. O'HARE, RACE TRACK OPERATOR, SLAIN IN STREET

Two Shotgun Blasts Fired Into Auto Window.

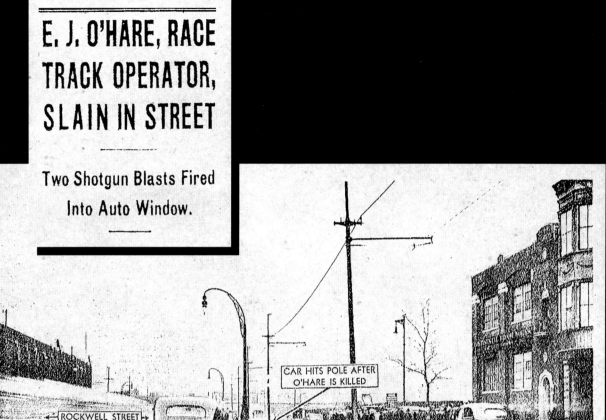

ROCKWELL STREET

CAR HITS POLE AFTER O'HARE IS KILLED

OGDEN AV.

N.E.

WHERE O'HARE WAS SHOT

TALMAN AVENUE

Photo-diagram of scene of Ogden avenue between Talman avenue and Rockwell street after Edward J. O'Hare, president of Sportsman's Park race track, had been shot to death in gangland fashion. O'Hare's car jumped curbing after he was fired upon from another auto and crashed into pole at Rockwell street.

[TRIBUNE Photo.]

(Story on page 1.)

On Nov. 8, 1939, Edward O'Hare died of two shotgun blasts to his head and neck as he raced his automobile northeast on Ogden Avenue near Rockwell Street in Chicago, in a futile effort to outdistance his assassins. O'Hare was an attorney who represented liquor and dog-track interests and worked for Al Capone. O'Hare's death was rumored to be connected to Capone's imminent release from prison; Capone supposedly resented O'Hare's rise to power and wanted to regain control. Another theory was that the mob suspected O'Hare of having "stooled" to the federal government on tax and other matters.

GUNMAN SLAYS ALFRED LINGLE IN I. C. SUBWAY

$25,000 for Capture, Is Tribune Offer.

The scene in the tunnel under Michigan Avenue leading to the Illinois Central train station at Randolph Street shortly after Alfred "Jake" Lingle, 38, an 18-year veteran Chicago Tribune crime reporter, was shot and killed by a single gunshot to the head on June 9, 1930. Lingle had been covering Chicago's crime underworld for years and had come to know many local gang leaders. Reports suggested that Lingle was not killed to prevent the exposure of gang activity, as many asserted, but that he was actually involved in the crime underworld. The Tribune reported that Lingle wore a diamond-studded belt buckle given to him by his friend Al Capone.

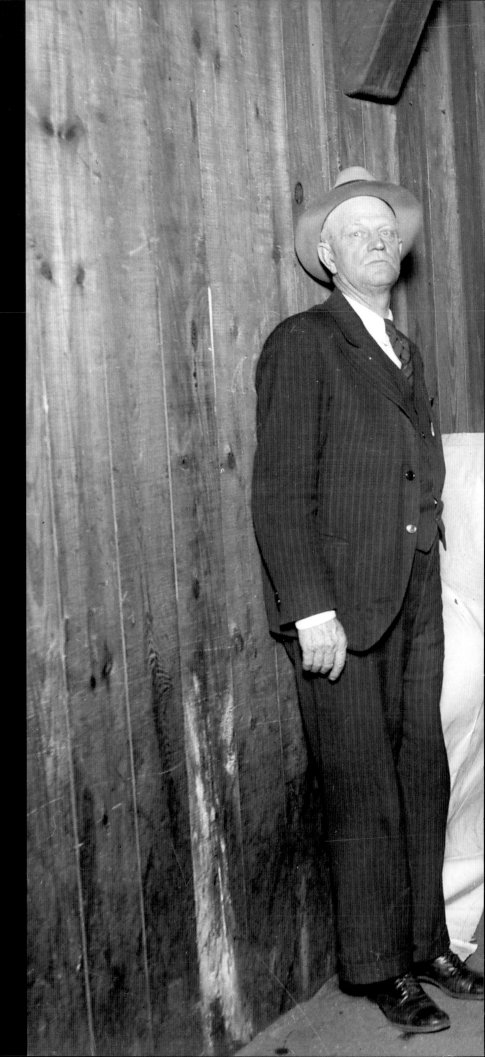

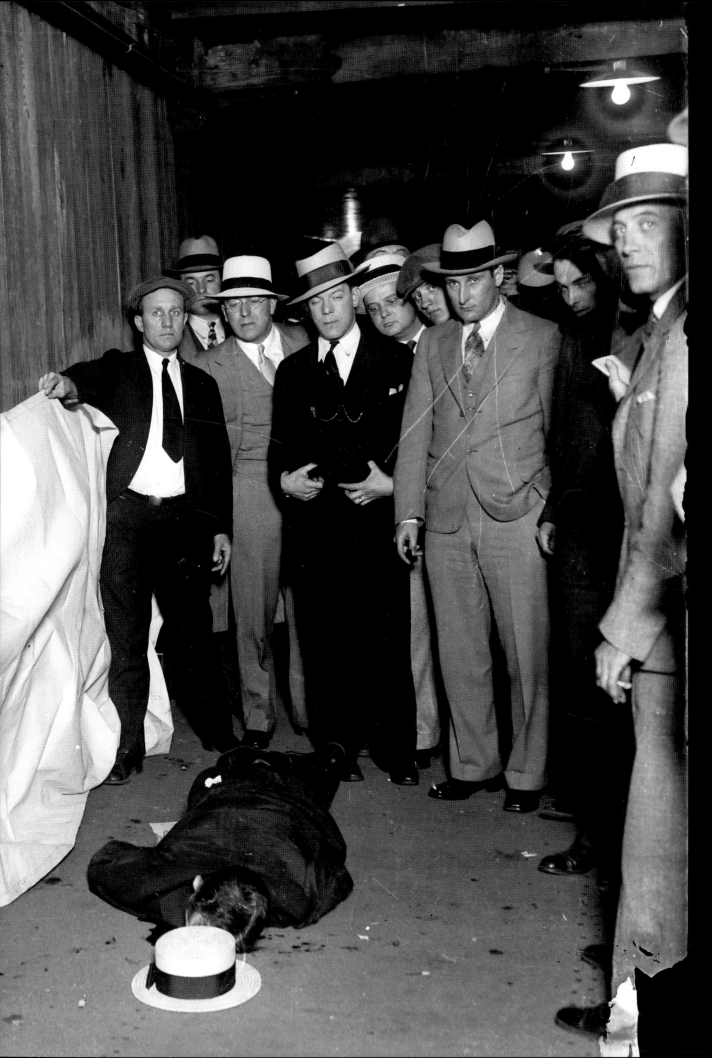

Gang leader George "Bugs" Moran, his face covered, is shown with Detective Phil Carroll, left, leaving the Lake County Courthouse in Waukegan, Ill., on Oct. 21, 1930. Carroll brought the gangster to Chicago and grilled him on the murder of Alfred "Jake" Lingle. Moran had succeeded Dean O'Banion as the leader of Chicago's North Side gang during Prohibition, making him the new rival of Al Capone and the Chicago Outfit.

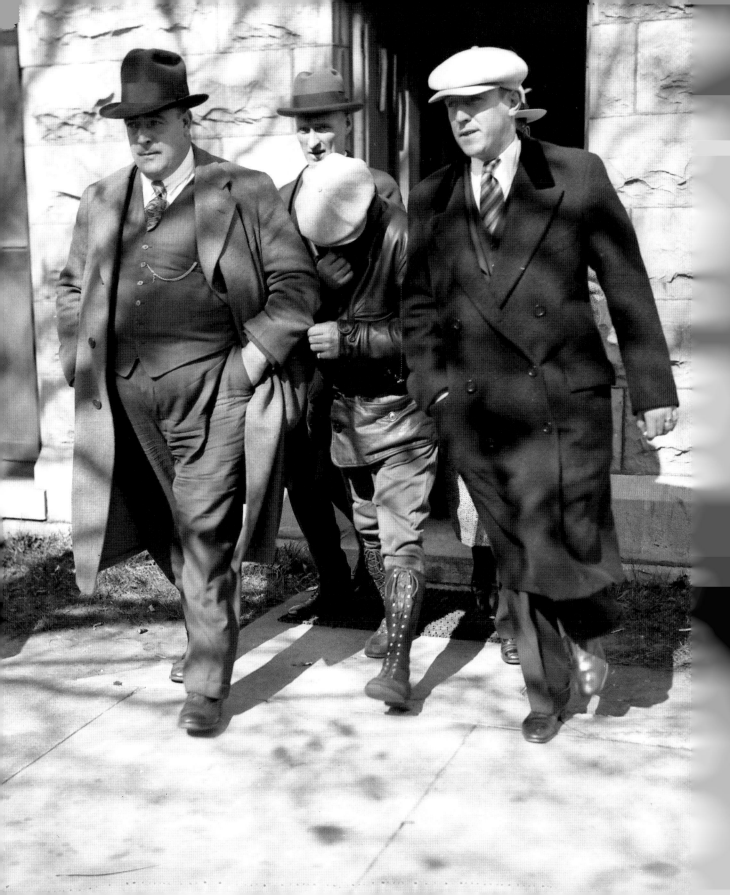

JOE AIELLO SLAIN IN AMBUSH

MACHINE GUN SLUGS RIDDLE GANG LEADER

Moran Ally Trapped in Cross Fire.

Joe Aiello, North Side alcohol king and partner of George "Bugs" Moran, died in a machine-gun ambush on Oct. 23, 1930. Many believed at the time that Al Capone's gang carried out the assassination. This police officer is showing one of the gunmen's hideouts on the 4500 block of West End Avenue, from where the final shots that killed Aiello originated. The Tribune reported "35 steel-coated bullets ended the career of Aiello."

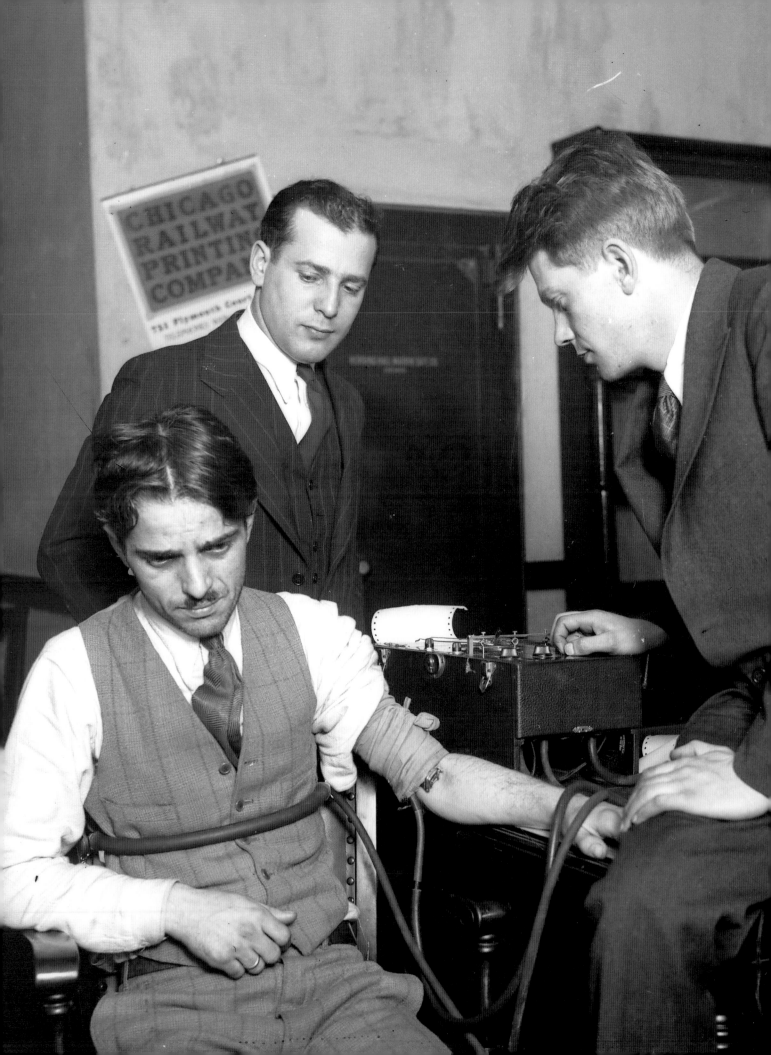

Leonarde Keeler, co-inventor of the polygraph test, administers the test in Chicago, circa April 1930. Born and raised in California, Keeler moved to Chicago in 1930 to work in the Scientific Crime Detection Laboratory at Northwestern University. He opened the first polygraph school and is regarded as the father of the machine.

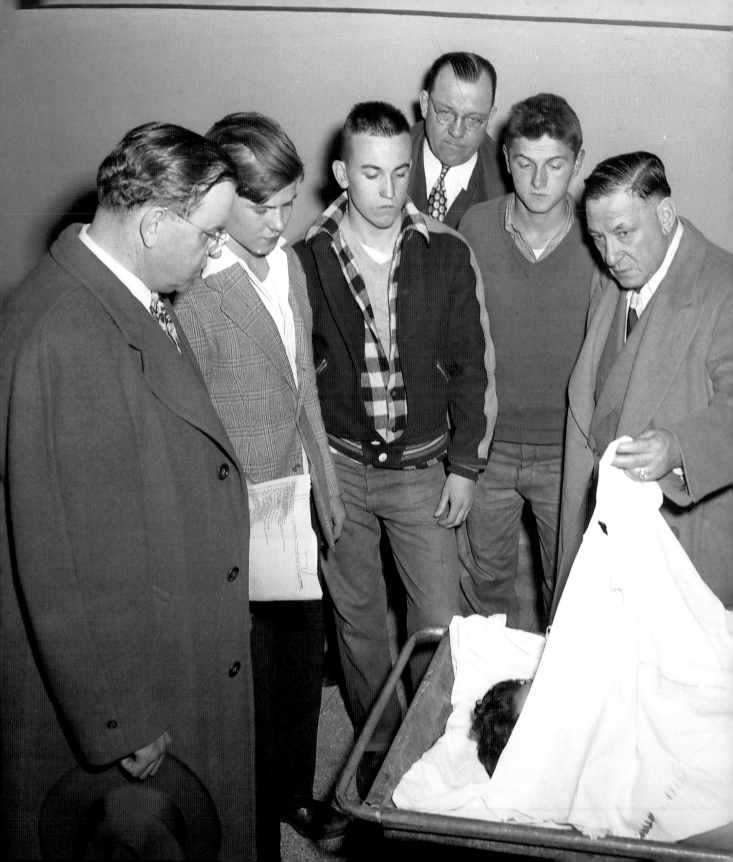

Capt. Tom Duffy, left, and Lt. Phil Breitzke, third from right, enlist the help of neighborhood boys to identify the body of Morton Stein, 16, in May 1945. Stein was murdered by his partner in crime, Donald Jay Cook, 15, on May 11, 1945. According to Cook, the boys had been committing robberies together, but when Cook said he wanted out, a fight ensued. Cook bludgeoned Stein with a blackjack, stabbed him several times and then stuffed him in the closet of their hotel room. Cook then fled to Louisiana, where he was arrested in September and sent back to Chicago to stand trial. Cook was sentenced to between 7 and 14 years in prison after he changed his plea from not guilty to guilty of manslaughter. CONTINUED ➡

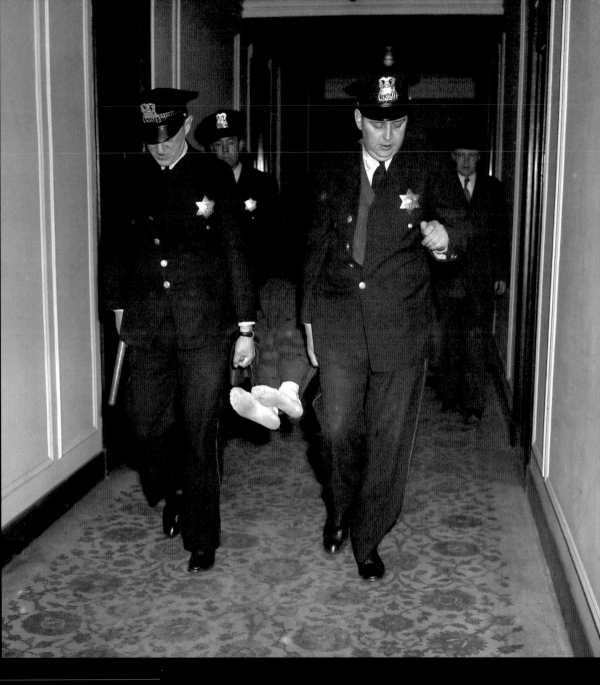

← CONTINUED

ABOVE: Police remove Morton Stein's body from a
room at the Stevens Hotel on May 11, 1945.

RIGHT: Donald Jay Cook in the Cook County Jail,

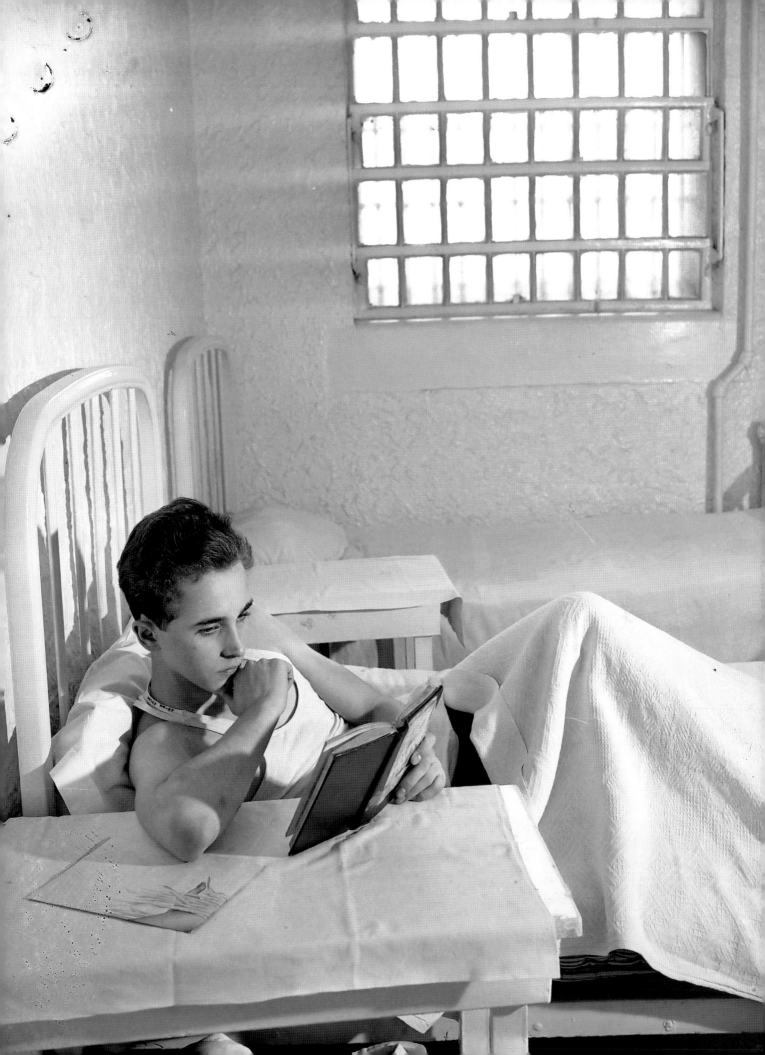

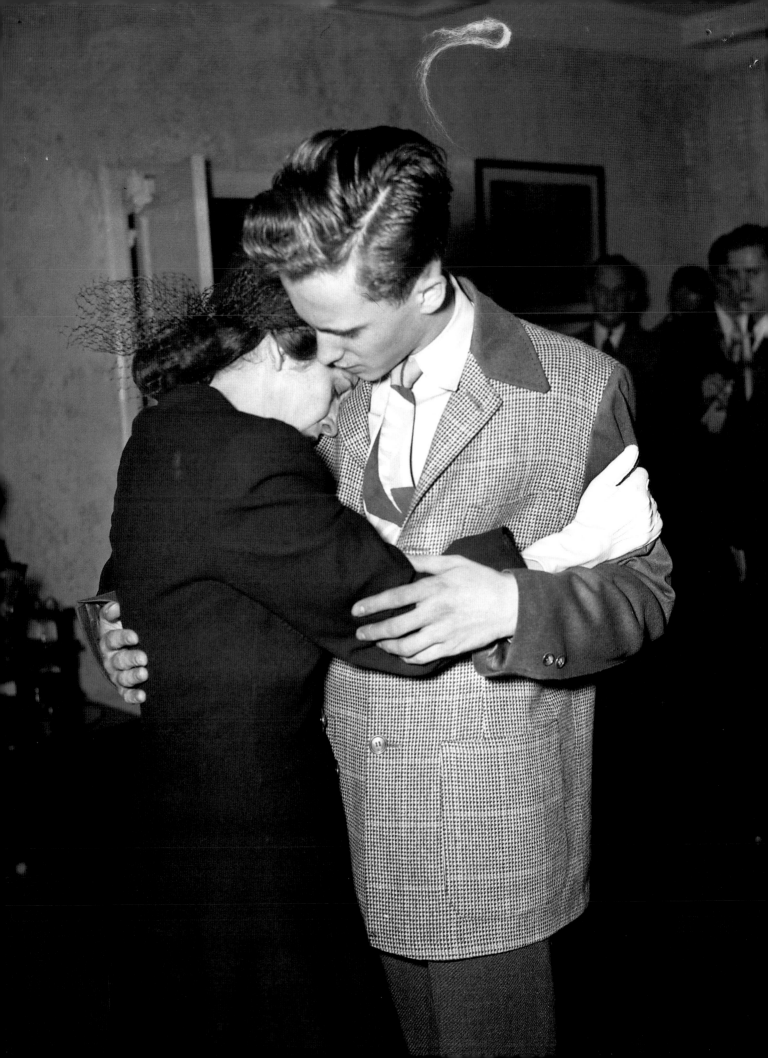

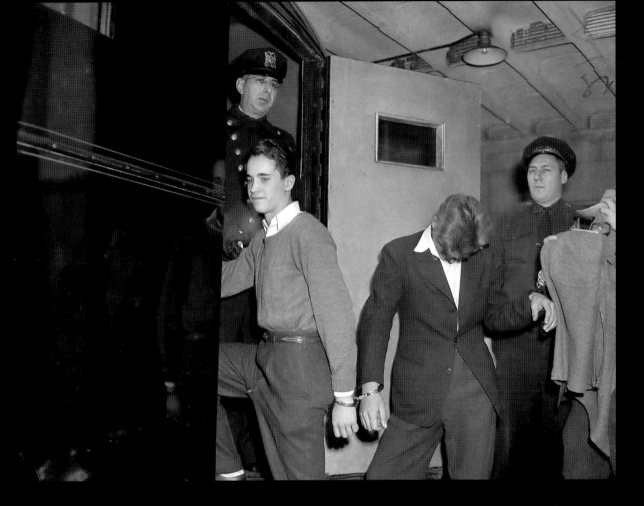

◀ CONTINUED

LEFT: Donald Jay Cook and his mother, Mrs. Isabel Edwards, meet at the warden's office in the Cook County Jail on Oct. 18, 1945. Edwards wept and said, according to the Tribune, "Whatever his trouble is, he is still my boy and I will do everything I can for him."

ABOVE: Cook, second from left, leaves the court to serve his

COOK ACCEPTS 7-14 YEAR TERM IN HOTEL KILLING

———

Defense Fight Lost, He Shifts Plea

FIND ENGINEER SLAIN; MYSTERY GIRL ESCAPES

William Dolan, from the Water Pipe Department, found the body of Arthur J. Hewitt, 59, in the 3600 block of S. Park Way in April 1936. Hewitt, a prosperous retired engineer from Wheaton, Ill., had been out drinking with Jewel "Jerry" Corley (who also used the aliases Cortez and Jean Scott) on April 16, 1936, the night he was killed. Corley, described by the Tribune as a "bar-room butterfly," attested that Hewitt fell down the stairs and hit his head. Her friends said she told them she hit him over the head with a bottle and took off to Detroit in his car.

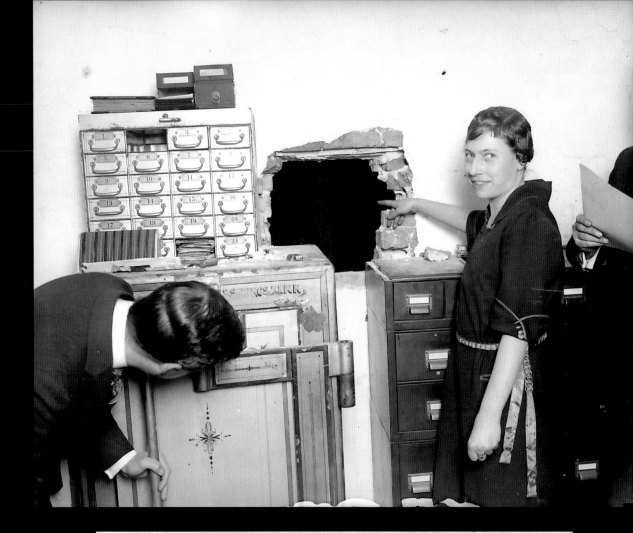

DYNAMITE BANK; LOOT VAULT

On March 22, 1933, six crooks blew open a vault at the Argo State Bank in the 6200 block of Archer Avenue in Argo, Ill. They looted 45 safe-deposit boxes, took $3,000 cash and $8,000 worth of stamps and ultimately escaped.

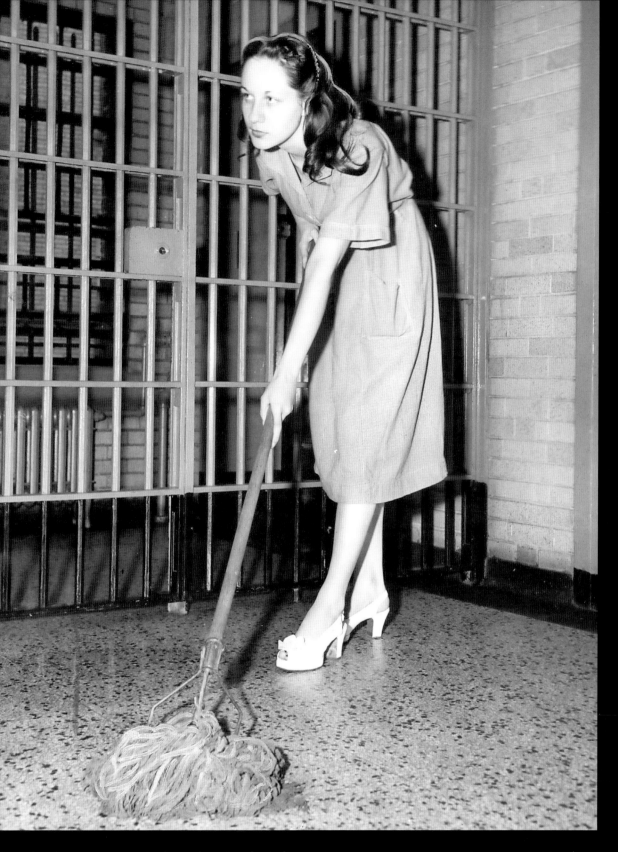

Ruth Steinhagen, 19, mops the floor of a cell in Cook County Jail on June 17, 1949, where she is being held in the shooting of Phillies first baseman Eddie Waitkus. Steinhagen had been obsessed with the baseball star, was declared insane and committed to Kankakee State Hospital. In 1952 she was judged sane and freed.

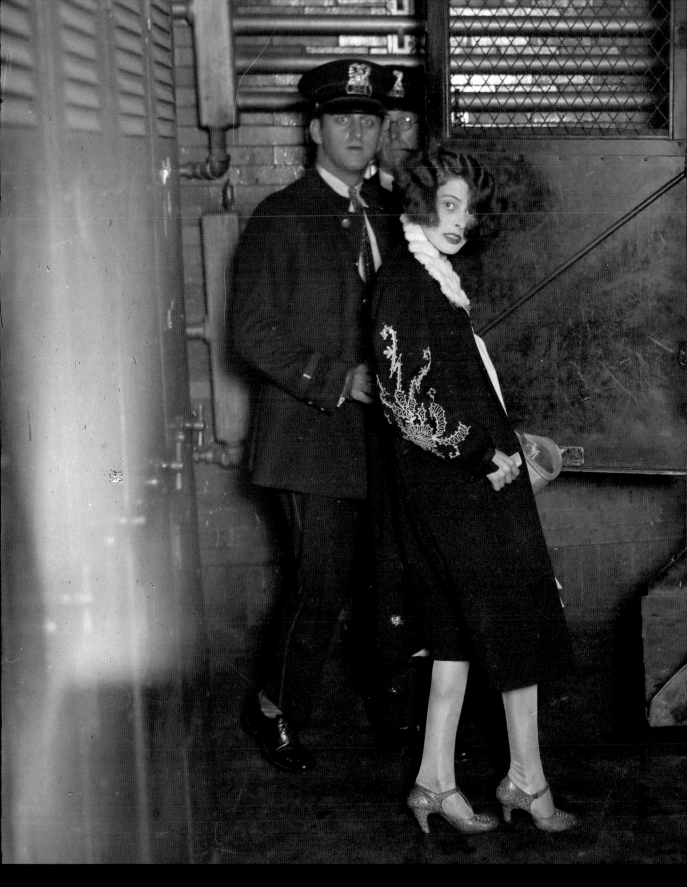

QUIZ LOVE RIVAL IN SEARCH FOR HOTEL MURDERER

Gertrude "Billie" Murphy, 22, is brought in for questioning in the murder case of Michael Stopec, who was shot and killed in an apartment hotel, circa July 1927. Murphy had been a friend of the married Stopec and his suspected killer Henry Guardino. The Tribune reported that Stopec and Guardino were "bitter rivals for the favor of Billie" and that Murphy had tired of Guardino and was going to stay with Stopec. Murphy was also married to a man in the Joliet penitentiary.

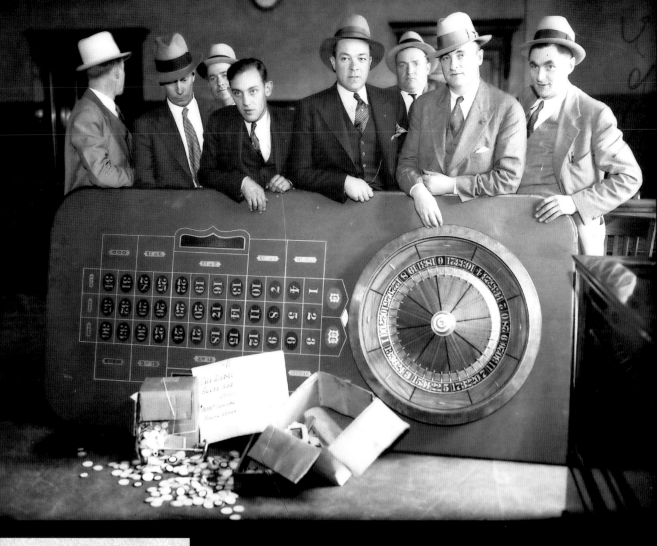

The gambling table seized from Frankie Pope's house is shown in a courtroom, circa September 1931. Pope had been a well-known gambler and owner of a still during Prohibition. The Tribune reported that he was the "squat proprietor of many gambling establishments on South Halsted Street."

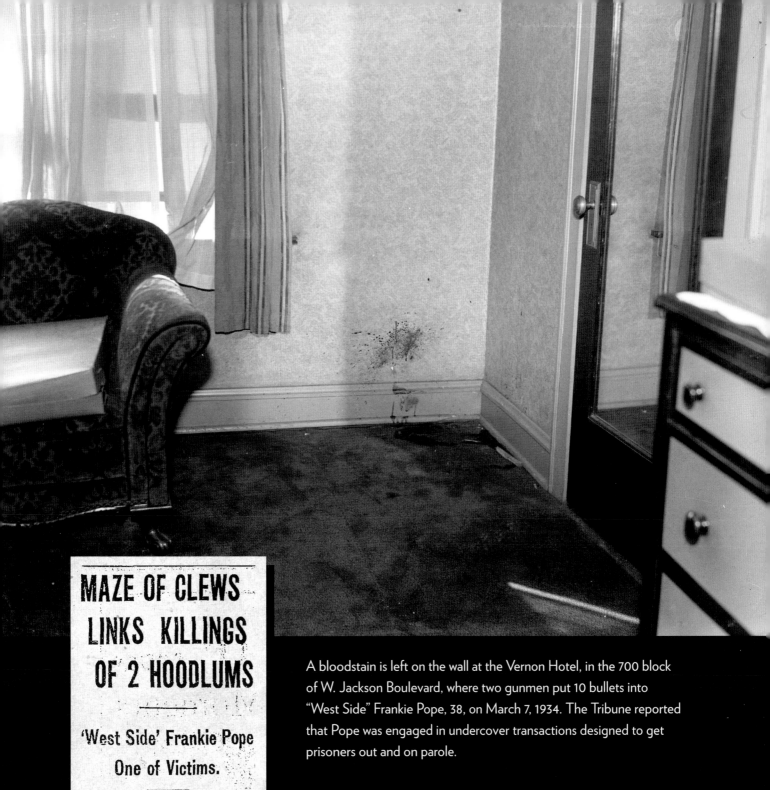

MAZE OF CLEWS LINKS KILLINGS OF 2 HOODLUMS

'West Side' Frankie Pope One of Victims.

A bloodstain is left on the wall at the Vernon Hotel, in the 700 block of W. Jackson Boulevard, where two gunmen put 10 bullets into "West Side" Frankie Pope, 38, on March 7, 1934. The Tribune reported that Pope was engaged in undercover transactions designed to get prisoners out and on parole.

KIDNAPED BOY DIED FIGHTING

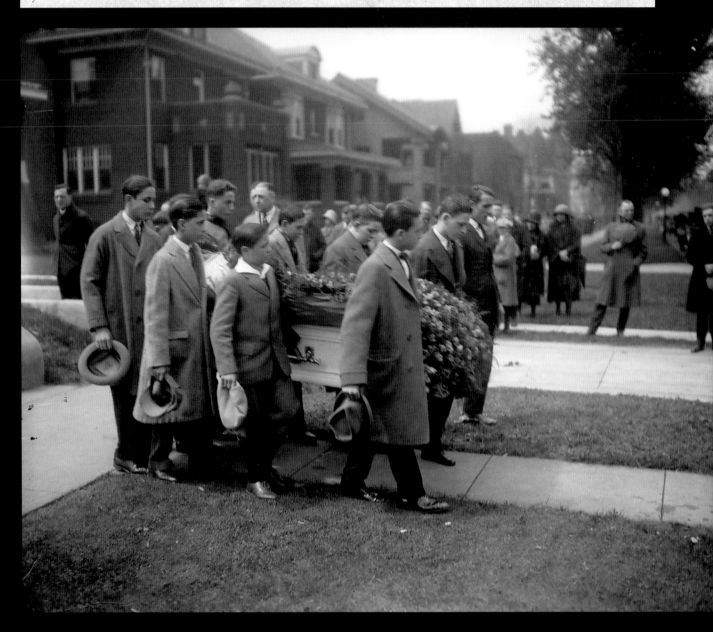

Eight of Robert "Bobby" Franks' friends from the Harvard private school he attended act as pallbearers at the 14-year-old's funeral on May 25, 1924. Franks, the youngest son of millionaire Jacob Franks, was killed by Richard Loeb, 18, and Nathan Leopold Jr., 19, on May 21, 1924. The funeral service was held at the Franks' home in the 5000 block of Ellis Avenue, and Bobby's casket, guarded by six motorcycle police, was taken to Rosehill Cemetery in Chicago. At the time of the funeral, the killers were still at large.

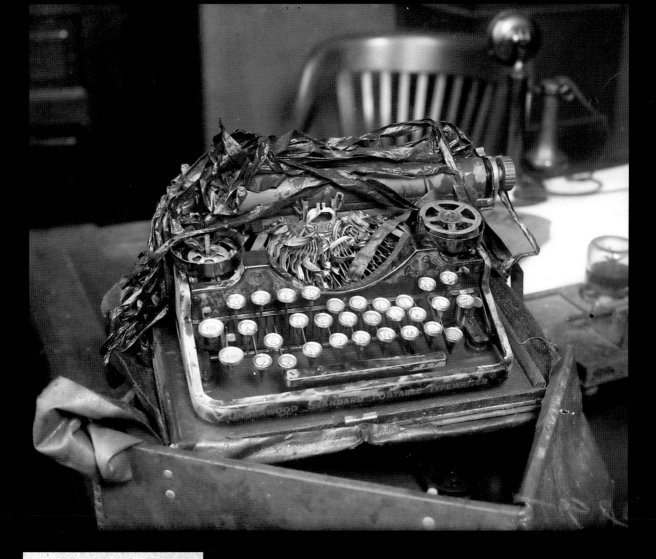

FRANKS SLAYERS PLAN TO ADMIT KILLING, REPORT

Must Be Insane to Have Done It, to Be Plea.

Leopold's Underwood typewriter was found in the Jackson Park Lagoon on June 7, 1924—clinching the case against Leopold and Loeb for the murder of Bobby Franks. The two University of Chicago graduate students had set out to commit the "perfect" murder and used the typewriter to write a ransom note asking for $10,000 from Franks' millionaire father. The pair twisted off several keys with pliers in an attempt to prevent the typewriter from being traced back to them. Both killers were sentenced to life in prison for the murder, with an additional 99 years for kidnapping. They served their time in Stateville Prison in Joliet, Ill. Loeb was killed in prison on Jan. 28, 1936; Leopold was paroled in 1958. CONTINUED ⇒

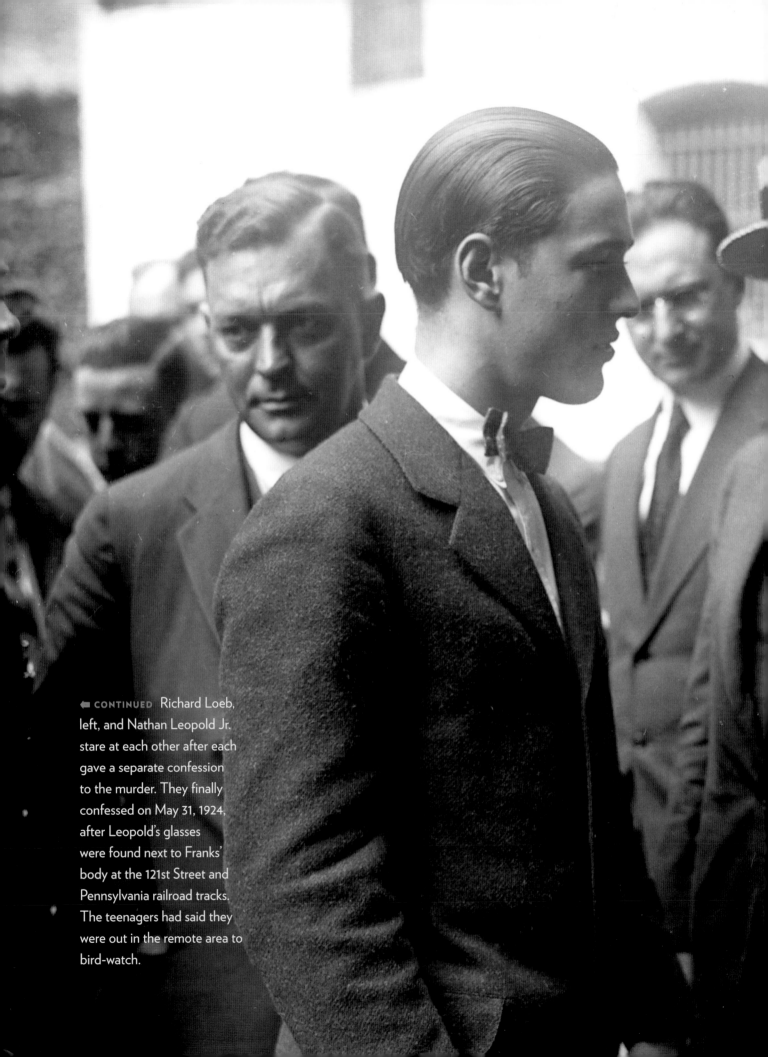

◀ CONTINUED Richard Loeb, left, and Nathan Leopold Jr. stare at each other after each gave a separate confession to the murder. They finally confessed on May 31, 1924, after Leopold's glasses were found next to Franks' body at the 121st Street and Pennsylvania railroad tracks. The teenagers had said they were out in the remote area to bird-watch.

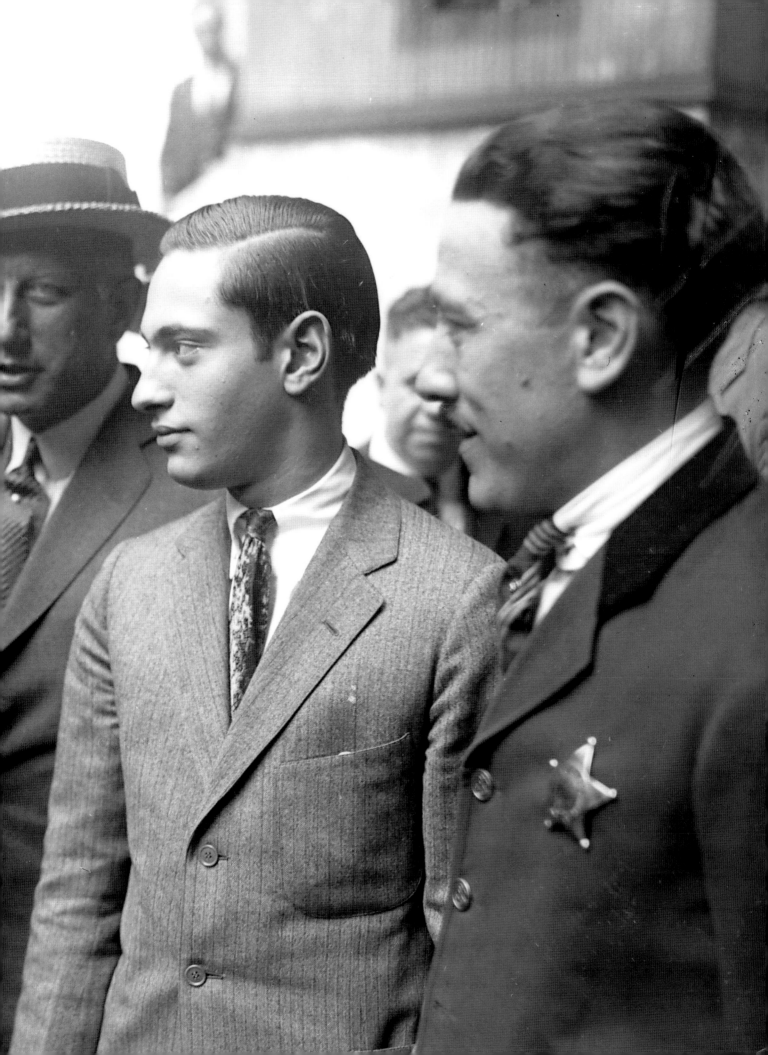

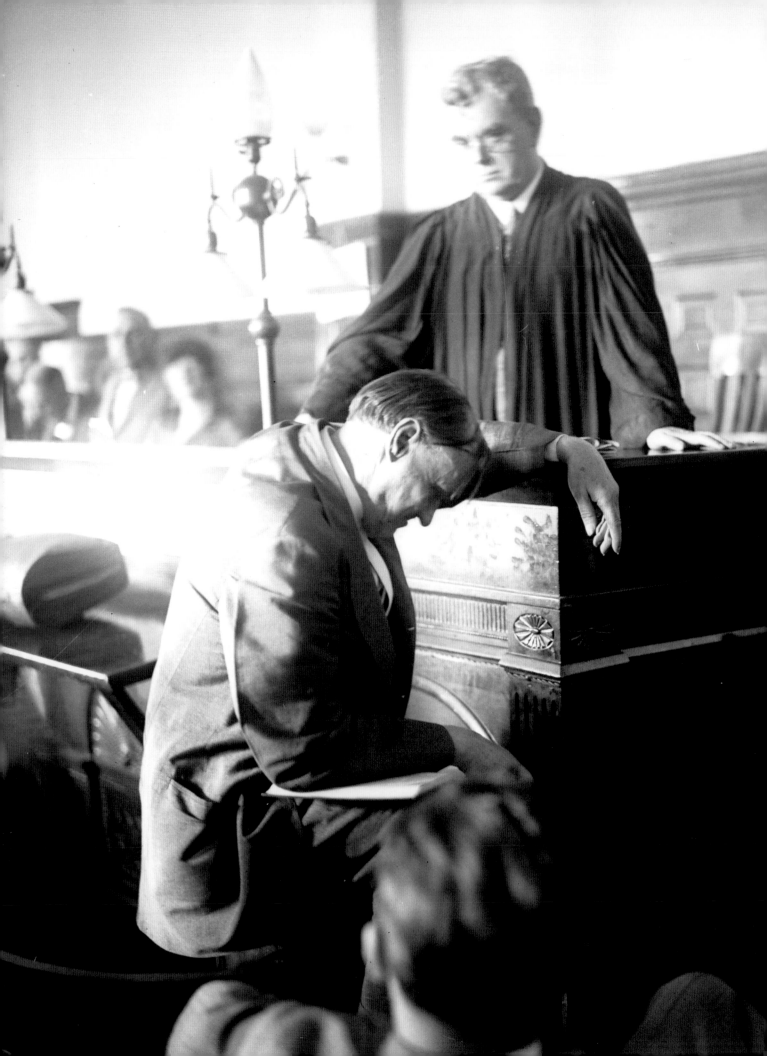

◀ CONTINUED Chief defense attorney and noted Chicago lawyer Clarence Darrow, seated, makes his case for life sentences before Judge John R. Caverly in the murder case against Richard Loeb and Nathan Leopold Jr. in the summer of 1924. In a shocking twist to the trial, Darrow pleaded the two defendants guilty in hopes of saving them from hanging. Darrow's masterful handling of the case has been the subject of many books and movies.

Police detectives from the Austin
station gather evidence at the scene
of a crime in this undated photo.

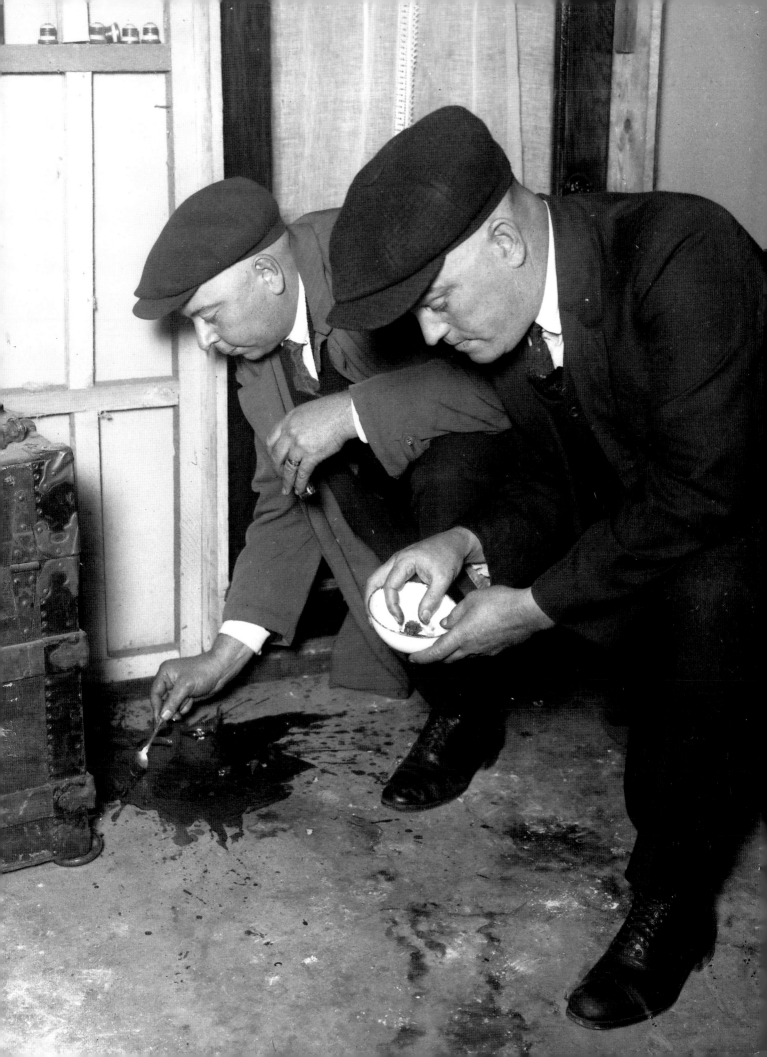

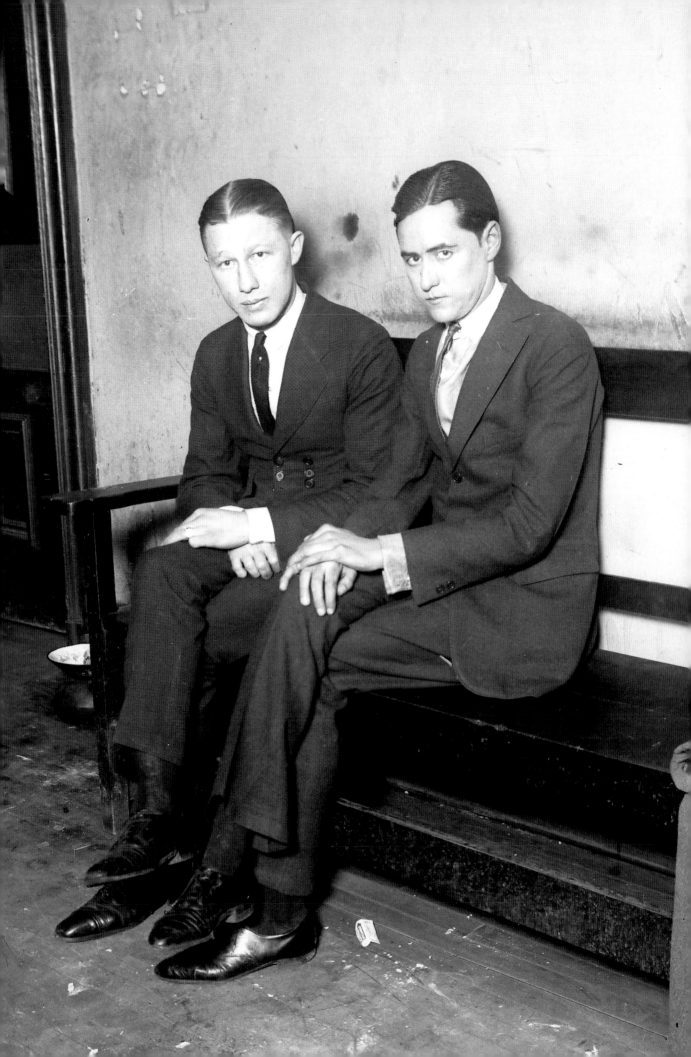

ROUGED YOUTHS HELD AS BANDITS; USE WATER GUNS

Taxi bandits Jack Loveland and Russell Sherrow, both 21, were arrested while trying to rob a taxicab at Eddy Street and Cicero Avenue on Jan. 24, 1923. The two bandits, who were wearing makeup during the holdup, were armed with powder puffs, lipsticks, rouge and 25-cent water pistols. They also confessed to committing 20 similar robberies.

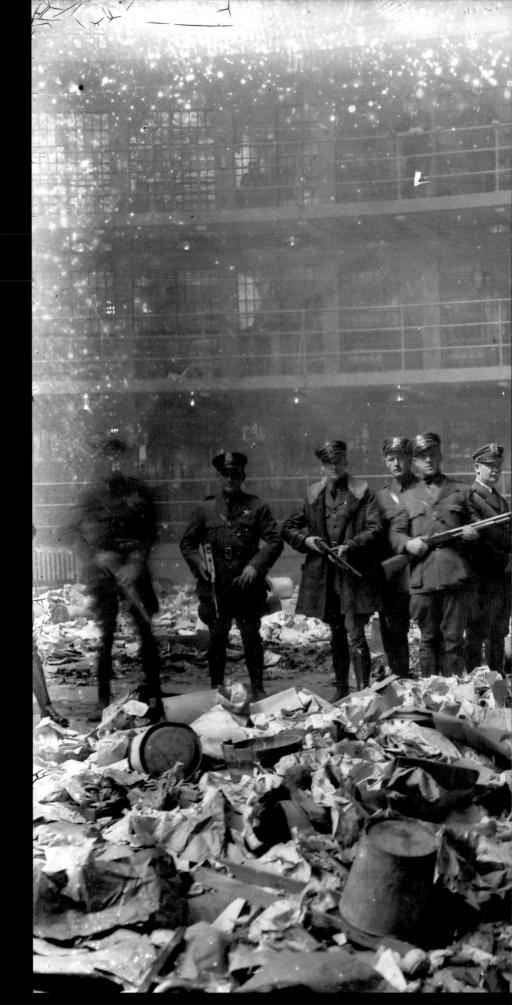

State highway policemen restore order in the circular cellblocks at Stateville Prison in Joliet, Ill., after 1,500 convicts rioted on March 18, 1931, lighting several buildings on fire. Three convicts were shot during the rioting; one of them was gravely wounded with a bullet to the abdomen.

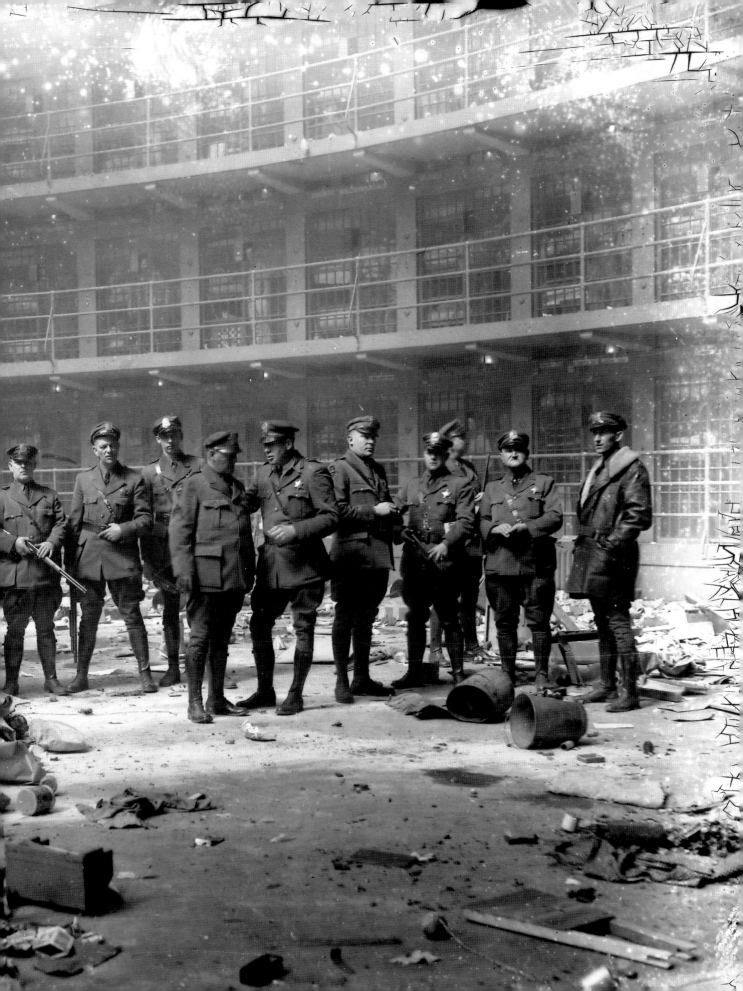

2 MEN SEIZED WITH GUN AND 2 SAW BLADES

Doomed Slayer's Scheme Told

Seen at the Lawndale Police Station are a saw, gun and spool of thread taken from Dominick De Maria and Erville Leroy Burdick, both 20, when they were caught outside the county jail on Nov. 24, 1949, trying to help convicted murderer James Morelli escape before he was executed. Burdick and De Maria said they were neighborhood friends of Morelli's.

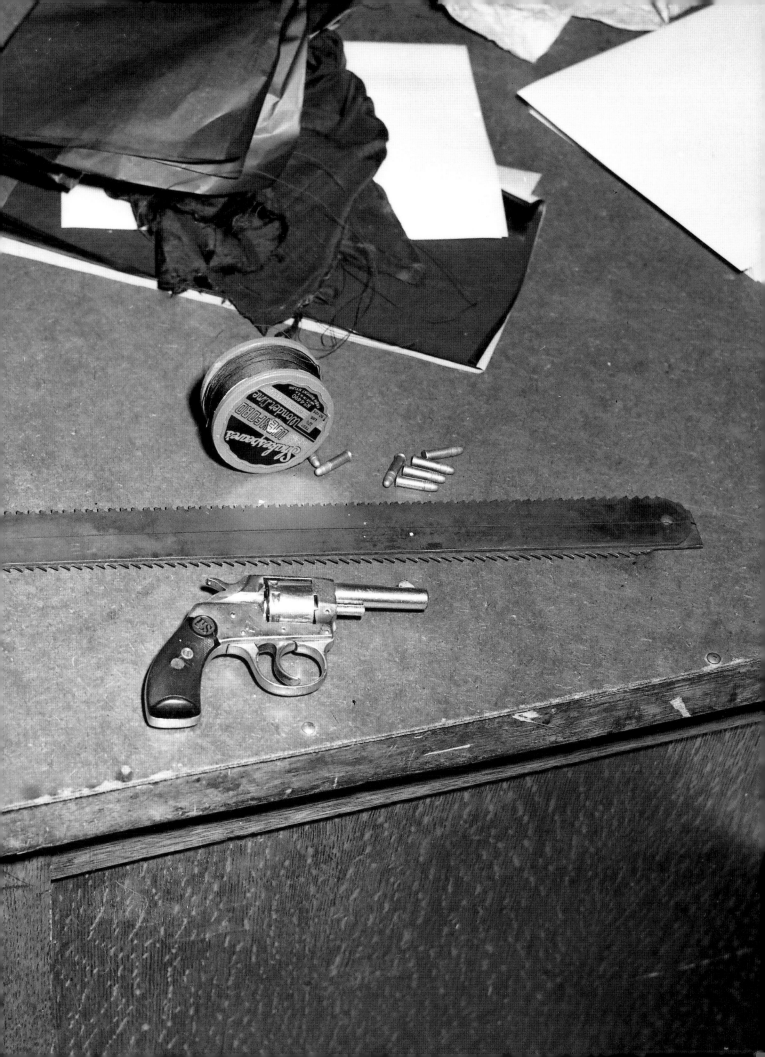

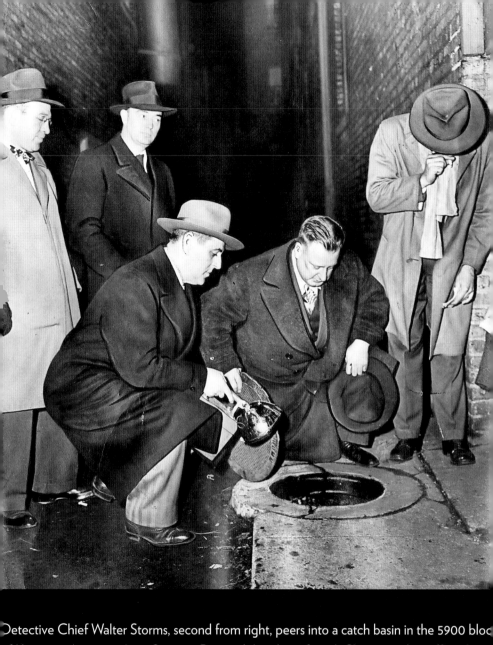

Detective Chief Walter Storms, second from right, peers into a catch basin in the 5900 bloc of Kenmore Avenue, where Suzanne Degnan's head was found. Chicago police officer Lee O'Rourke, who noticed that the soil around the circular edge of the cover was loose, holds the flashlight. Degnan was kidnapped from her bedroom on Jan. 7, 1946. Her dismembered body was found in several sewers across the city. Police questioned more than 400 suspects and public and private rewards were posted, including $10,000 by the Tribune. CONTINUED

REWARD! $10,000 FOR KILLER

Ladder Traced in Kidnap Slaying; Points to New Suspect

TWO JANITORS TAKE LIE DETECTOR TEST; INSIST THEY ARE INNOCENT

Search Turns to Sherman in Degnan Case

Sherman Cleared in Degnan Case

FIND PRINTS ON KIDNAP NOTE

Quiz Detroit Grocer in Degnan Case

LAUNDRY MARK IS NEW CLEW IN CHILD'S MURDER

Police Trail Suspect in Degnan Case

ONE FINGERPRINT ON DEGNAN NOTE IS A STRANGER'S

HERE ARE FACTS AND THEORIES IN KIDNAP MURDER

Police Surmises Listed in Crime Review

DEGNAN MURDER: PUZZLE THAT IS STILL UNSOLVED

Review Facts in Pattern of Kidnap Slaying

400 VOICE PROTESTS ON POLICE HANDLING OF DEGNAN INQUIRY

Police Resift All Clews in Degnan Case

HUNT MAD 'LIPSTICK KILLER'

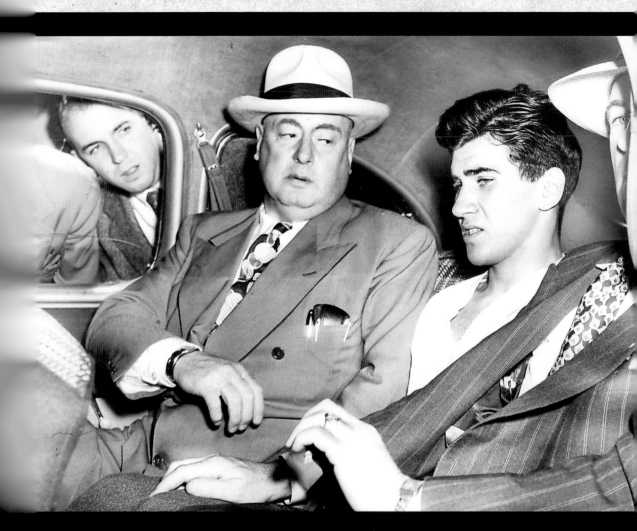

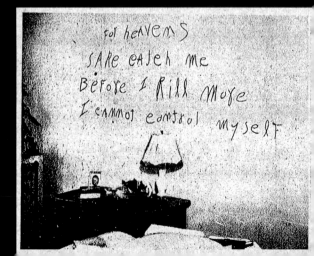

■ CONTINUED Detective Chief Walter Storms, second from left, and Capt. Michael Ahern, far right, accompany University of Chicago student William Heirens, 17, to a detective bureau lineup on July 1, 1946. On Jan. 7, 1946, Heirens was convicted of kidnapping, strangling and dismembering Degnan as well as murdering Frances Brown, 33, and Josephine Ross, 43, in separate crimes in 1945. On Brown's apartment wall the murderer wrote in lipstick, "For heaven's sake, catch me before I kill more. I cannot control myself." This gave Heirens the nickname "The Lipstick Killer."

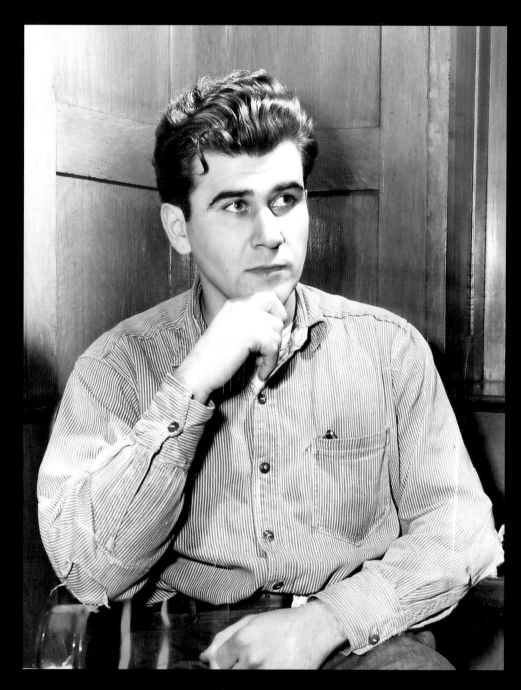

Heirens, 25, in Stateville Prison after learning a review of his case had been granted on Jan. 22, 1954. He would become the longest-serving inmate in Illinois and would die in prison on March 5, 2012.

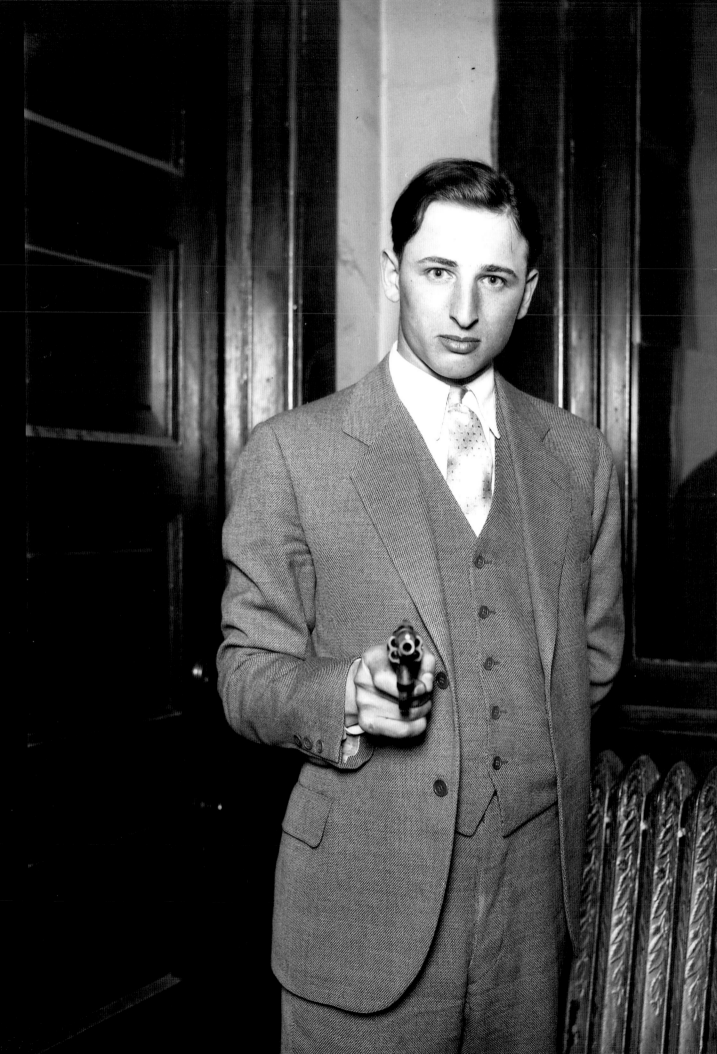

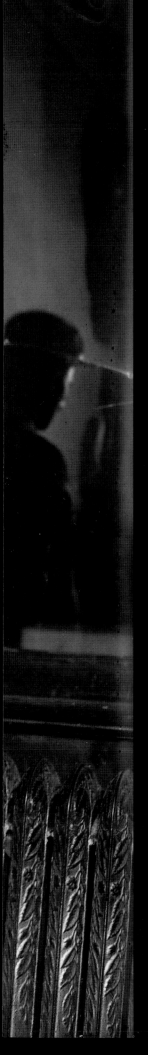

POLICEMAN KILLS BANDIT AND WINS APRIL HERO PRIZE

Promptness, Bravery Get Him Promotion, $100.

On April 28, 1929, policeman Sidney Block of the South Chicago district, off duty and in plain clothes, shot and killed a well-dressed young gunman who'd held up two 63rd Street shops. According to the Tribune, Block yelled "Halt there, I'm a policeman" as he drew his gun. "Go to hell," cried the robber over his shoulder as Block pumped three bullets into the thief, which stopped him dead.

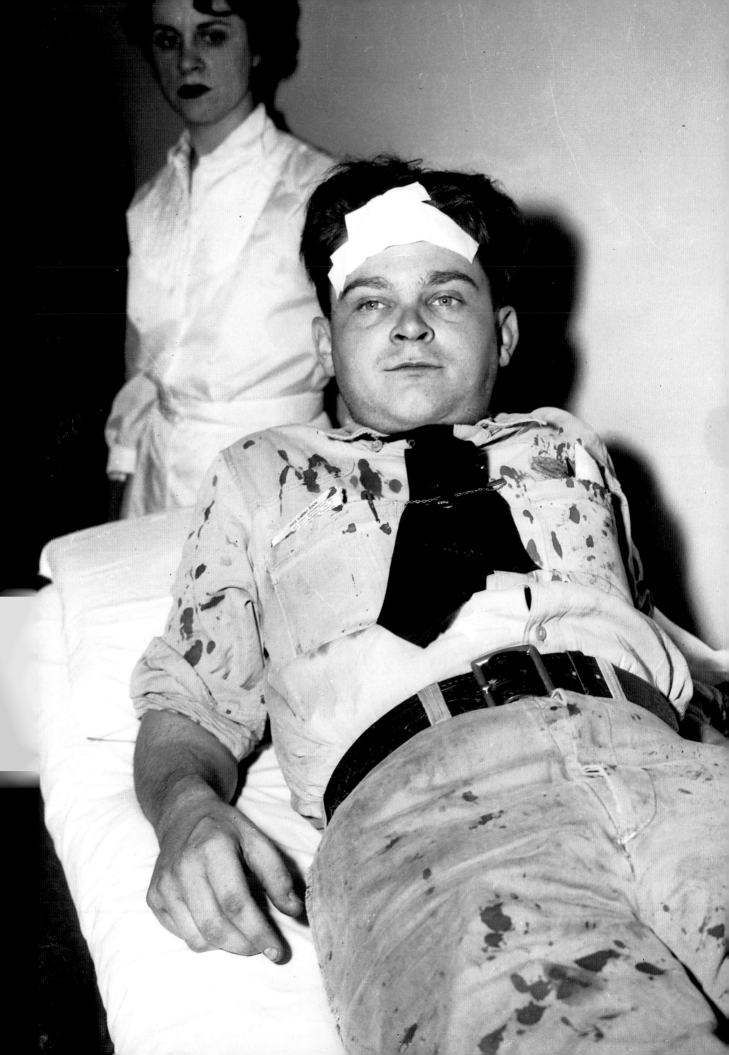

GUARD SHOOTS ROBBER PAIR RAIDING TRUCK

Slugged in Midst of Gun Duel

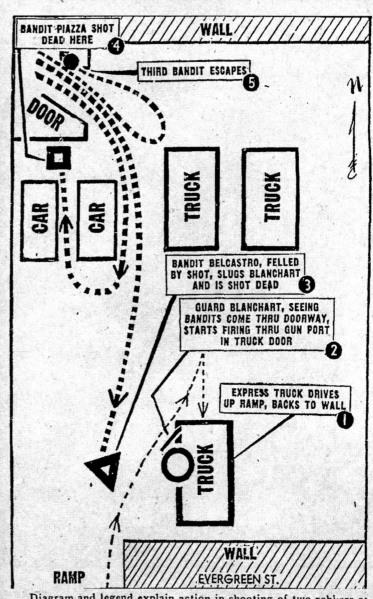

BANDIT PIAZZA SHOT DEAD HERE ④

THIRD BANDIT ESCAPES ⑤

WALL

DOOR

CAR CAR TRUCK TRUCK

BANDIT BELCASTRO, FELLED BY SHOT, SLUGS BLANCHART AND IS SHOT DEAD ③

GUARD BLANCHART, SEEING BANDITS COME THRU DOORWAY, STARTS FIRING THRU GUN PORT IN TRUCK DOOR ②

EXPRESS TRUCK DRIVES UP RAMP, BACKS TO WALL ①

TRUCK

WALL

RAMP EVERGREEN ST.

Diagram and legend explain action in shooting of two robbers attempting to rob Brink's Express men yesterday.

Julius Blanchart Jr., 25, was taken to Henrotin Hospital after the Brink's truck he was driving was attacked by four robbers on July 9, 1951, at the Bowman Dairy Company branch located in the 800 block of Evergreen Street. Blanchart killed two of the robbers, Rocco Belcastro, 36, and Frank Piazza, 42, as he defended the truck. Belcastro struck Blanchart on the forehead with his shotgun and the gun jammed, saving Blanchart's life. The heroic guard, formerly a mailman, had been on the job only three months and had a wife and young daughter.

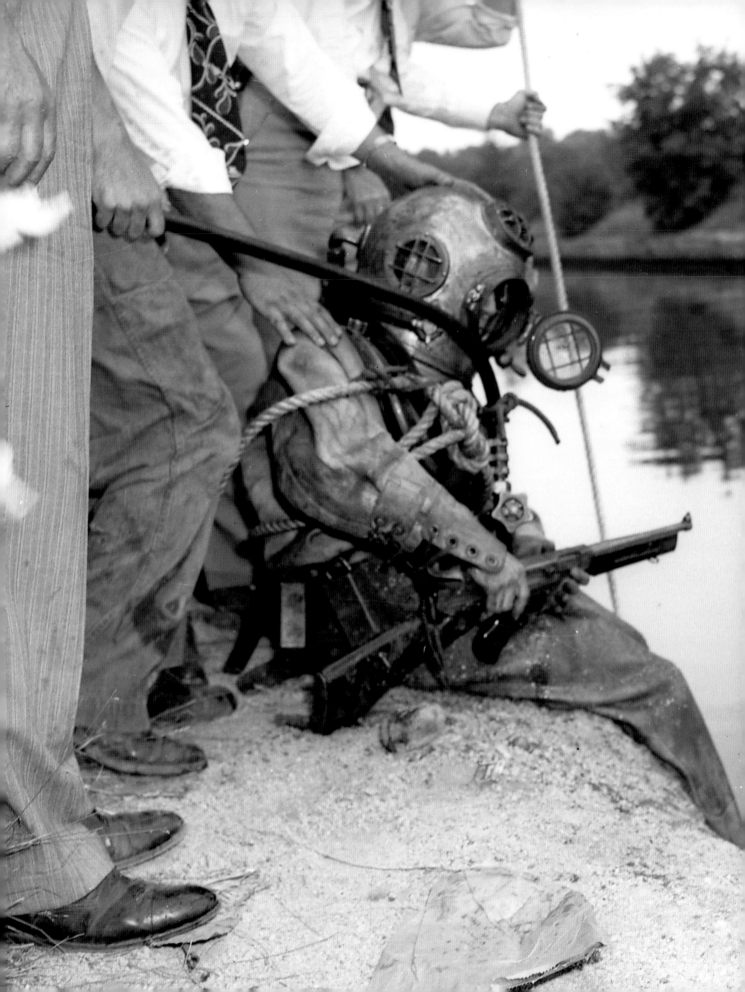

BRINKS HOLDUP MACHINE GUN FOUND IN CANAL

Diver James P. Bodor, 23, finds a shotgun after dragging the bottom of the Calumet-Saganashkee Channel at 107th Street and Archer Avenue on Aug. 5, 1949. Bodor and other officers were looking for evidence in another Brink's Express robbery case, in which four men robbed the South Chicago Savings Bank located in the 2900 block of E. 92nd Street on June 25, 1949. They killed two Brink's Express guards, Joseph Den, 40, and Bruno Koziol, 36. Robber James Hoyland eventually confessed and fingered the three other bandits, Joseph Jakalski, Richard Tamborski and David Edgerly. CONTINUED ➡

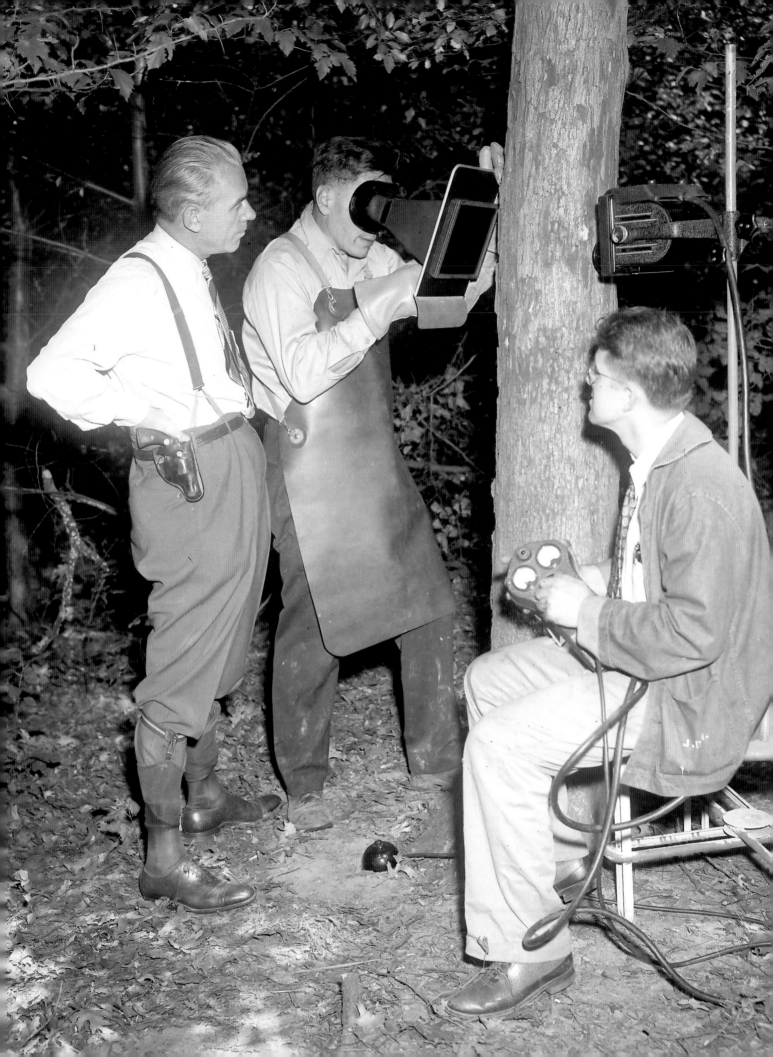

◄ CONTINUED From left, State's Attorney Officer John Sojat; Joseph Nicol, a civilian technician at the police crime lab; and Lt. James Oakey use an early X-ray machine called a fluoroscope to locate bullets in a tree near 139th Street and Ridgeland Avenue on Sept. 3, 1949. The trio was looking for bullets fired from a gun used in the Brink's Express killings; the forest preserve was said to be the target practice area for the four bandits. The Tribune reported that they "failed to reveal traces of bullets in 150 examined trees."

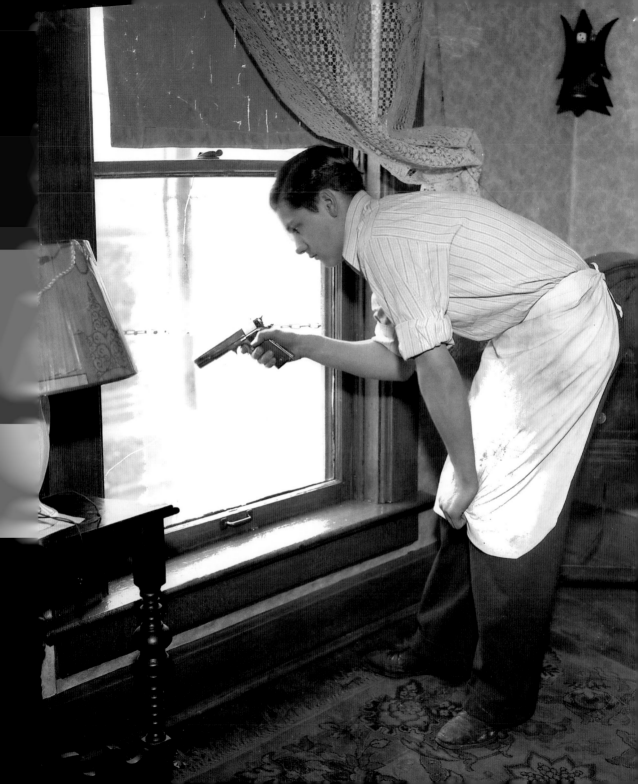

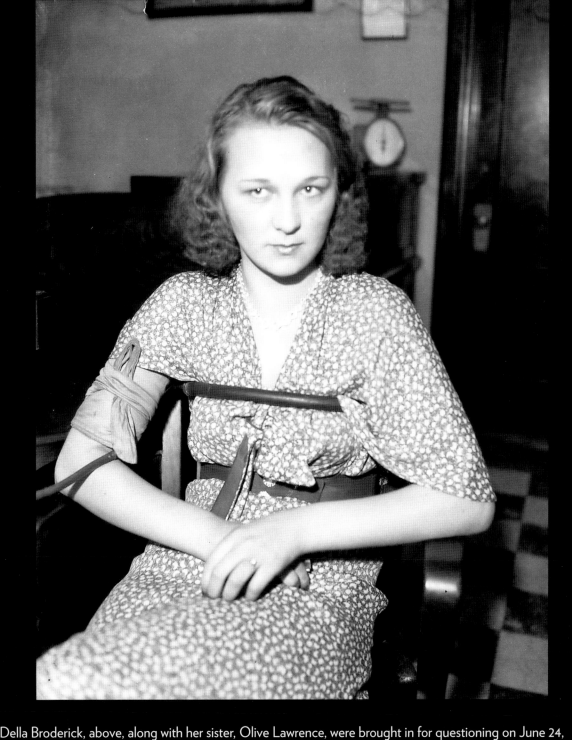

Della Broderick, above, along with her sister, Olive Lawrence, were brought in for questioning on June 24, 1932. The two were suspected of smuggling a pistol to Broderick's brother-in-law and Lawrence's husband, Jack. Jack Lawrence, who had been jailed for robbery and was about to go on trial for killing policeman John Nerad of Cicero, Ill., shot and killed a guard on June 22, 1932. After shooting the guard and failing to find a way out of the jail, he then shot and killed himself as guards surrounded him. Olive Lawrence had visited her husband on the day of the shootings, and Broderick had brought him a fruit basket several days before.

Charles E. Snyder, 25, and
Harold Cole, 24, were arrested
on Jan. 16, 1950, for robbing the
home of Henry Sonnenschein
(in the 2400 block of South
Ridgeway Avenue) on April 9,
1946. The burglars said they
stole $39,000, but Sonnenschein,
who didn't report the crime for
four years, said they stole only
$7,300. Snyder and Cole were
freed shortly after their arrest
because too much time had
passed without a police report
being filed. Sonnenschein,
who was a court clerk and
the 22nd Ward Democratic
committeeman, said that most
of the money belonged to the
Democratic Ward Organization.

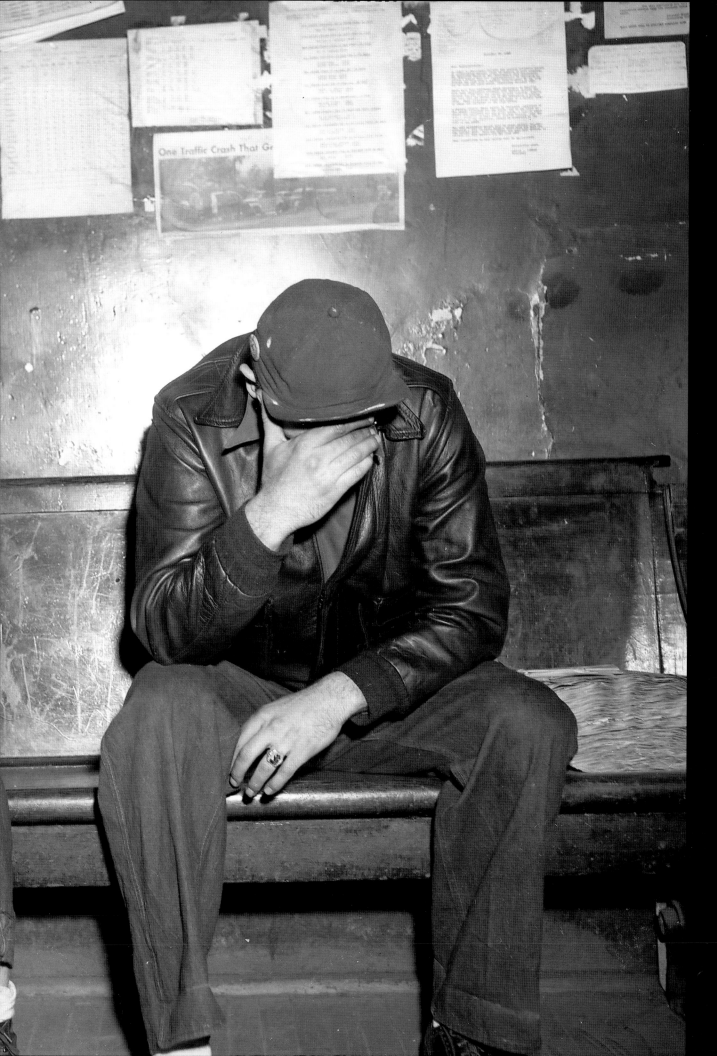

G MEN KILL 2;
FBI CHIEF HERE

Police carry out the bodies of St. Clair McInerney, 31, and James O'Connor, 36, from an apartment in the 1200 block of Leland Avenue on Dec. 28, 1942. McInerney and O'Connor were two of seven convicts who had escaped from the Stateville penitentiary on Oct. 9, 1942, along with gang leader Roger Touhy. The FBI discovered the hideaway and surrounded the apartment, hoping to capture "Touhy the Terrible" but found only McInerney and O'Connor. CONTINUED ➡

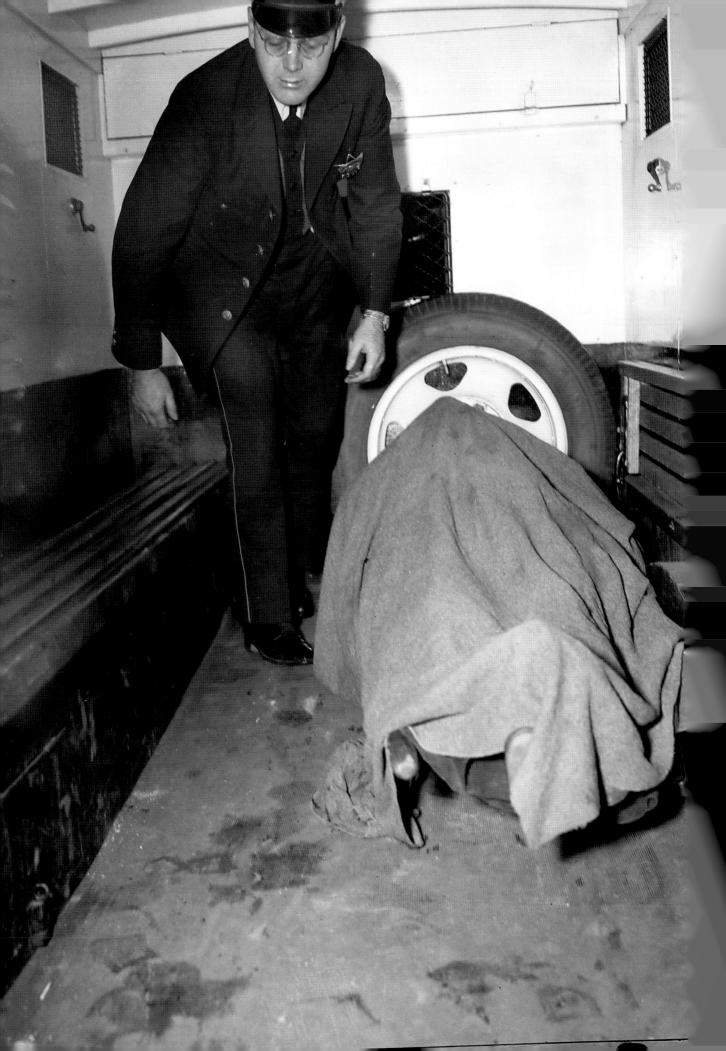

GANGSTERS IN FLAT BUILDING ARE AMBUSHED

Police Hear Touhy's Pals Slain.

◀ CONTINUED Mary Jagusch looks at bullet holes left on the second floor of her apartment building where the FBI killed St. Clair McInerney and James O'Connor.

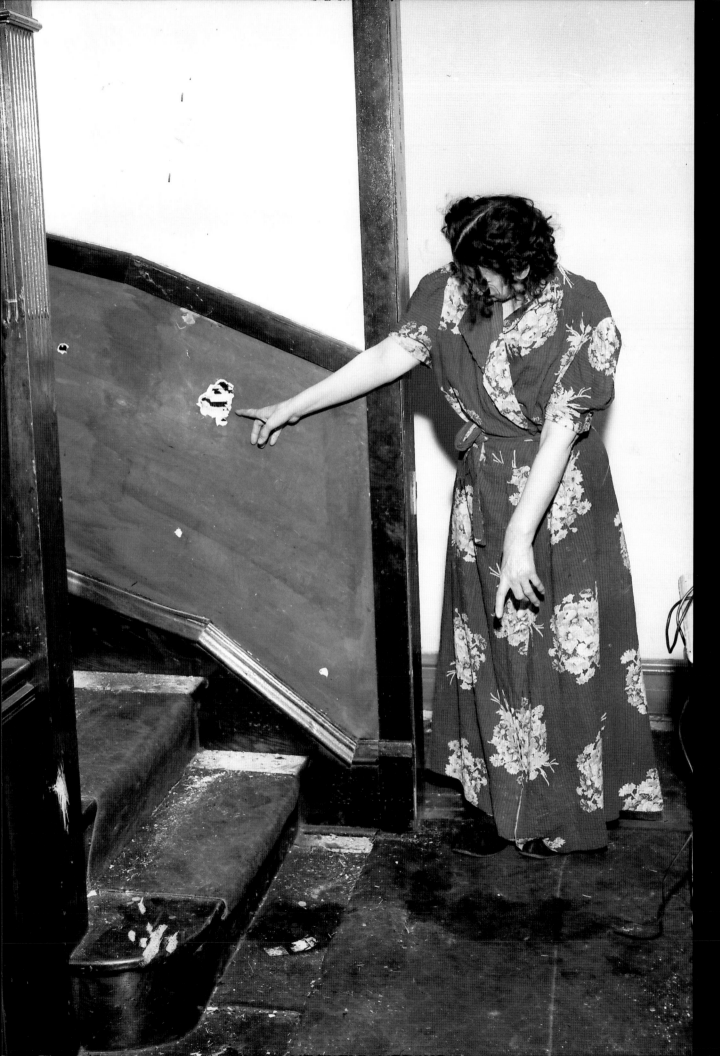

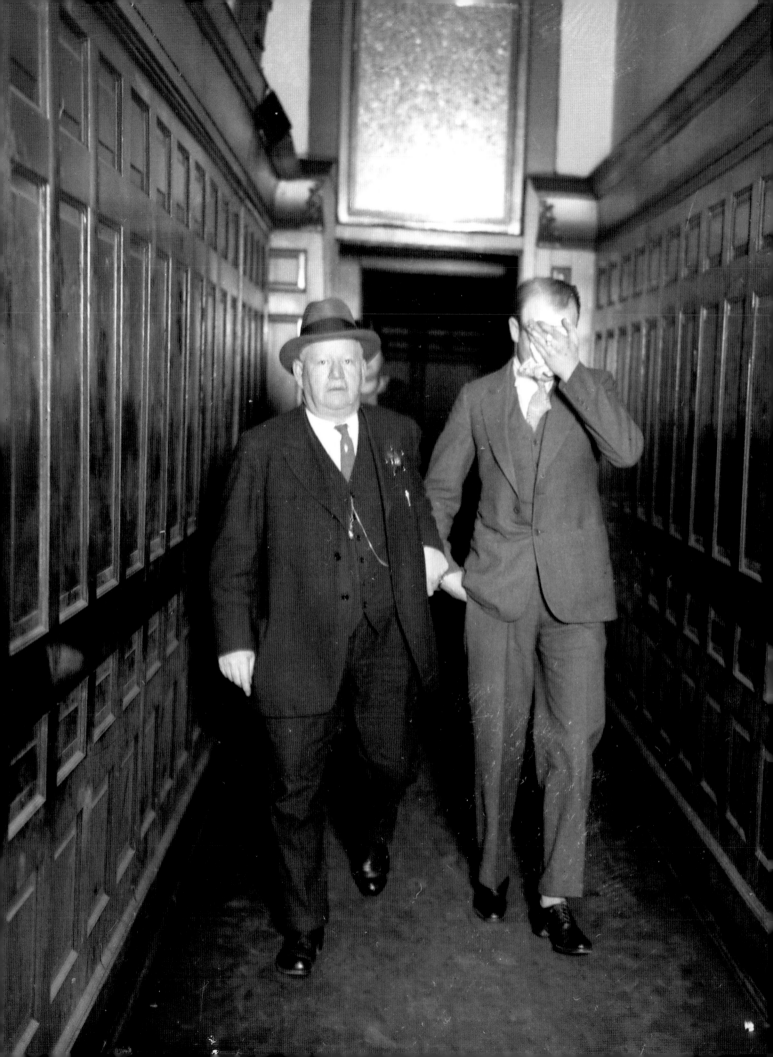

William "Three Fingered Jack" White is led back to his jail cell in 1926 during his trial for the murder of Forest Park policeman Edward Pflaume in River Forest on Dec. 13, 1925. White was tried twice for the murder, and twice the charges were overturned. By 1929, White was a free man, and he became a union boss for the coal teamsters and a gunman for Al Capone. By 1930 he was listed on the first Public Enemies list. According to the Tribune, White was missing two fingers on his right hand and was known to wear a white glove with cork tips in the two empty fingers.

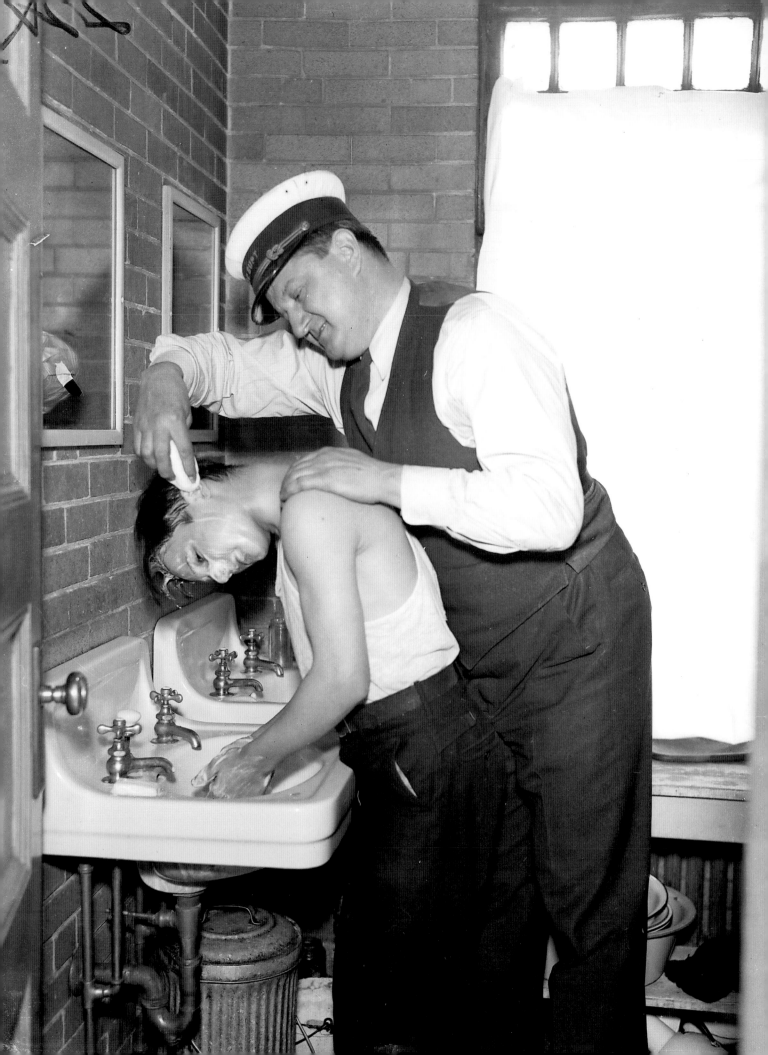

YOUNG ROGALSKI IN COURT; TRIAL SET FOR FRIDAY

Jail Is Better than Home, Says Boy Kidnaper.

Assistant Sgt. George Gibson washes the ears of George Rogalski, 14, who was convicted of kidnapping Dorette Zietlow, 2, on April 8, 1934, and leaving her to die in an abandoned icehouse two days later. Rogalski is seen here in the county jail, circa April 1934. According to the Tribune, Rogalski, whom the police called a "moron," confessed to the kidnapping. Rogalski lured the child from outside her grandmother's house, explaining, "I told her I would give her a nickel to buy candy with if she would come with me. Then I led her away by the hand." Rogalski stripped the child naked and left her without food or water in an abandoned icehouse in the 1700 block of Milwaukee Avenue. He said he "just wanted to look at her." The little

FIND ROGALSKI BOY GUILTY

◀ CONTINUED From left, Officer Edward Colleeny, George Rogalski and Officer Joseph Lally stand in the vacant building where Dorette Zietlow, 2, was found, circa April 1934.

TEN YEAR TERM IN PRISON FOR BABY KIDNAPER

Youth Smiles; Says: 'I Expected It.'

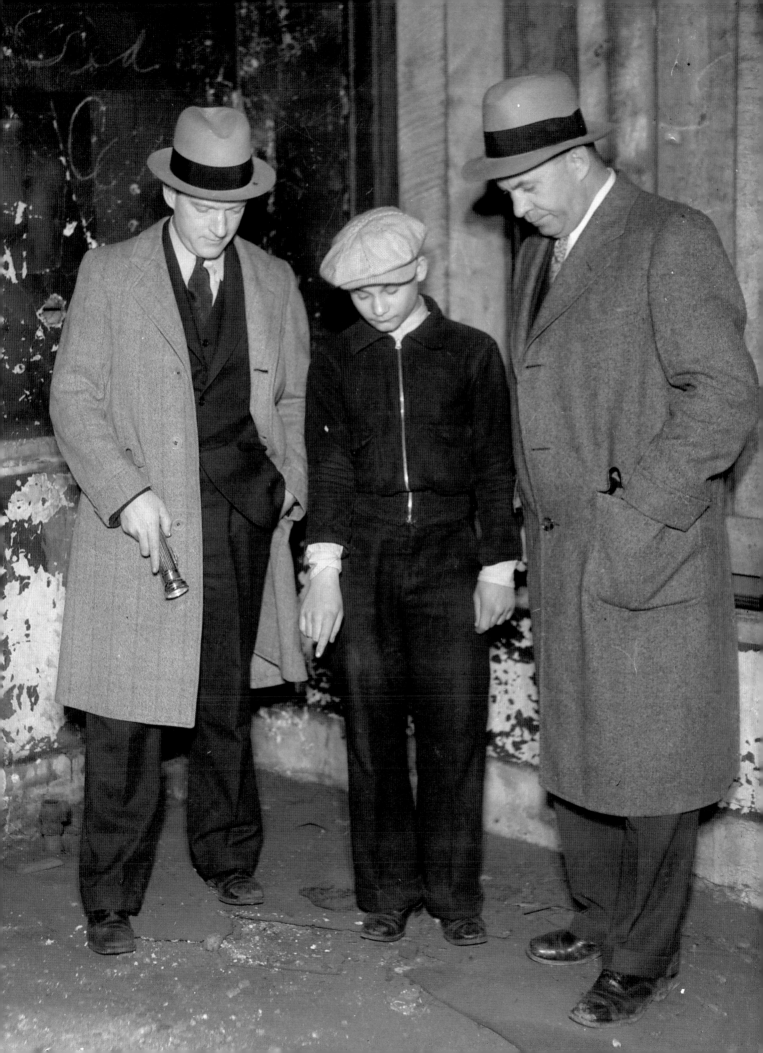

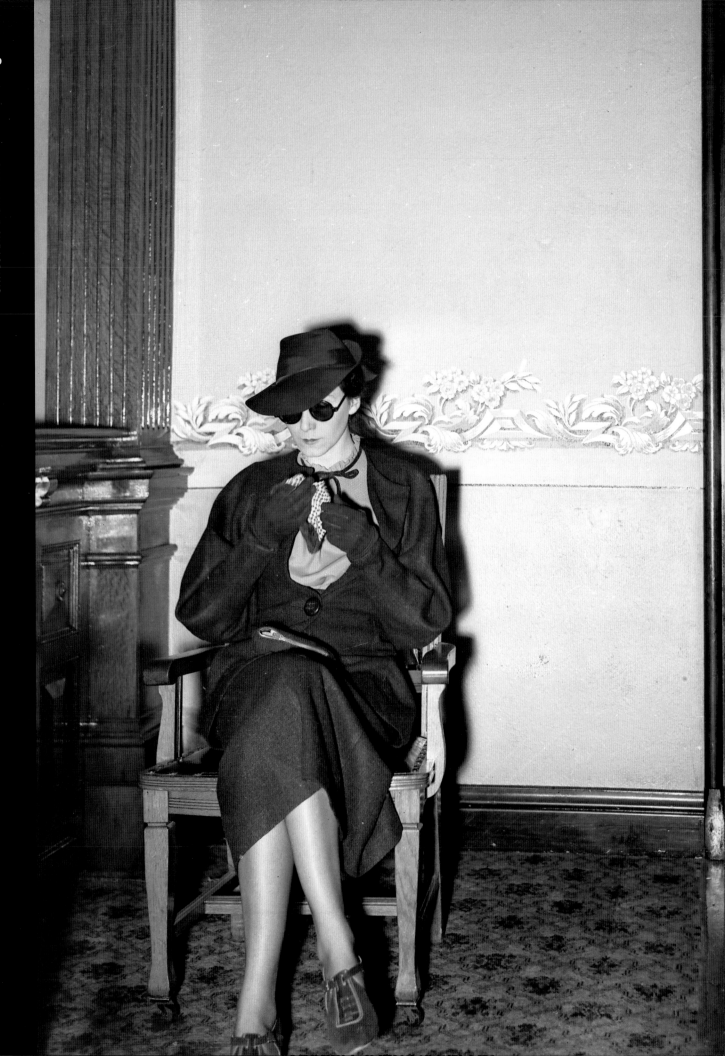

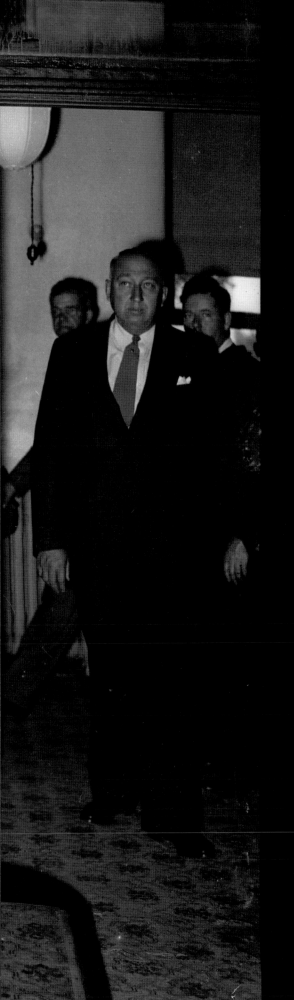

WIDOW IN COURT TELLS COURTSHIP BY WIFE SLAYER

Identifies Tallmadge Gift Ring and Love Letter.

Mrs. Frances Birch, a 32-year-old widow from Rock Island, Ill., on the witness stand during the murder trial of Guy M. Tallmadge in Oregon, Ill., on Oct. 19, 1936. Tallmadge, whom the Tribune described as "bald-headed and paunchy," was an assistant undertaker in Rockford, Ill., who shot and killed his wife Bessie, 51, along a gravel road 6 miles east of Oregon on May 19, 1936—Bessie's birthday. Tallmadge had been dating Birch on the side, given the young widow an engagement ring and told her he had asked his wife for a divorce. "I don't know why he would do anything like that," Birch said in reference to the murder, according to newspaper reports. Later she was ordered to remove her dark sunglasses, which she had worn since the beginning of the trial.

TWO CAPTURED DRAKE BANDITS CONFESS CRIME

Give Details of Plan and Execution of Stickup.

From left, Drake Hotel bandits Joseph Holmes and Jack Wilson, circa August 1925. Both Holmes and Wilson confessed to their involvement in the July 29, 1925, daylight holdup of the Gold Coast neighborhood's Drake Hotel. Out of the five bandits who held up the hotel, two died at the hands of police, two were caught and hanged and one was never caught.

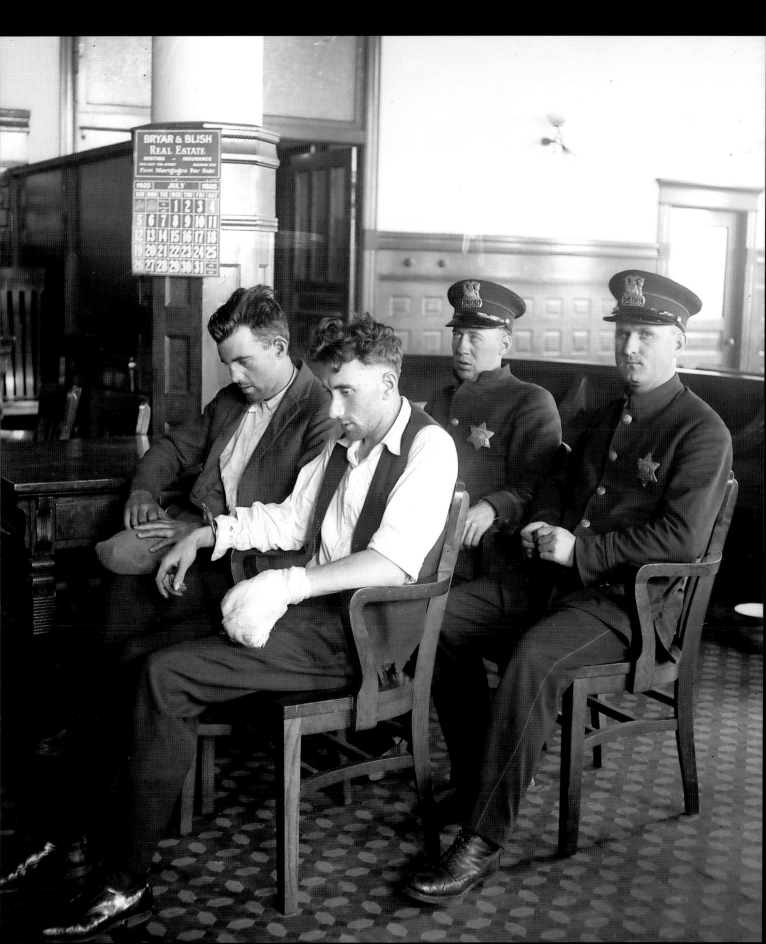

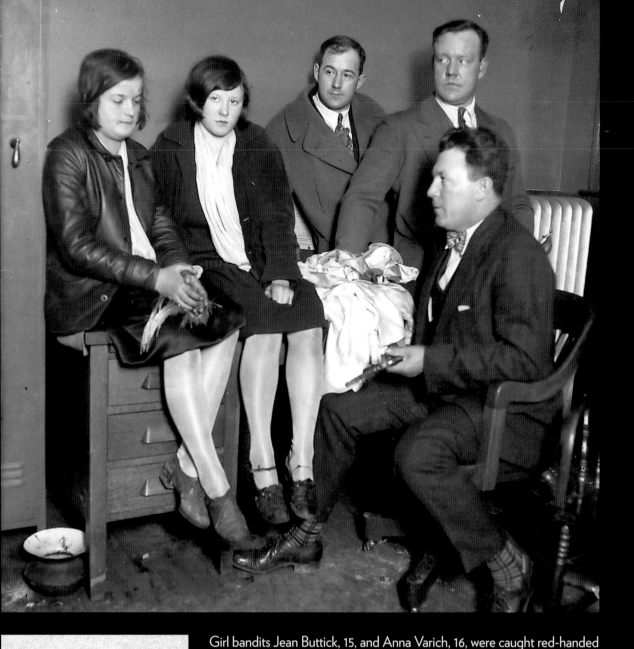

Police Catch Girl Burglars Looting Home

Girl bandits Jean Buttick, 15, and Anna Varich, 16, were caught red-handed while looting the bungalow of Louis Oehler in the 6100 block of South California Avenue on March 20, 1927. The Tribune reported that when the police seized Varich in the kitchen, "she spilled rings, bracelets, beaded bags, and what not from every part of her clothes. When they shook her she literally dripped booty." Police officers believe the two bandits had looted about a dozen other homes in the prior two weeks. With Buttick and Varich are Charles Goss, Bert Harlem and Sgt. William H. Doyle (seated).

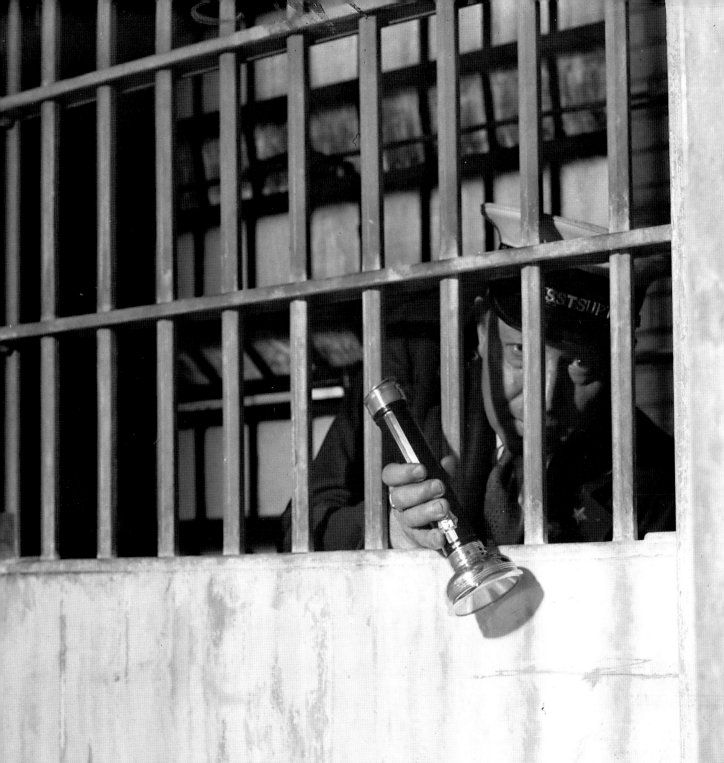

Assistant Supt. John Dohmann shows where 30 prisoners were plotting to build an escape route out of Cook County Jail on March 7, 1935. The warden recovered a key fashioned out of a metal spoon and five saw blades; the convicts had already started sawing through the lower part of the shower room door.

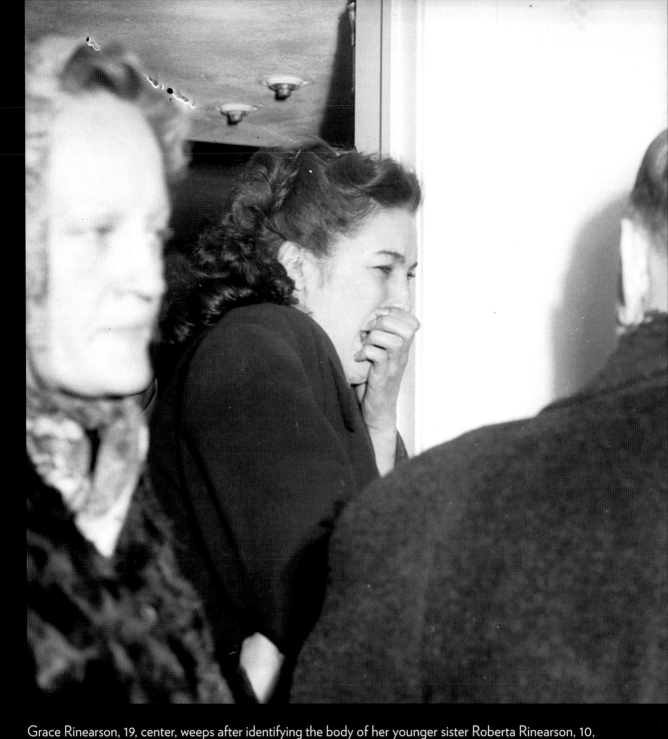

Grace Rinearson, 19, center, weeps after identifying the body of her younger sister Roberta Rinearson, 10, who was murdered on Dec. 17, 1948. She was found beaten and strangled in a ditch on County Line Road, northeast of Elmhurst, Ill. The young girl had been headed to a movie by herself at the Park Theater in La Grange, Ill. but never made it there.

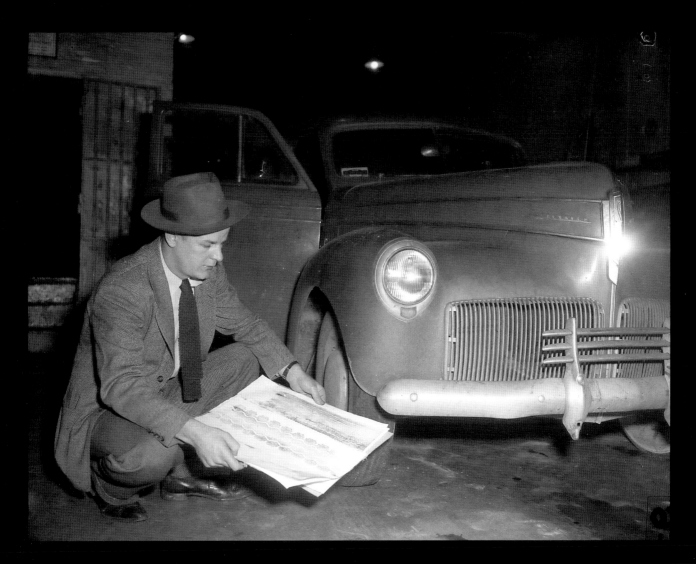

Joseph Haas of the Chicago crime lab checks the tire marks found near Roberta Rinearson's body against tires from a car belonging to Harold Poull. Poull's car was found in La Grange on Feb. 12, 1949. The police spent years following up on many leads trying to find Rinearson's killer. CONTINUED ➡

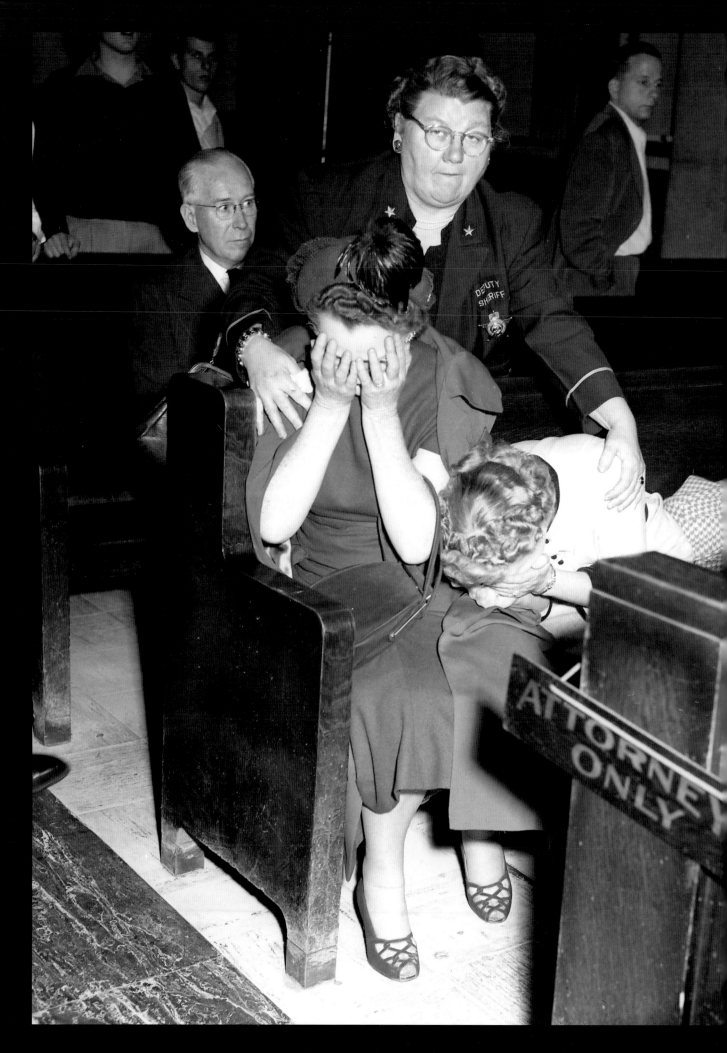

◄ CONTINUED Deputy Sheriff Jessie Tamillo, back center, comforts Susan Lettrich, second from right, and her friend after Lettrich's estranged husband George Lettrich Jr. was convicted of murdering Roberta Rinearson and sentenced to the electric chair on Oct. 18 1951. Two years later, in 1953, the Supreme Court voided the death sentence, saying Lettrich's confession was "taken by police after he was held incommunicado for 60 hours," the Tribune reported. Furthermore, the court stated there was "not a scintilla of evidence" to connect Lettrich with the crime.

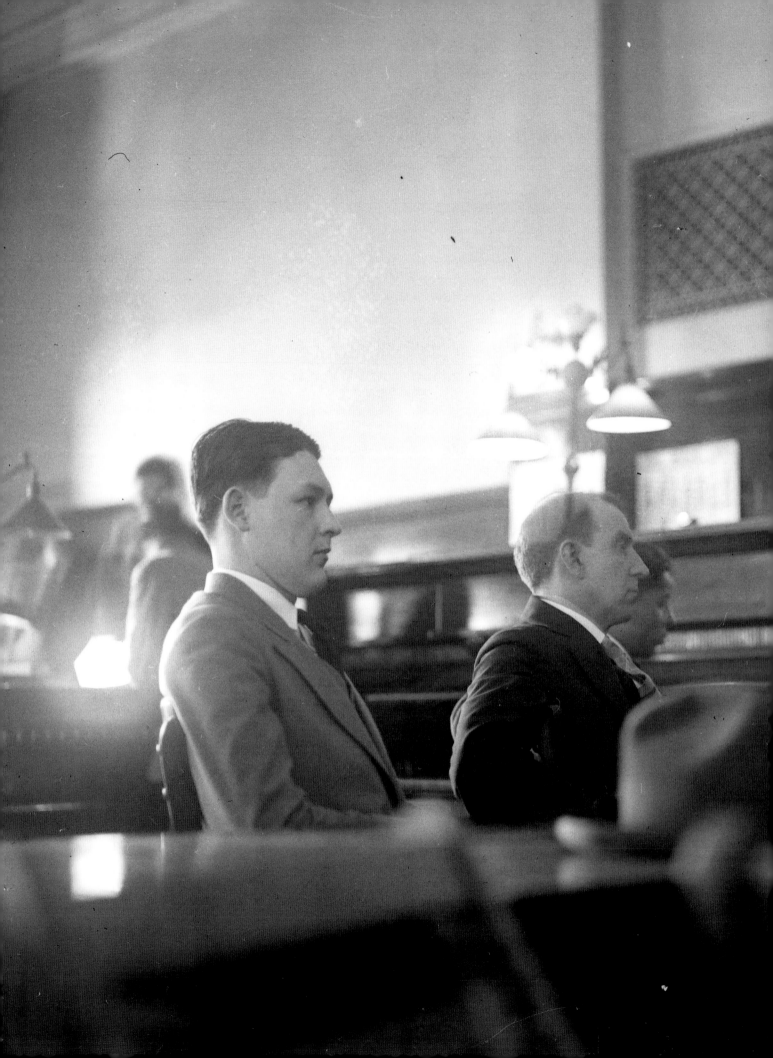

Martin Durkin sits in court with his lawyer, Eugene McGarry, circa June 1926. The first person ever to kill a federal agent, Durkin was on trial for the murder of FBI Agent Edwin C. Shanahan. On Oct. 11, 1925, Shanahan had attempted to arrest Durkin in Porter's Garage in the 6200 block of Princeton Avenue. The charge was violation of the Dyer Act (transportation of a stolen automobile), a charge Durkin denied. Durkin led the FBI on a three-month chase through five states before his capture in 1926. After serving 19 years in an Illinois prison for the murder of Shanahan, Durkin was transferred to Leavenworth Prison in Kansas to serve 15 years for violation of the Dyer Act, a federal crime. CONTINUED

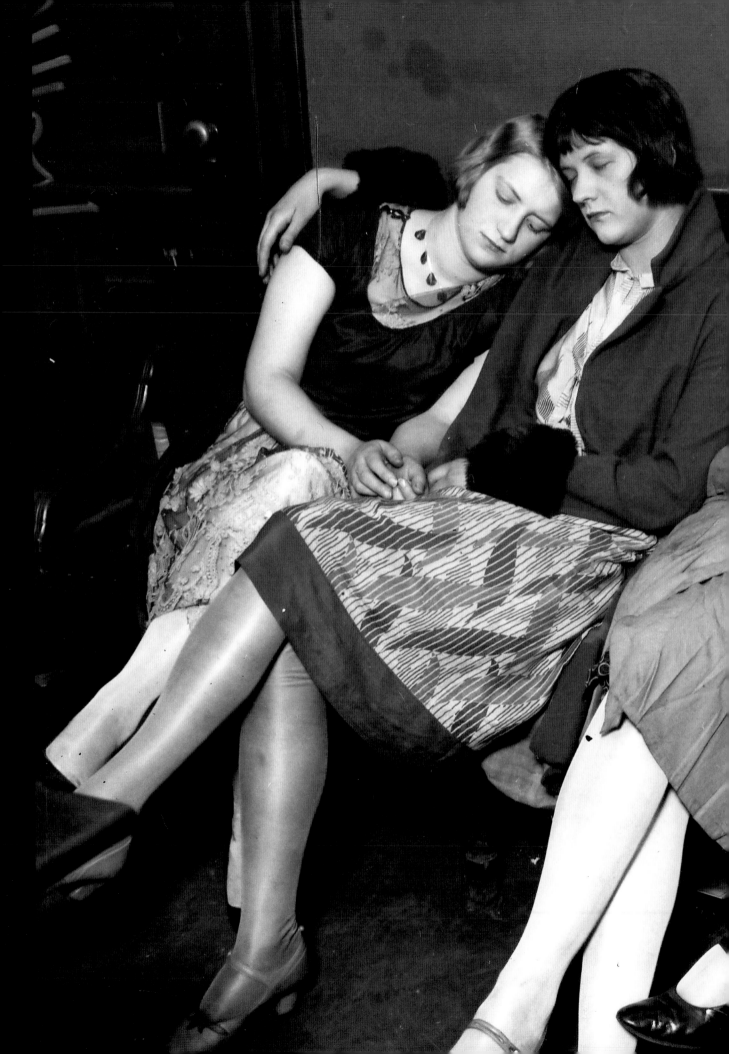

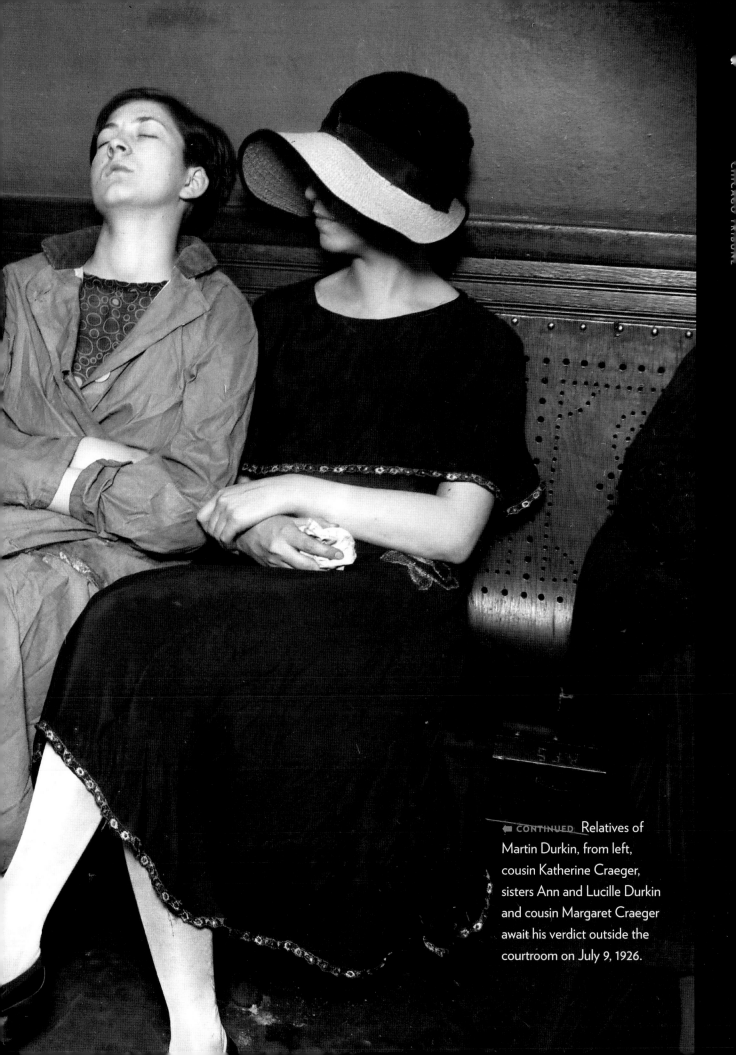

◀ CONTINUED Relatives of Martin Durkin, from left, cousin Katherine Craeger, sisters Ann and Lucille Durkin and cousin Margaret Craeger await his verdict outside the courtroom on July 9, 1926.

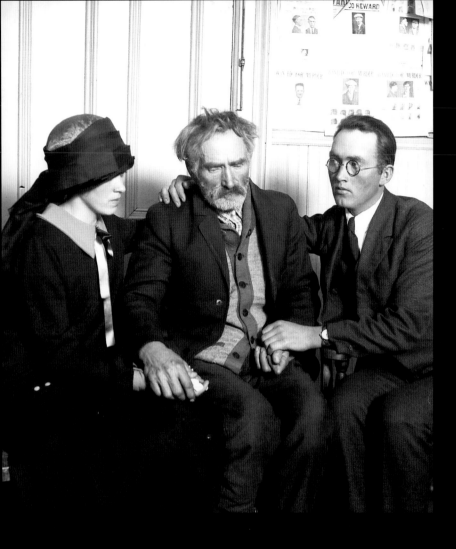

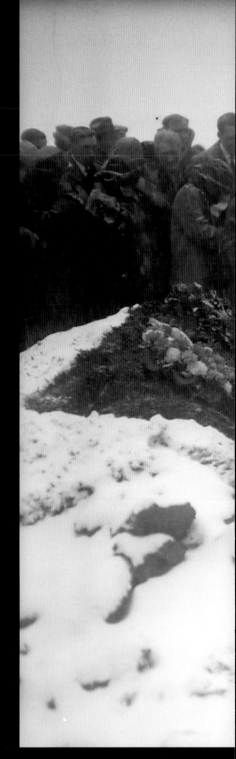

Christ Olson, center, is comforted by his children Alice, left, and Bernard, in December 1926, days after finding the body of his other daughter, Clara Olson, 22. Missing since Sept. 10, Clara's badly beaten body was finally found on Dec. 2 in a shallow grave on a hill called Battle Ridge near Rising Sun, Wis. The Tribune described her body as having "terrific, crushing blows" to the back of her head. Clara was six months pregnant. The father was college student Erdman Olson, 18, who was of no relation and lived just 6 miles from her home near Mt. Sterling, Wis. The night she went missing, Clara had received a letter from Erdman for a midnight tryst. She was hoping for marriage, and both families knew of her "predicament." Erdman denied he had anything to do with her disappearance

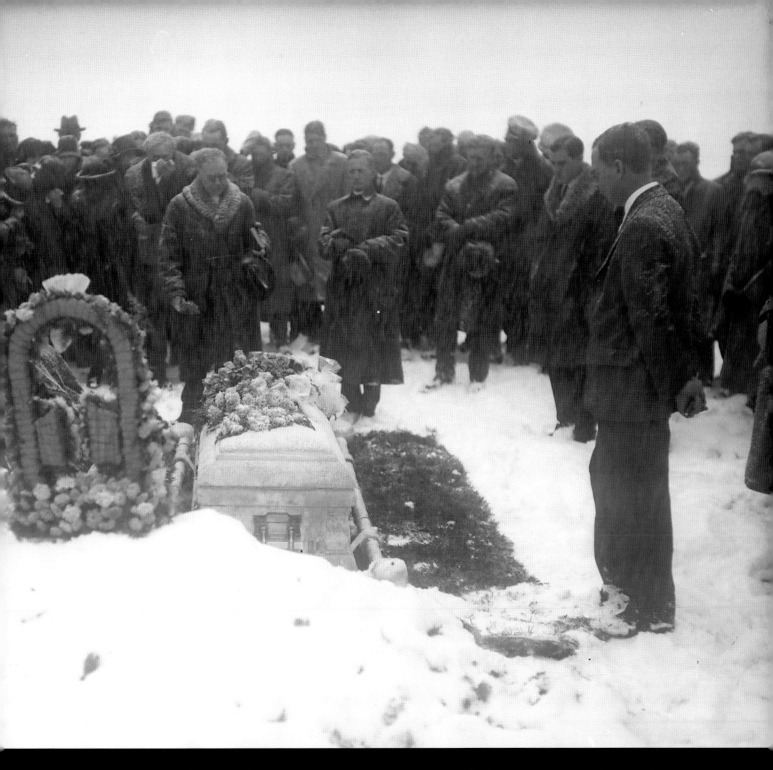

According to the Tribune, Clara Olson was laid to rest on Dec. 7 in a "little graveyard surrounding the Utica Lutheran Church, while her parents and brothers and sisters stood by the grave, weeping."

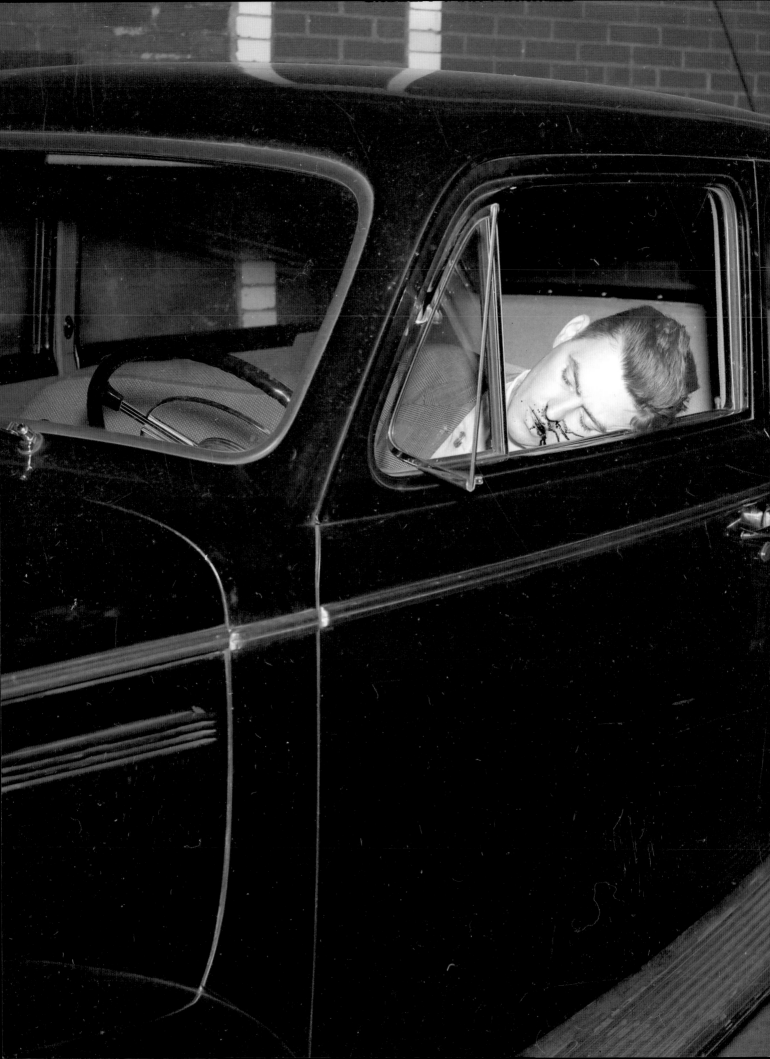

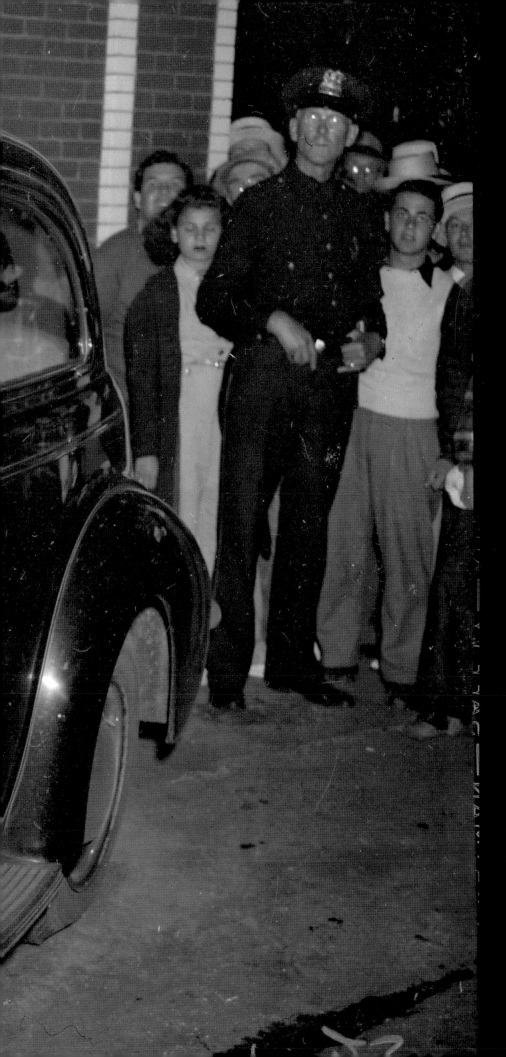

Carroll "Kickey" Corcoran, 35, was found shot and killed in his car on Aug. 19, 1940, near 75th Street and Exchange Avenue during the South Side handbook war. Corcoran was a partner in a bookie operation at 79th Street and Ashland Avenue as well as the owner of several other South Side gaming places. Tally sheets inside Corcoran's car indicated he had just visited a handbook. Corcoran had been a brick mason until three years prior, when he took over his brother-in-law's interests in the gaming world following the latter's death. Corcoran had a wife and two daughters.

ELECTRIC CHAIR
IS INSTALLED IN
COUNTY JAIL HERE

Used to Punish Crimes
Committed Since July 1.

On July 6, 1927, the electric chair officially replaced the hangman's rope in Illinois. This chair, installed at Cook County Jail on Aug. 9, 1927, was one of only three electric chairs in the state of Illinois at the time. It was built by convicts in the penitentiary in Michigan City, Ind.

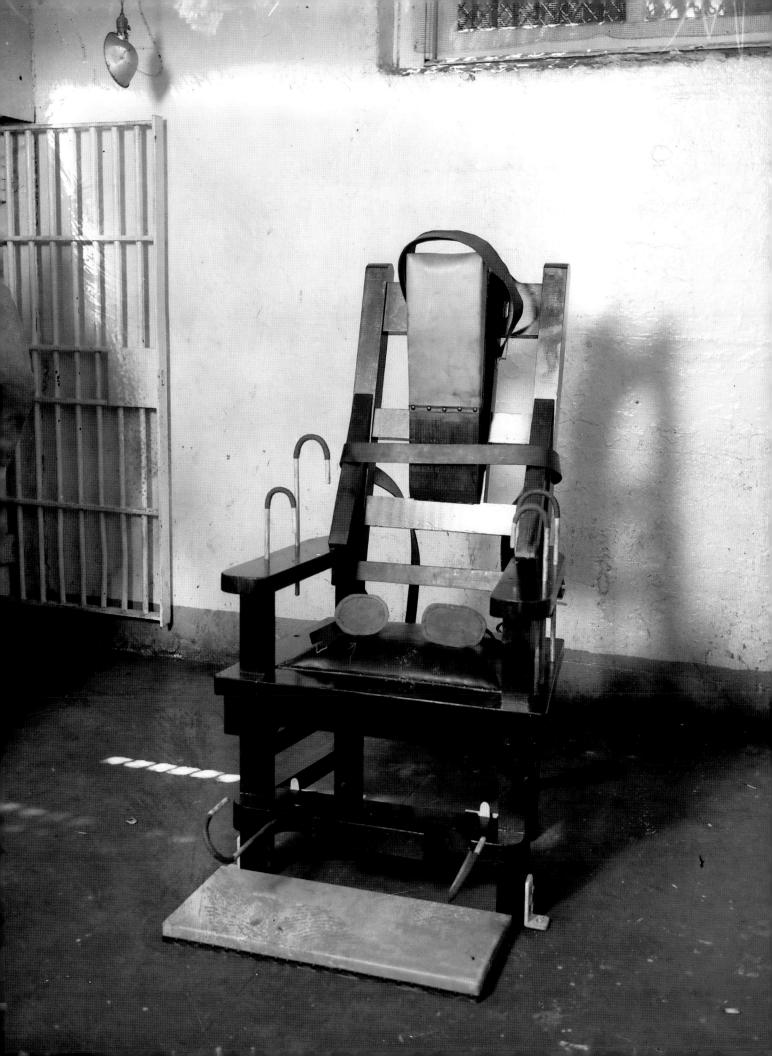

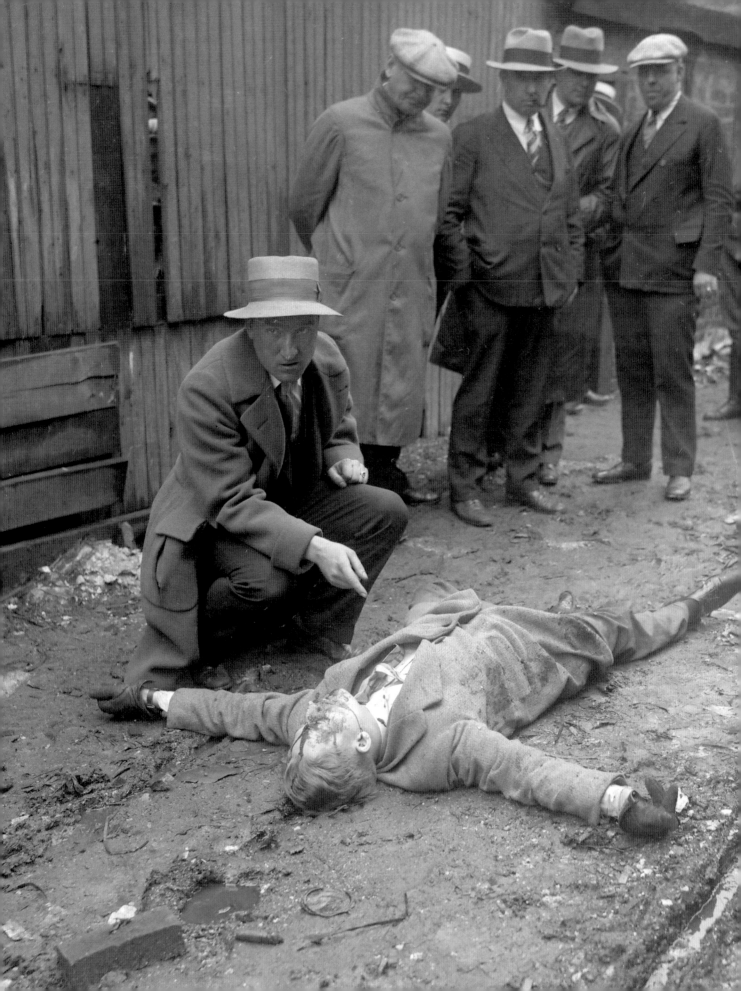

Sgt. Joseph Connolly looks over the body of holdup bandit Ralph Weinberg, whom Connolly and his men riddled with bullets on June 25, 1928. Weinberg, 25, and two other men attempted to rob the Golden Rod Ice Cream Company in the 2100 block of Ward Street. The police were tipped off to the crime and waited for the bandits, finding them in the alley in the 1400 block of Custer Street. Of the three bandits, Weinberg was killed, one was taken into custody and the third escaped.

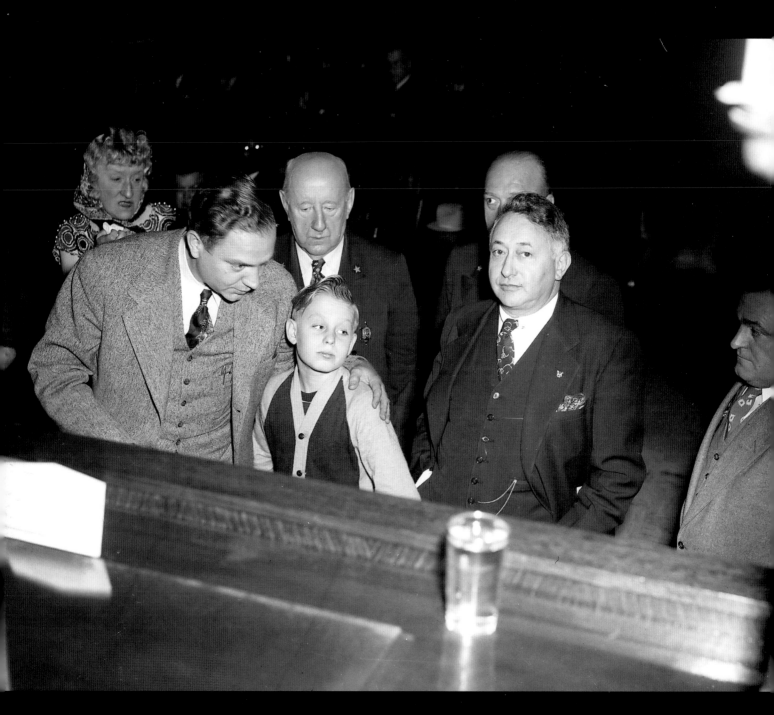

Howard Lang, 13, is flanked by his lawyers Julius Cordell, left, and Samuel Andalman on Feb. 21, 1948. Lang was accused of murdering his schoolmate, 7-year-old Lonnie Fellick, and leaving his body in the Thatcher Woods Forest Preserve on Oct. 18, 1947. Lang admitted to killing Fellick in order to prevent Fellick from telling Lang's mother that the boy had stolen $10 from her. "I gave Lonnie a cigaret [sic], and told him this would be the last one he'd ever smoke," Lang related unconcernedly. "Then, a few minutes later, I stabbed him and dropped a stone on his head." Lang's mother is in the background with a scarf around her head.

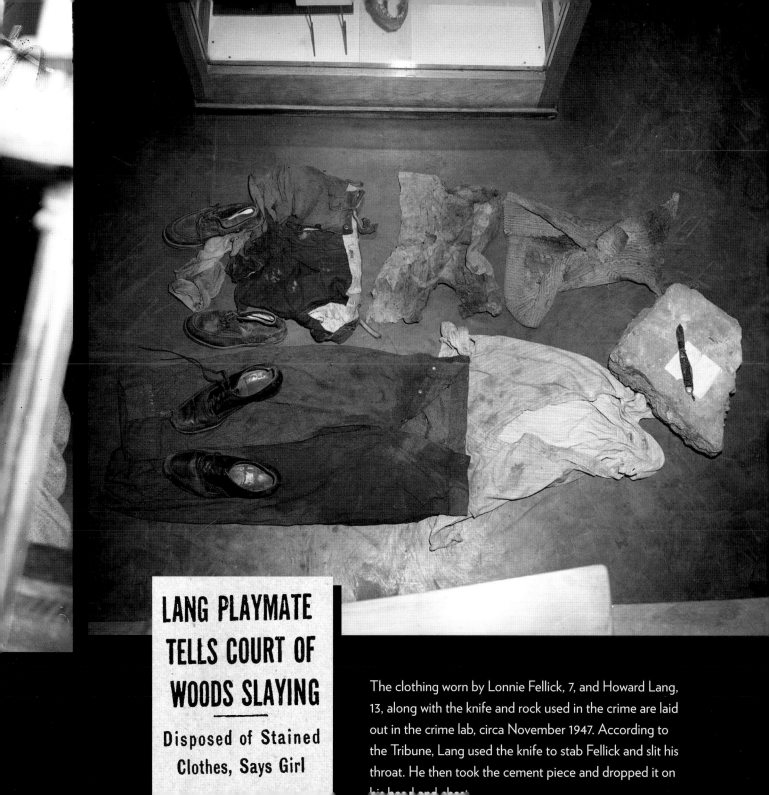

LANG PLAYMATE TELLS COURT OF WOODS SLAYING

Disposed of Stained Clothes, Says Girl

The clothing worn by Lonnie Fellick, 7, and Howard Lang, 13, along with the knife and rock used in the crime are laid out in the crime lab, circa November 1947. According to the Tribune, Lang used the knife to stab Fellick and slit his throat. He then took the cement piece and dropped it on

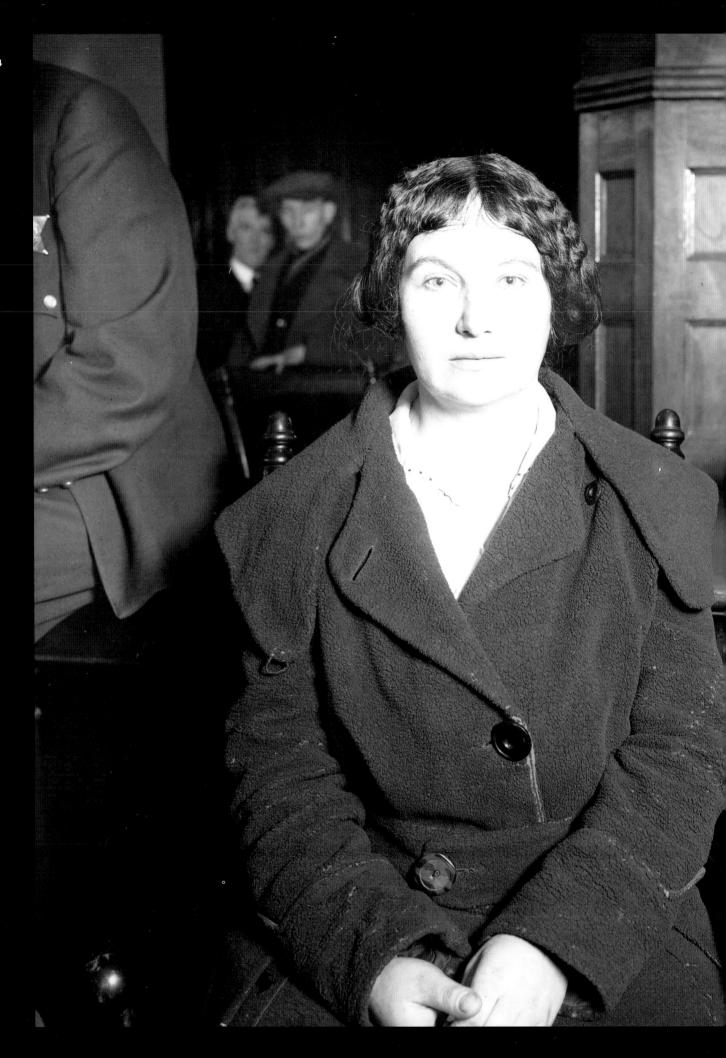

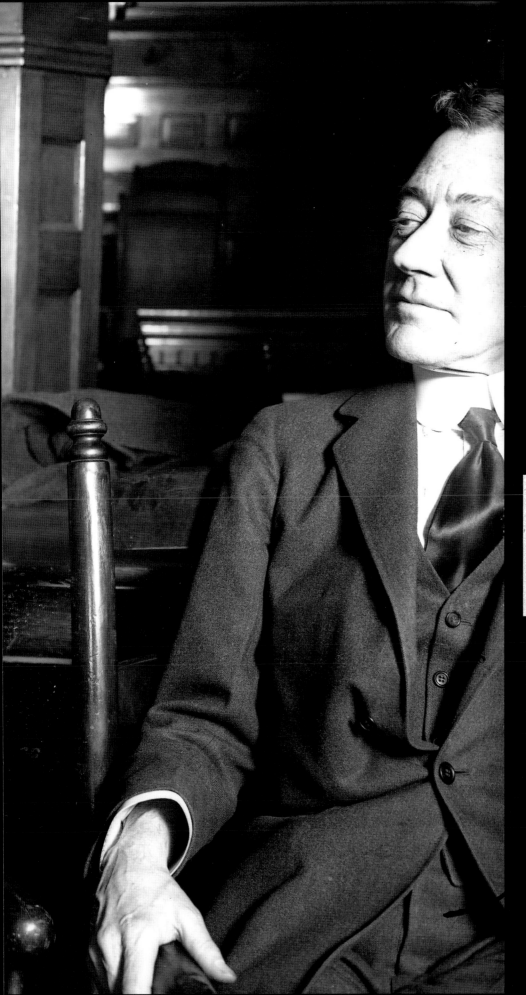

WOMAN GOES ON TRIAL FOR DEATH BY POISON RUM

Mary Wazeniak, circa 1924. The 34-year-old mother of three, born in Poland, was the first woman in Illinois to be convicted of selling fatal moonshine. Wazeniak's husband had fallen permanently ill, so she turned her La Grange Park, Ill. home into a saloon. In November 1923, four men came to the saloon and ordered a shot. Wazeniak served them, and one of them, George L. Rheutan, later died. The press dubbed her "Moonshine Mary."

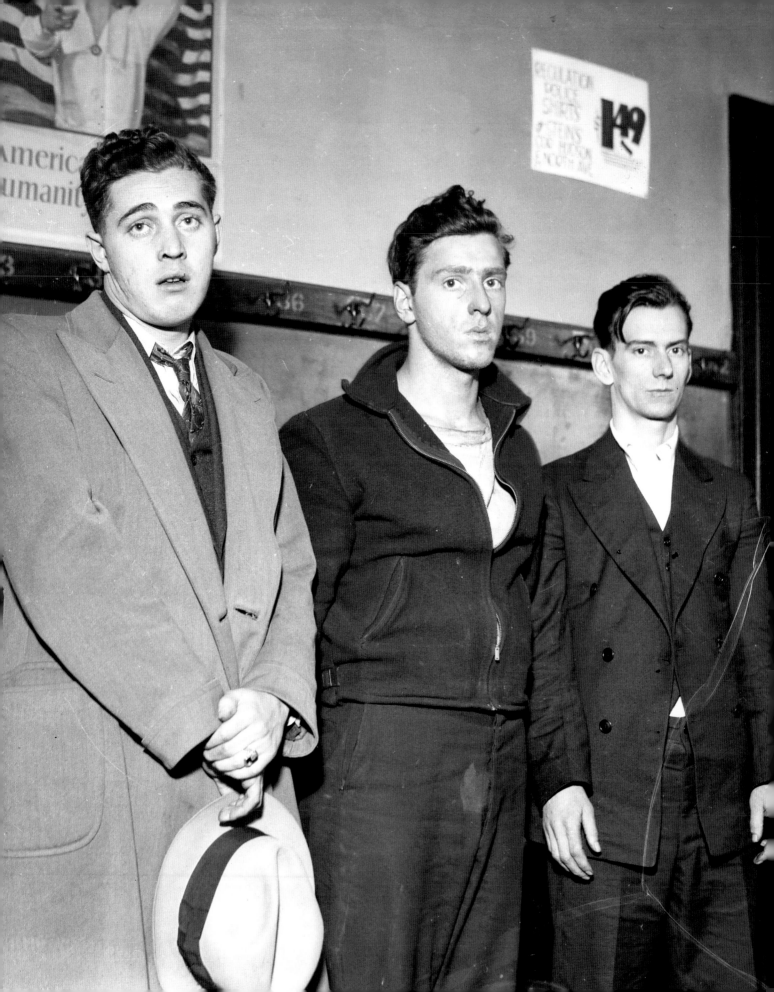

BANDITS CAUGHT IN THE ACT

From left, burglars St. Clair McInerney, 25; Edward Bell, 20; and Thomas Lanning, 29, were caught by police as they tried to open a safe at the Swedish Club of Chicago in the 1200 block of N. LaSalle Street on Jan. 8, 1937. McInerney was an ex-convict on parole from Stateville Prison in Joliet, Ill., and a known associate of gang leader Roger Touhy.

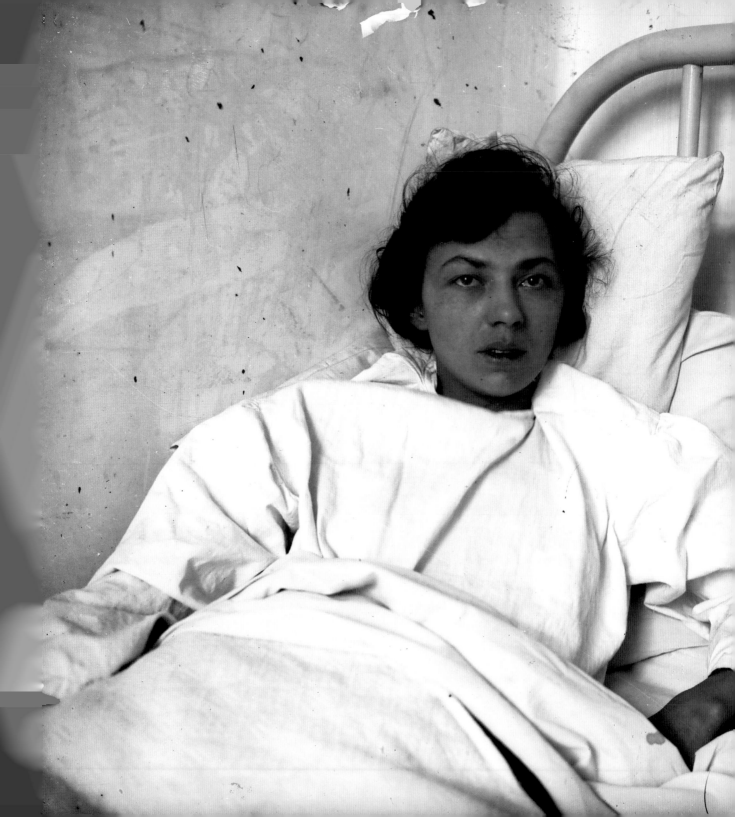

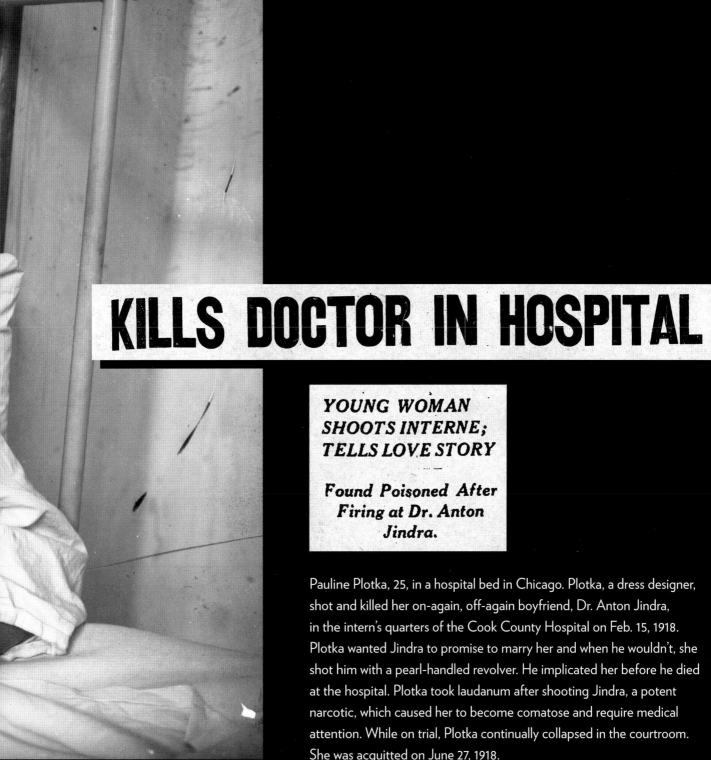

KILLS DOCTOR IN HOSPITAL

YOUNG WOMAN SHOOTS INTERNE; TELLS LOVE STORY

—

Found Poisoned After Firing at Dr. Anton Jindra.

Pauline Plotka, 25, in a hospital bed in Chicago. Plotka, a dress designer, shot and killed her on-again, off-again boyfriend, Dr. Anton Jindra, in the intern's quarters of the Cook County Hospital on Feb. 15, 1918. Plotka wanted Jindra to promise to marry her and when he wouldn't, she shot him with a pearl-handled revolver. He implicated her before he died at the hospital. Plotka took laudanum after shooting Jindra, a potent narcotic, which caused her to become comatose and require medical attention. While on trial, Plotka continually collapsed in the courtroom. She was acquitted on June 27, 1918.

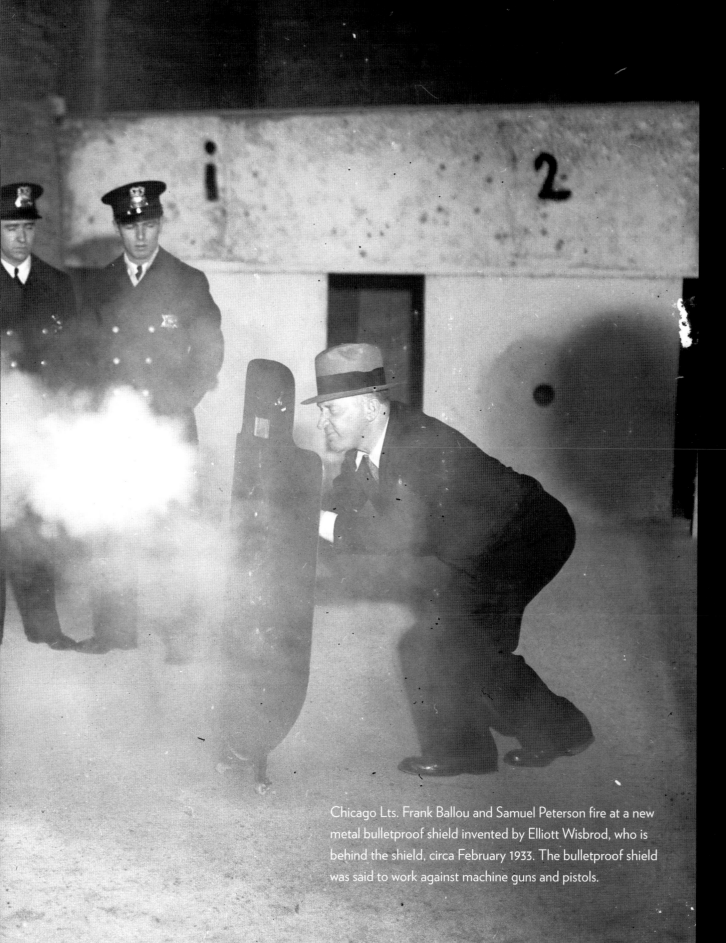

Chicago Lts. Frank Ballou and Samuel Peterson fire at a new metal bulletproof shield invented by Elliott Wisbrod, who is behind the shield, circa February 1933. The bulletproof shield was said to work against machine guns and pistols.

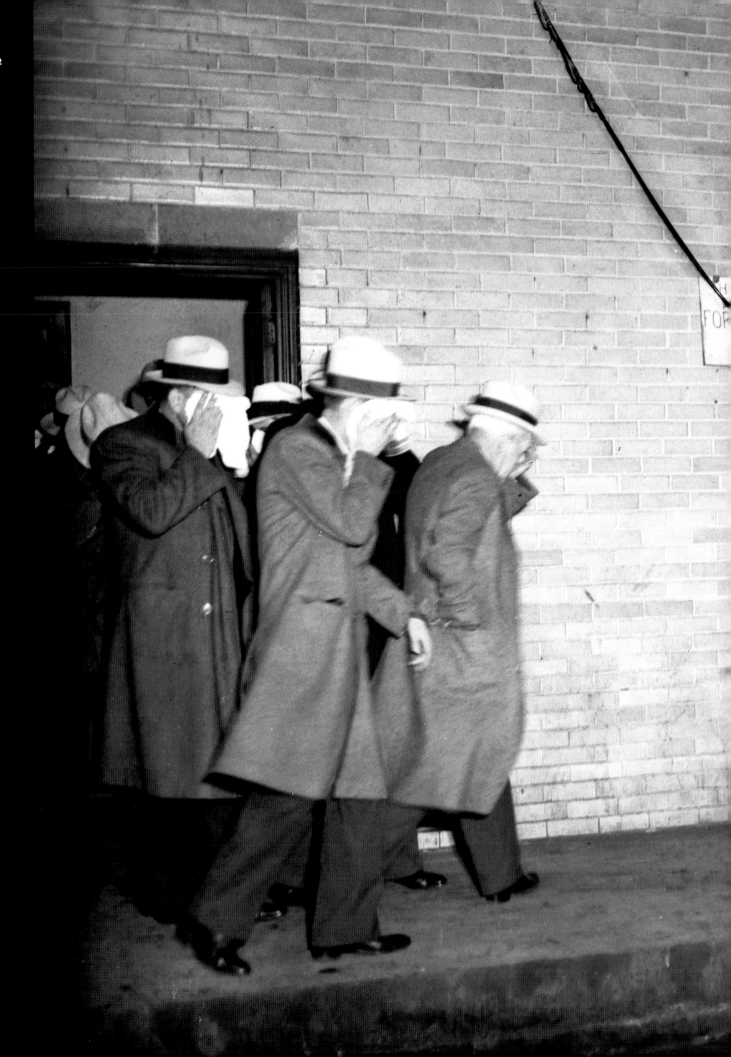

GANG IN CELLS; MILLION A YEAR RACKET BARED

Two Hoodlums Call for Silk Pajamas.

Police shuttle suspected hoodlums from the detective bureau to a patrol wagon and eventually on to the Criminal Court Building, circa November 1932. The detective bureau raided several establishments on Nov. 2 and 3, 1932, rounding up the lawbreakers. They managed to roust 12 of Chicago's most impressive gangsters, including the big boss, "Three Fingered Jack" White, and several men who were said to work for Al Capone.

ROBBERS KILLED IN GUN BATTLE IN ROGERS PARK

Hunt for Dillinger Takes 3 Others.

Capt. John Stege was in charge of a 40-man special detail to round up John Dillinger and his gang. On Dec. 21, 1933, Stege acted on a tip that Dillinger and gang were hiding out in an apartment in the 1400 block of Farwell Avenue. The police raided the apartment but ended up killing three men unconnected with Dillinger. According to the Tribune, for three hours after the raid, the police thought they had killed Dillinger and his associates Jack Hamilton and Harry Pierpont. Instead, they had killed Louis Katzewitz, 28, a fugitive on a bank robbery charge; Charles Tattlebaum, 30, a fugitive and jailbreaker; and Sam Ginsburg, 33, an ex-con who owned a cigar store. The shooting brought hundreds of Rogers Park residents to the scene.

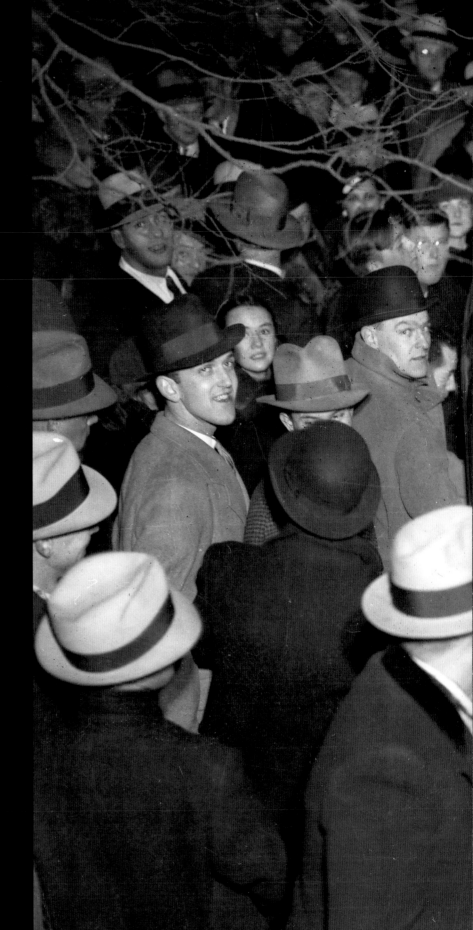

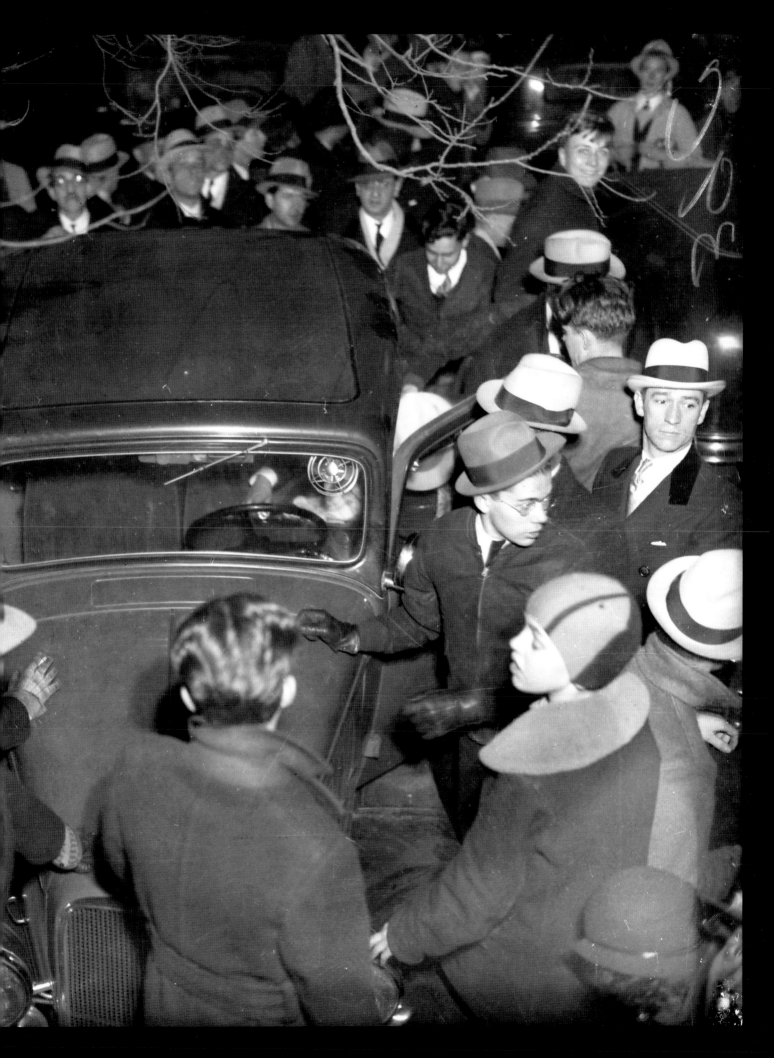

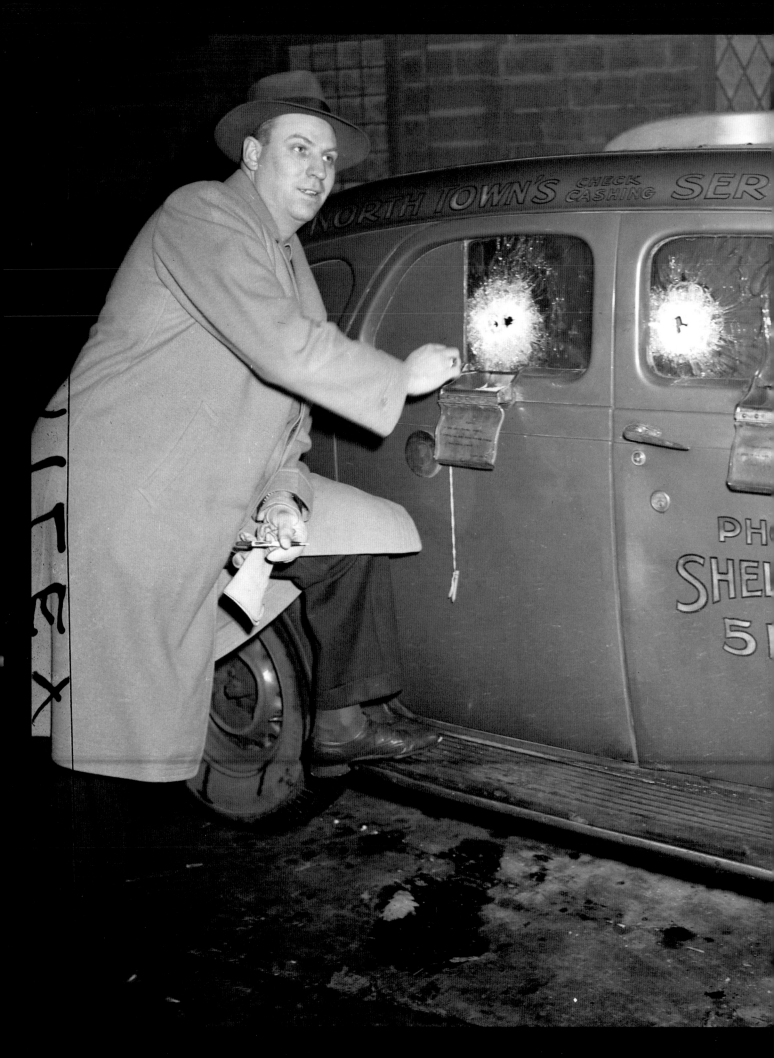

Lt. Elwood H. Martin examines a bullet-riddled Buick armored money car in Franklin Park, Ill. On Dec. 18, 1942, the armored money car had been parked outside the Buick plant in Melrose Park, Ill., where its occupants were cashing paychecks for Buick employees, when bandits fired rifles at the shatterproof windows, stuck the barrels through the holes and ordered the occupants out of the car. The robbers wounded one occupant, forced another out and drove away with $20,000 before abandoning it. It was rumored that the robbery was the work of five men from the Roger Touhy gang, according to the Tribune. Seven men, including Touhy, had escaped from prison just two months prior, on Oct. 9. In the end, the FBI didn't have enough evidence to link Touhy and his men to the robbery.

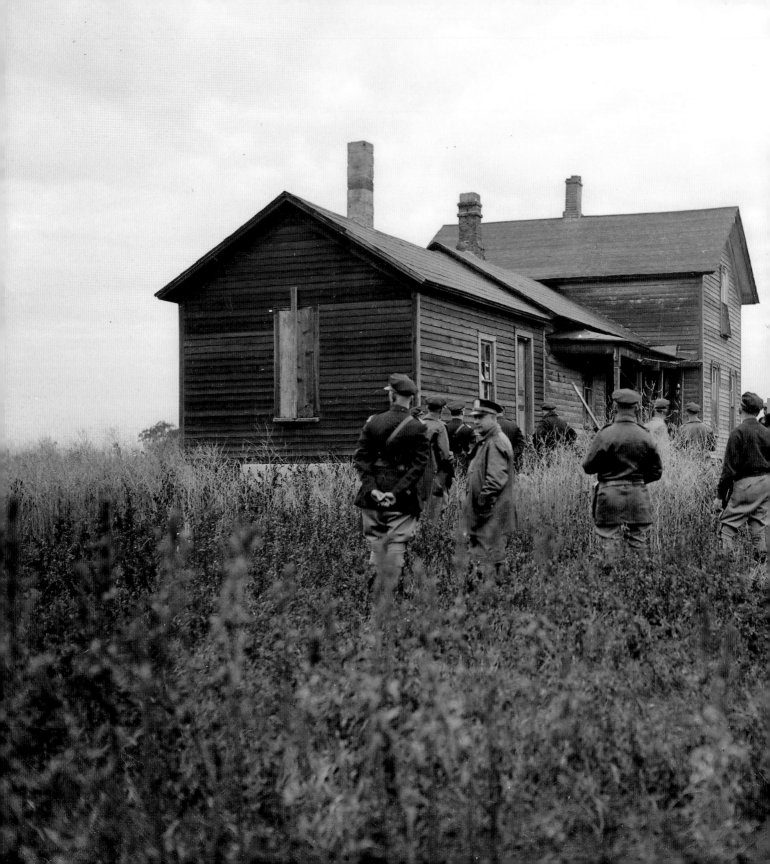

DILLINGER PLAYS A PART IN THREE ESCAPE PLOTS

Boasts No Jail Is Strong Enough to Hold Him.

Indiana State Police surround the house where two fugitives were suspected of hiding after a prison break. On Sept. 26, 1933, 10 convicts, led by John "Red" Hamilton, broke out of the Indiana State Prison in Michigan City, Ind. In the days after the prison break, the Tribune reported that more than 500 vigilantes, police and deputy sheriffs were searching the farming districts near Michigan City for the felons. John Dillinger, who was in a jail cell in Lima, Ohio, had engineered the convicts' escape and arranged for guns to be smuggled in for them. Less than a month after their jailbreak, several of the men helped Dillinger escape from the Lima jail. The Michigan City escapees became known as Dillinger's gang; one year later, two of the felons would be dead, five back in prison, and three would still be at large, including Hamilton. CONTINUED ➡

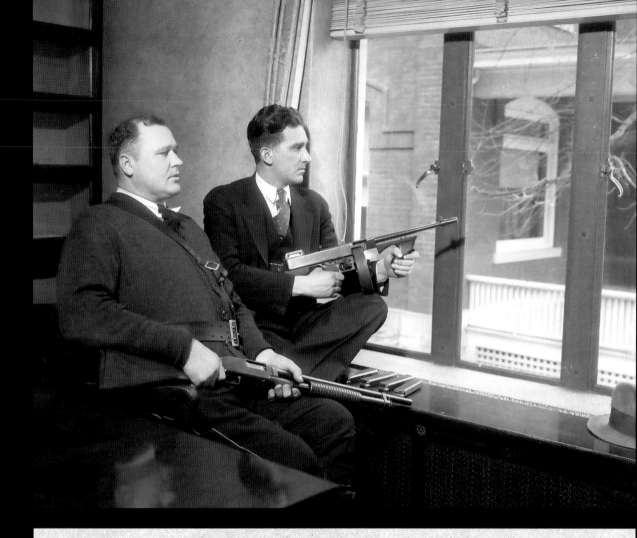

CATCH DILLINGER AND 3 AIDS

◀ CONTINUED John Dillinger arrives back at the county jail at Crown Point, Ind., on Jan. 30, 1934, after being caught in Arizona five days earlier. Authorities were fearful that Dillinger's gang would try to rescue its leader, so heavily armed guards surrounded the courthouse and jail. Dillinger was charged with killing police officer William O'Malley, 43, during a bank robbery in East Chicago, Ind., on Jan. 15, 1934.

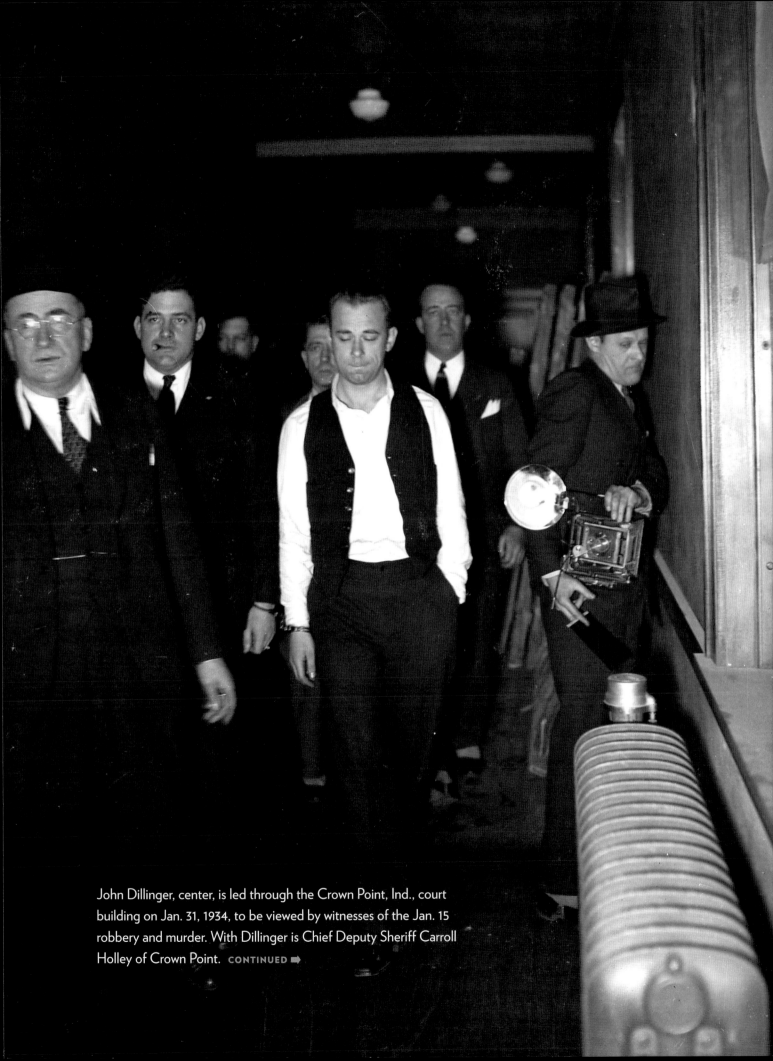

John Dillinger, center, is led through the Crown Point, Ind., court building on Jan. 31, 1934, to be viewed by witnesses of the Jan. 15 robbery and murder. With Dillinger is Chief Deputy Sheriff Carroll Holley of Crown Point. CONTINUED ➡

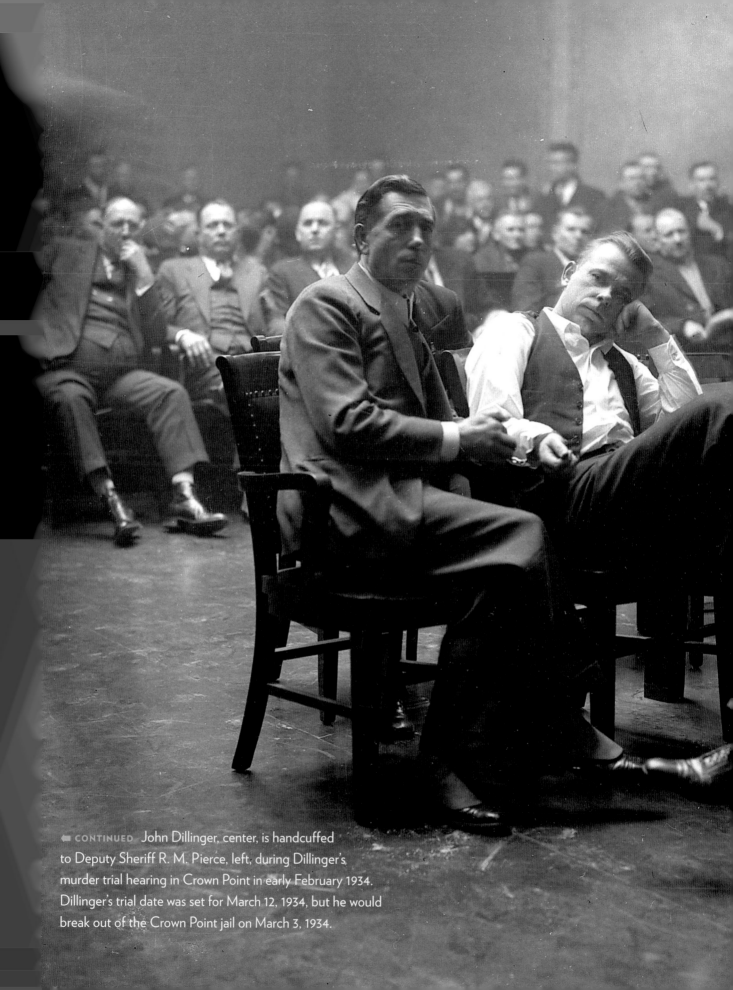

◄ CONTINUED John Dillinger, center, is handcuffed to Deputy Sheriff R. M. Pierce, left, during Dillinger's murder trial hearing in Crown Point in early February 1934. Dillinger's trial date was set for March 12, 1934, but he would break out of the Crown Point jail on March 3, 1934.

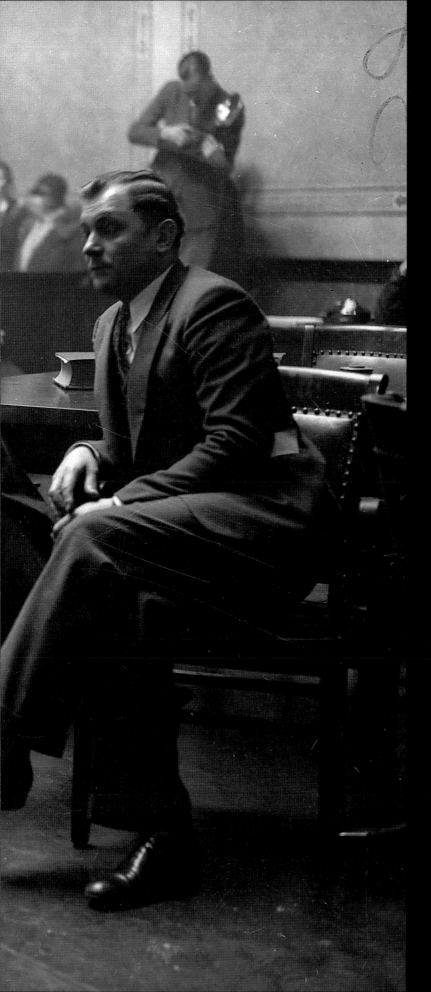

It didn't take much for John Dillinger to break out of the Crown Point jail on March 3. He threatened deputy sheriffs with a wooden gun and then locked up more than a dozen guards before fleeing in the sheriff's own car. CONTINUED ➡

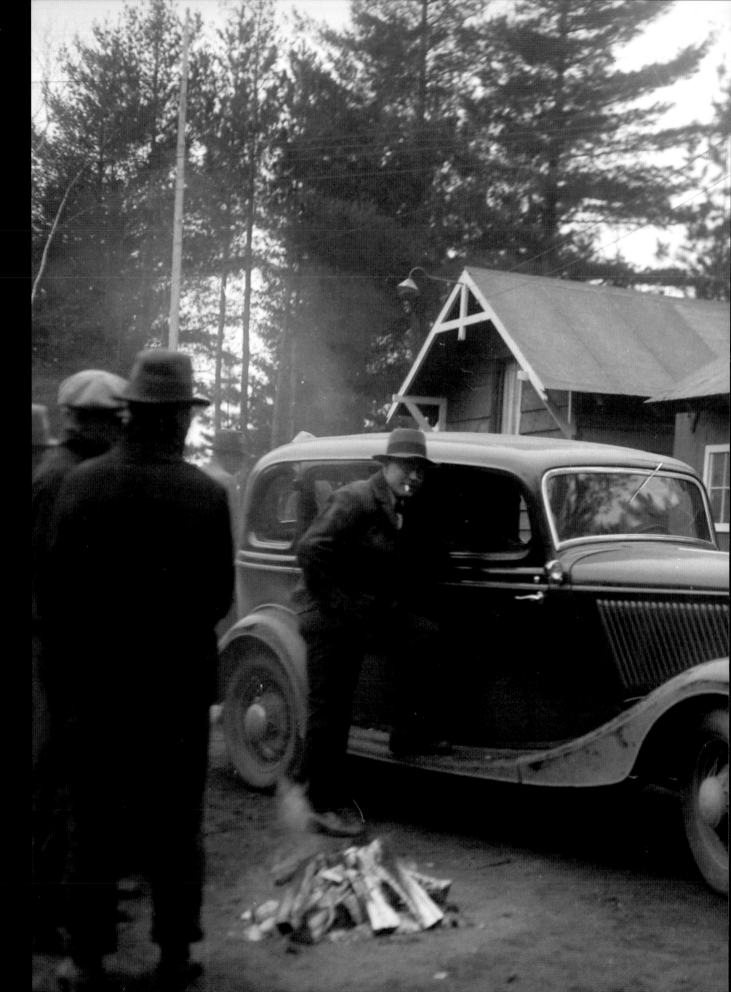

HUNT DILLINGER; 2 DIE, 4 SHOT

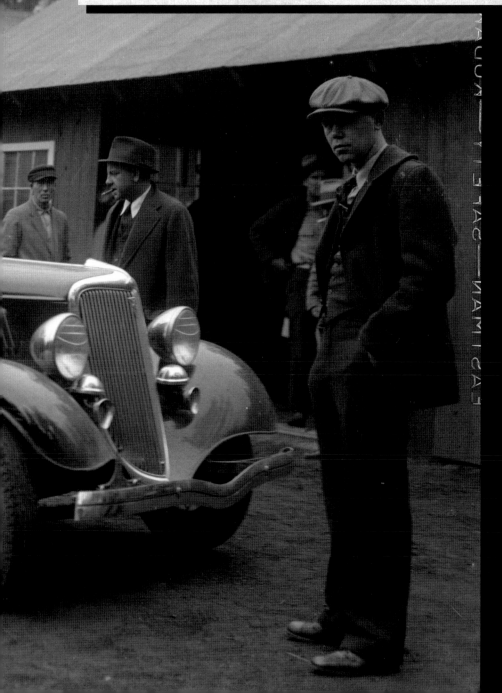

Desperadoes Escape North Woods Trap

◀ CONTINUED Government men stand by the Ford that John Dillinger abandoned during a gun battle at the Little Bohemia Resort in Manitowish Waters, Wis., on April 22, 1934. FBI agents had surrounded the lodge, but Dillinger and his gang were able to escape along the shore of the nearby lake. Two people were killed during the raid: an FBI agent and a local man who was mistaken for one of Dillinger's gang. Leading the group of G-men were federal agents Melvin Purvis and Hugh Clegg. CONTINUED ➡

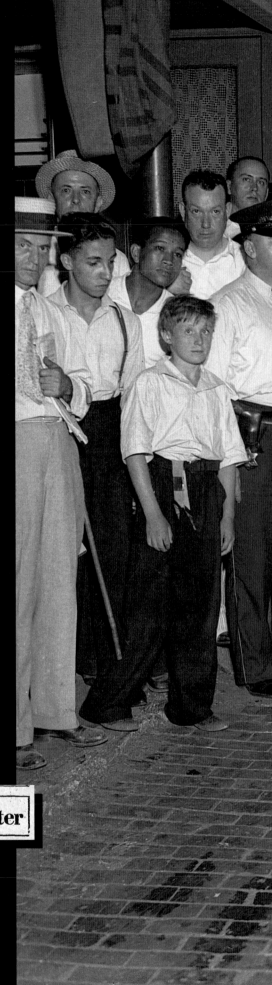

John Dillinger, 'America's Public Enemy

No. 1, Shot to Death by U. S. Agents

as He Leaves North Side Theater

◀ CONTINUED A group gathers around the bloodstain left by John Dillinger in the alley behind the Biograph Theater in Chicago where he was shot on July 22, 1934. CONTINUED ➡

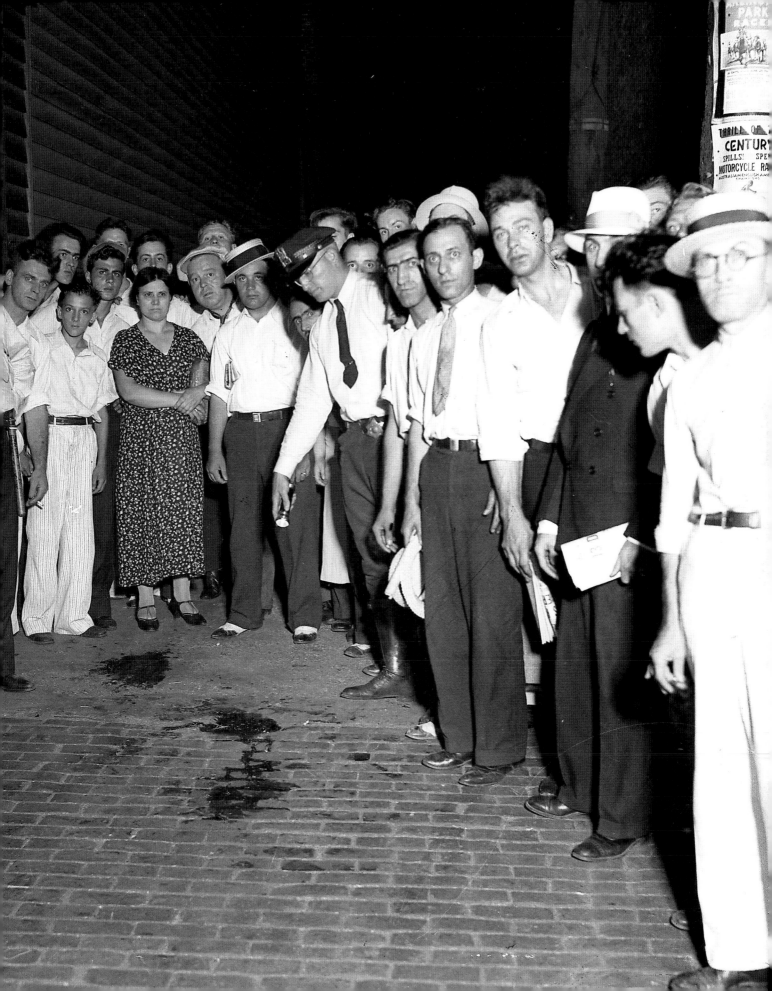

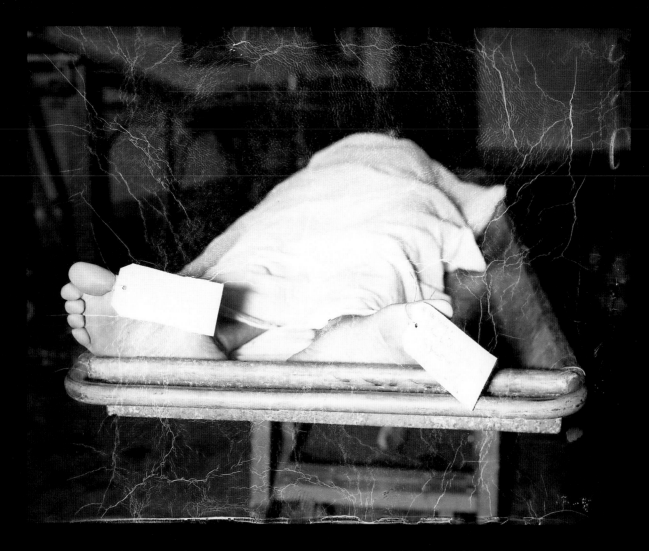

◄ CONTINUED John Dillinger's body lies on a slab at the Cook County Morgue after FBI agents shot and killed him on July 22, 1934, at the Biograph Theater. According to the Tribune, Dillinger was "partly covered with a sheet below which well manicured feet protrude, a tag labeled 'Dillinger' on each big toe."

CROWDS OF HOME TOWN FOLKS SEE DILLINGER BODY

May Be Buried Today in Famous Old Cemetery.

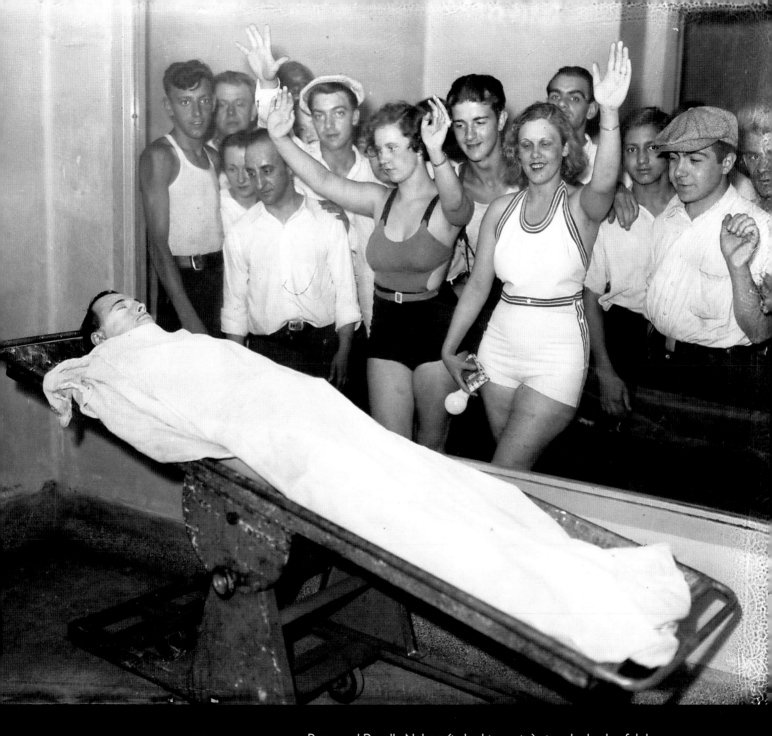

Betty and Rosella Nelson (in bathing suits) view the body of John Dillinger, 32, at the Cook County Morgue. In the days following Dillinger's death, massive crowds lined up outside the morgue to get a glimpse of the notorious public enemy. CONTINUED ▶

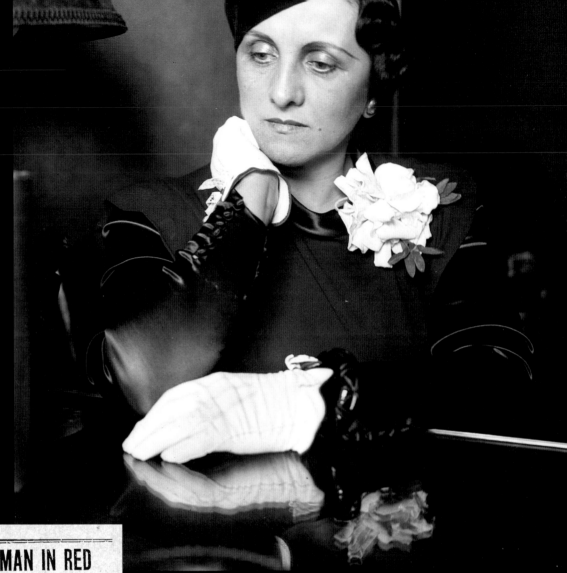

WOMAN IN RED TELLS CHASE BY DILLINGER PALS

Mrs. Sage Fights to Avoid Deportation.

◄ CONTINUED Anna Sage sits in her attorneys' office on Sept. 27, 1935. Sage gained notoriety after betraying John Dillinger to the federal agents who shot him to death at the Biograph Theater. A brothel owner, Sage was facing deportation to her home country of Romania when she made a deal with famous FBI Agent Melvin Purvis. In exchange for information on Dillinger's whereabouts, she would not be deported. Sage told the FBI she and Dillinger's girlfriend, Polly Hamilton, would be with Dillinger at the movies, and that she would wear red to the theater as a distinctive mark. Sage became known as the "Woman in Red," though some reports say she was actually dressed in orange. Despite her cooperation, Sage was later deported.

Evelyn "Billie" Frechette, circa June 1936. Frechette was arrested in Chicago while her boyfriend and fugitive, John Dillinger, watched helplessly on April 9, 1934. Frechette, who had met Dillinger in 1933, was charged with harboring a fugitive in her St. Paul, Minn., apartment. She spent two years in jail, until 1936. Upon her release, Frechette toured in a theatrical production called "Crime Doesn't Pay" with members of Dillinger's family.

"GUILTY" IS KLIMEK VERDICT

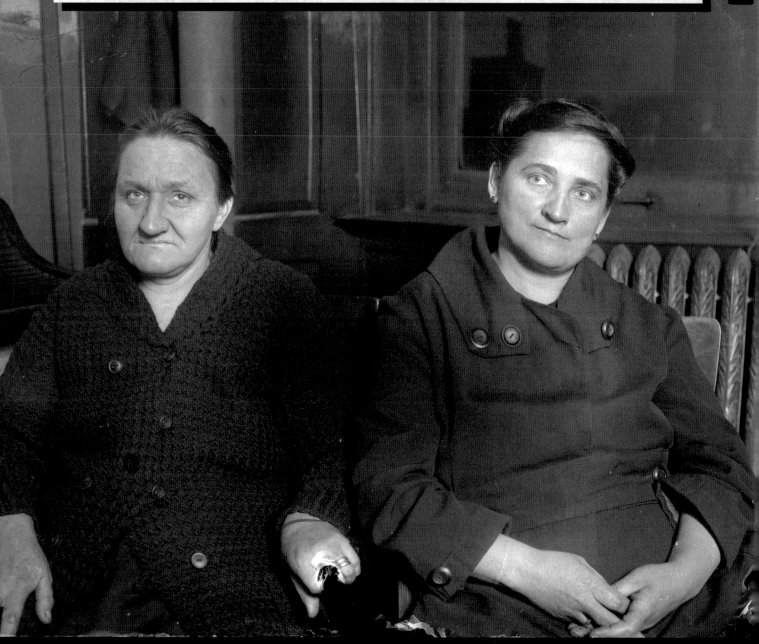

Tillie Klimek, right, and her cousin Nellie Stermer-Koulik were accused of poisoning 20 husbands, children and friends with arsenic. "We have here a woman of average intelligence, a modern housewife and a good cook. When she is among women she is affectionate and it is said, she is the most popular woman in the jail. Yet, the testimony showed, cold bloodedly, without feeling or remorse, she killed three of her husbands and attempted to kill the fourth," said Judge Marcus Kavanagh as he sentenced her to life in prison. Stermer-Koulik was found not guilty.

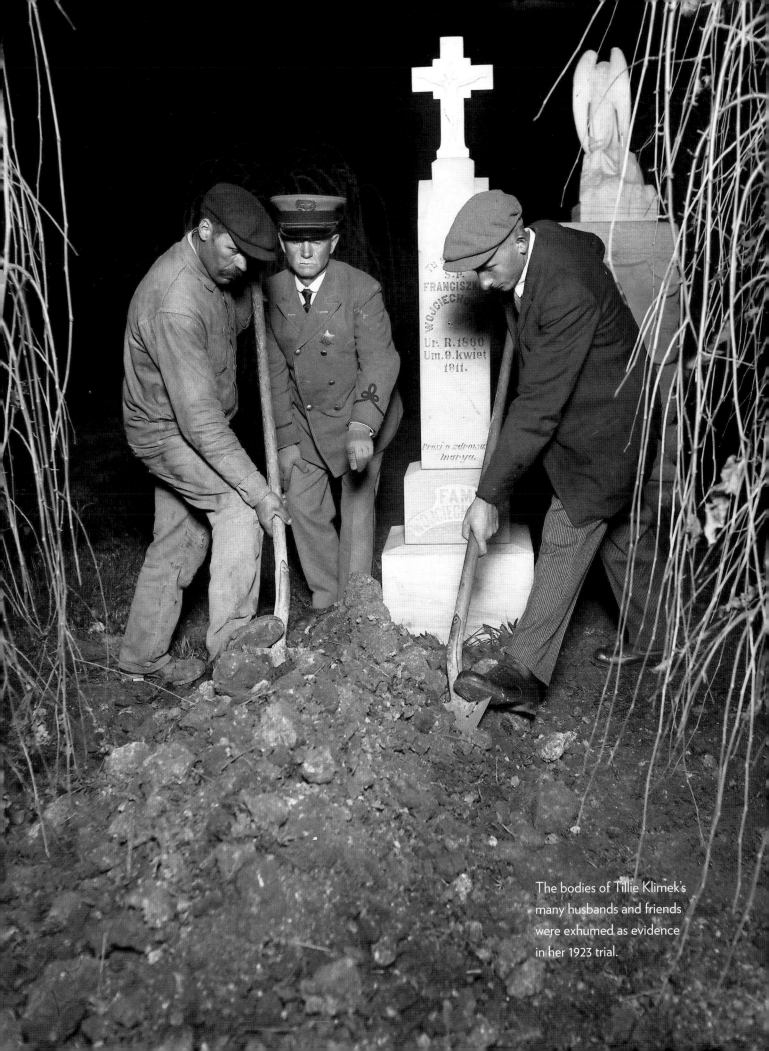

The bodies of Tillie Klimek's many husbands and friends were exhumed as evidence in her 1923 trial.

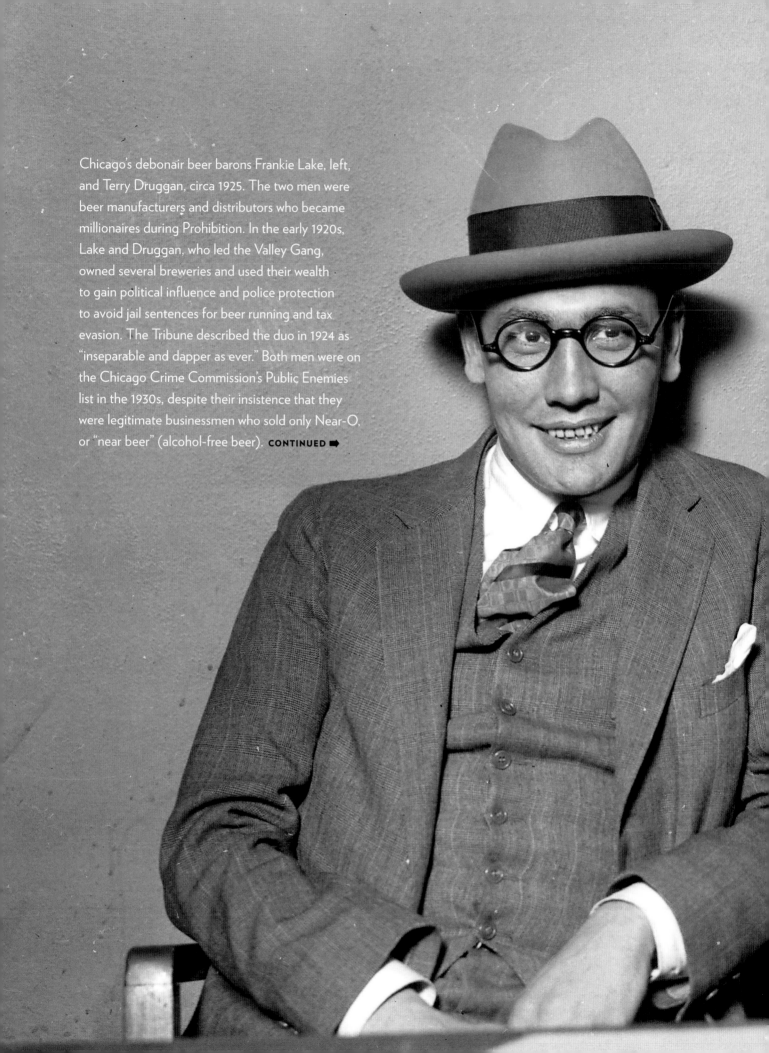

Chicago's debonair beer barons Frankie Lake, left, and Terry Druggan, circa 1925. The two men were beer manufacturers and distributors who became millionaires during Prohibition. In the early 1920s, Lake and Druggan, who led the Valley Gang, owned several breweries and used their wealth to gain political influence and police protection to avoid jail sentences for beer running and tax evasion. The Tribune described the duo in 1924 as "inseparable and dapper as ever." Both men were on the Chicago Crime Commission's Public Enemies list in the 1930s, despite their insistence that they were legitimate businessmen who sold only Near-O, or "near beer" (alcohol-free beer). **CONTINUED** ➡

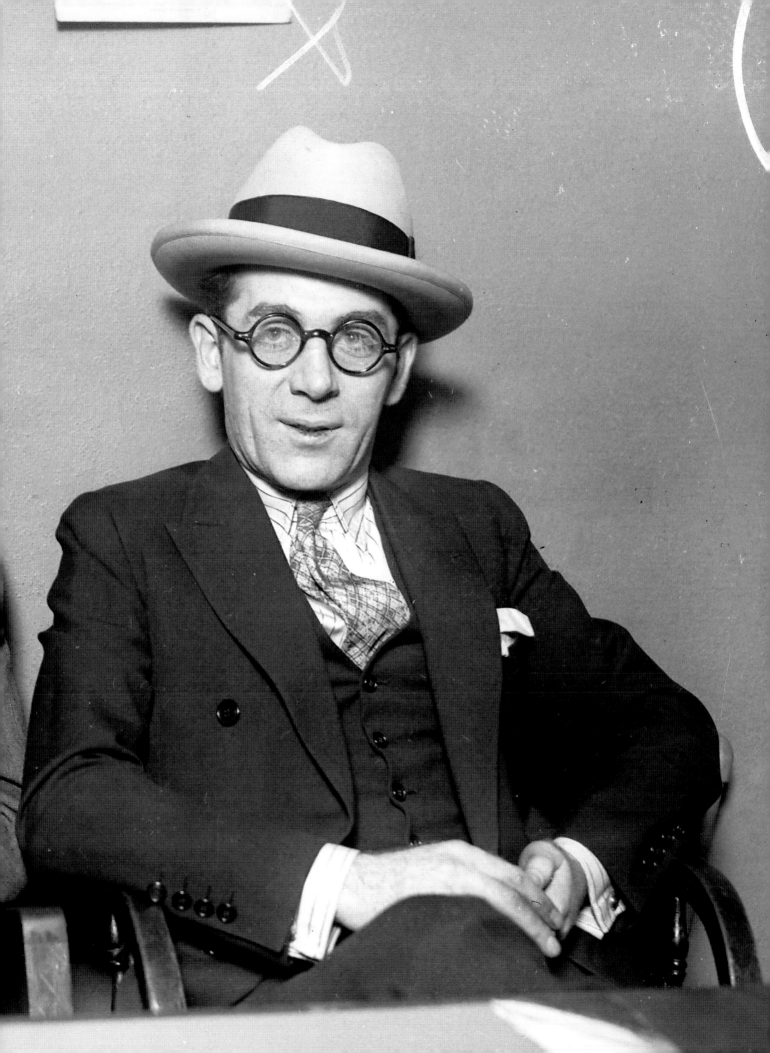

← CONTINUED Terry Druggan's ex-wife, Grace, 26, in court on March 7, 1941, to retrieve her son Terrance Jr., 3. A custody agreement allowed Druggan to have the boy only on weekends, but the gangster refused to give him up. He finally returned Terrence Jr. after a threat from the judge. Grace committed suicide five years later by jumping off of Navy Pier. Druggan died in 1954, at the age of 51, from constant stomach ulcers, asthma and heart troubles, according to the Tribune.

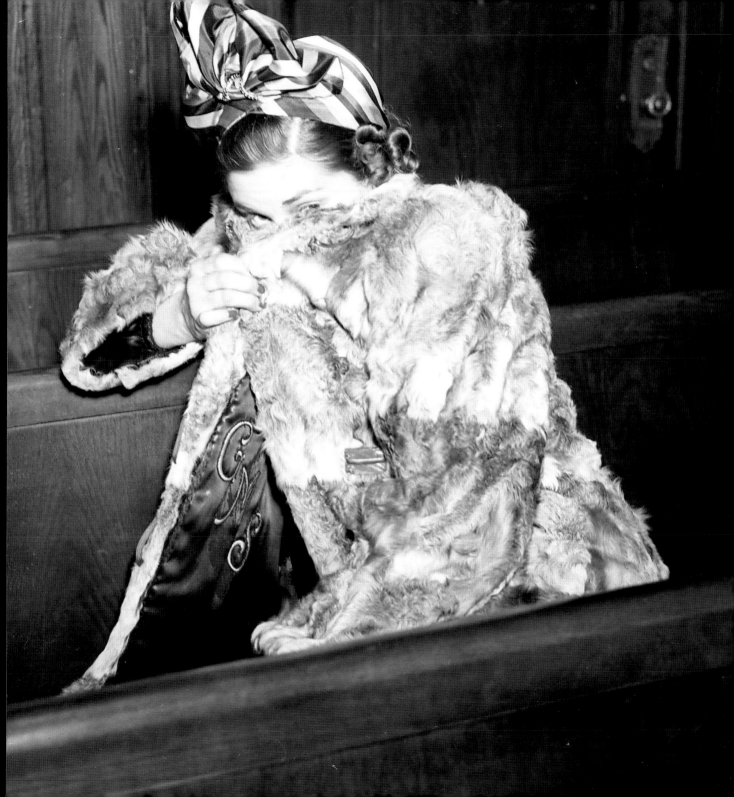

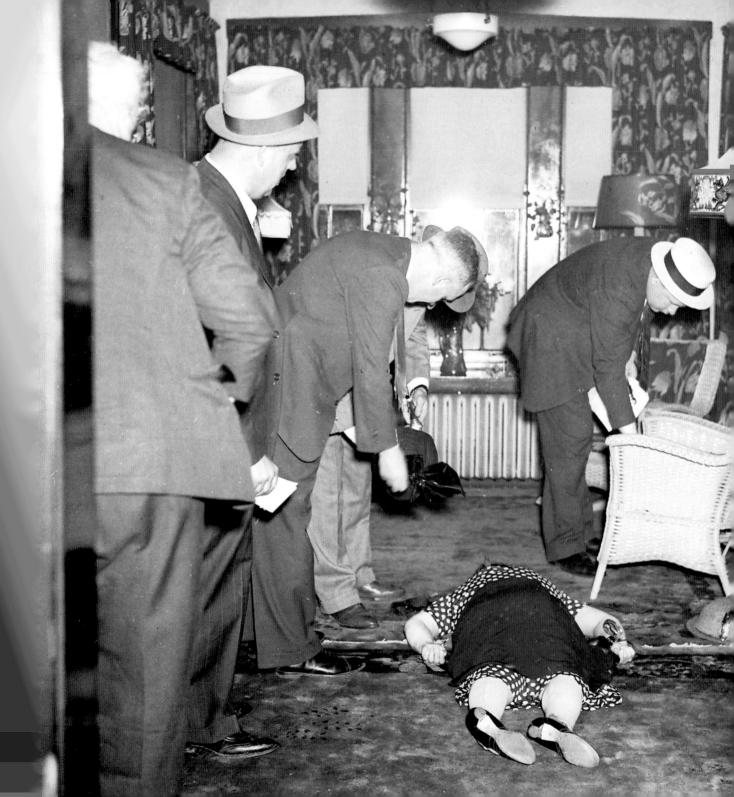

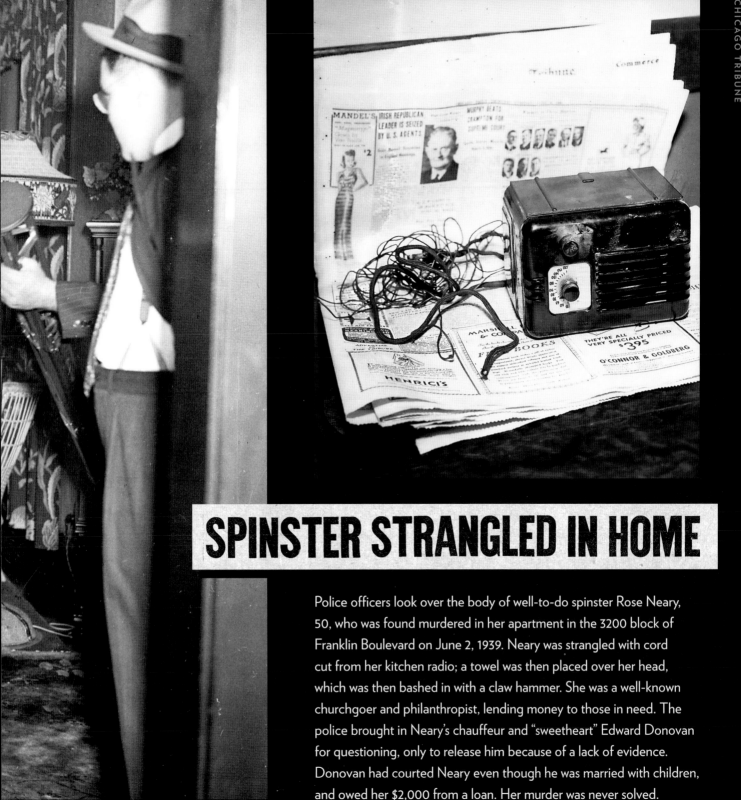

SPINSTER STRANGLED IN HOME

Police officers look over the body of well-to-do spinster Rose Neary, 50, who was found murdered in her apartment in the 3200 block of Franklin Boulevard on June 2, 1939. Neary was strangled with cord cut from her kitchen radio; a towel was then placed over her head, which was then bashed in with a claw hammer. She was a well-known churchgoer and philanthropist, lending money to those in need. The police brought in Neary's chauffeur and "sweetheart" Edward Donovan for questioning, only to release him because of a lack of evidence. Donovan had courted Neary even though he was married with children, and owed her $2,000 from a loan. Her murder was never solved.

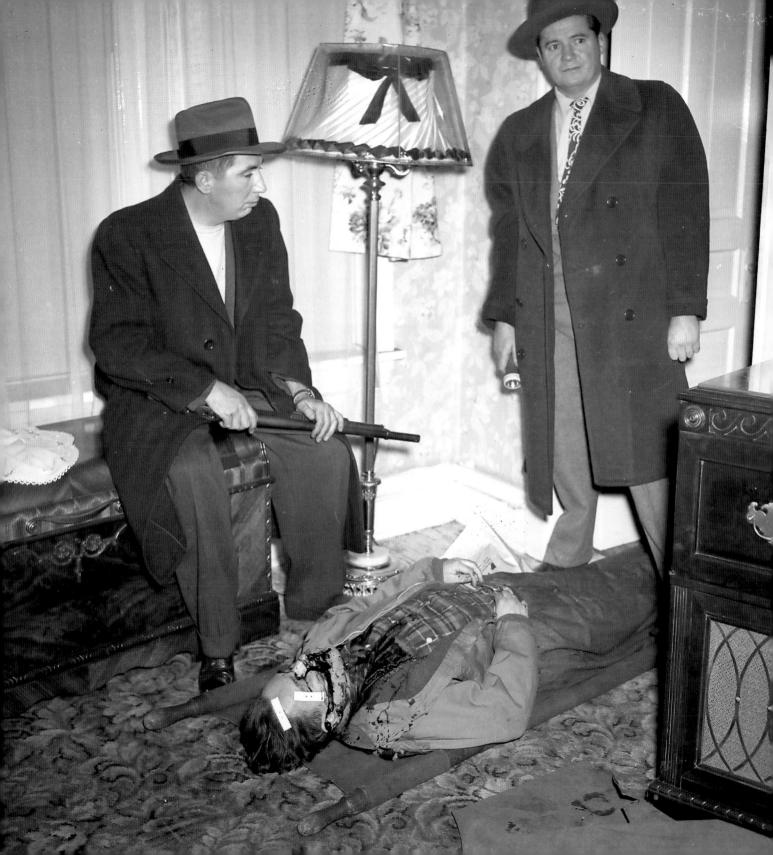

GANG MASSACRE
OF 3 TOLD

COPS SLAY MOB CHIEF IN HIS HOME

Third Terrorist Is Hunted

Detectives Emil Smicklas and Frank Pape look at the body of Thomas Daley, 42, on Dec. 13, 1947, at the home of James Morelli. Smicklas and Pape shot Daley four times in the face as he tried to escape through a window.

Daley, 42, was involved in the "mad dog" murder spree of Dec. 12, 1947, along with Lowell Fentress, 19, and Morelli, 20. It all started when the three killed John Kuesis, 33, because he had told the cops about the trio's involvement in a robbery. Four people witnessed the murder at Kuesis' garage in the 3600 block of Emerald Avenue, so the killers took the four witnesses on a death ride, shooting one witness at a time and then dumping the bodies around the western suburbs. Frank Baker, 17, and Kuesis' younger brother Nick survived, despite receiving gunshot wounds to the chest and neck, respectively. CONTINUED ➡

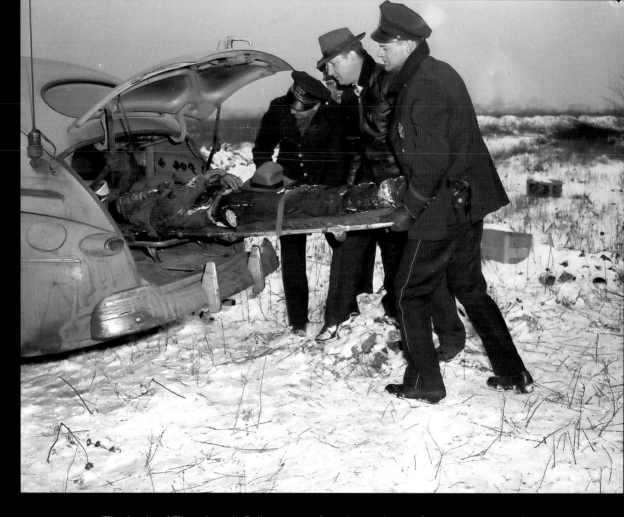

◀ CONTINUED The body of Theodore J. Callis, 29, was found at 39th and Central Avenue in Stickney, Ill. Callis, one of the "mad dog" murder victims, was the father of two small children.

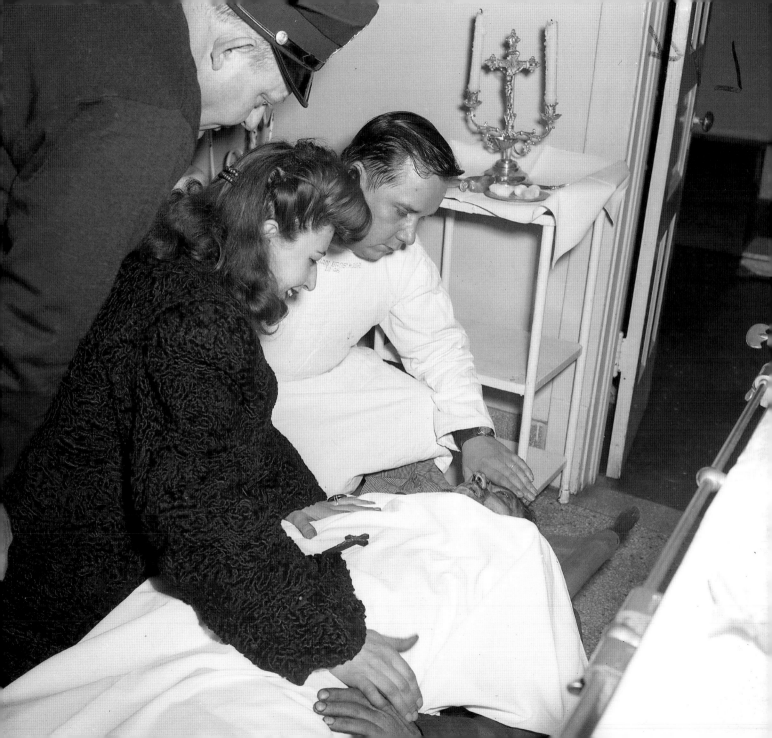

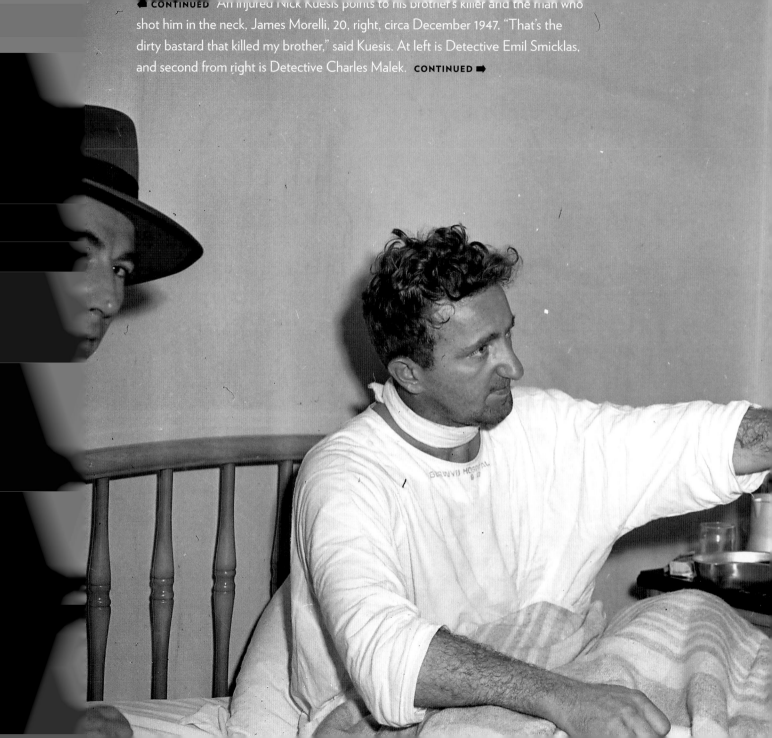

◀ CONTINUED An injured Nick Kuesis points to his brother's killer and the man who shot him in the neck, James Morelli, 20, right, circa December 1947. "That's the dirty bastard that killed my brother," said Kuesis. At left is Detective Emil Smicklas, and second from right is Detective Charles Malek. CONTINUED ➡

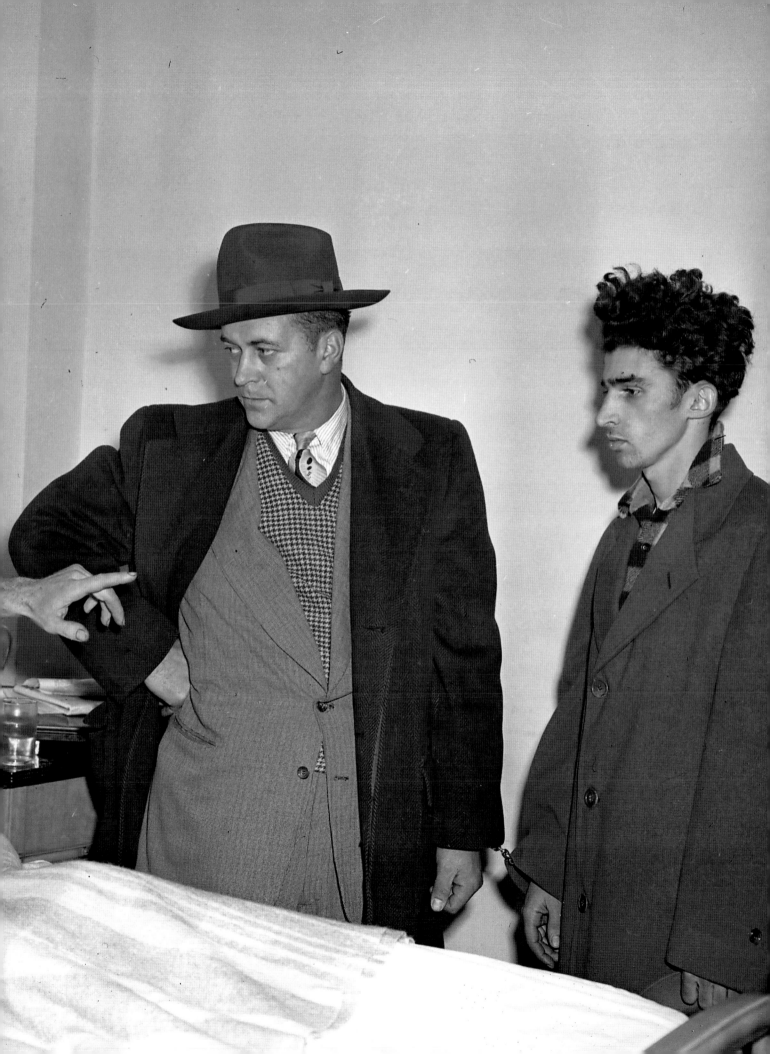

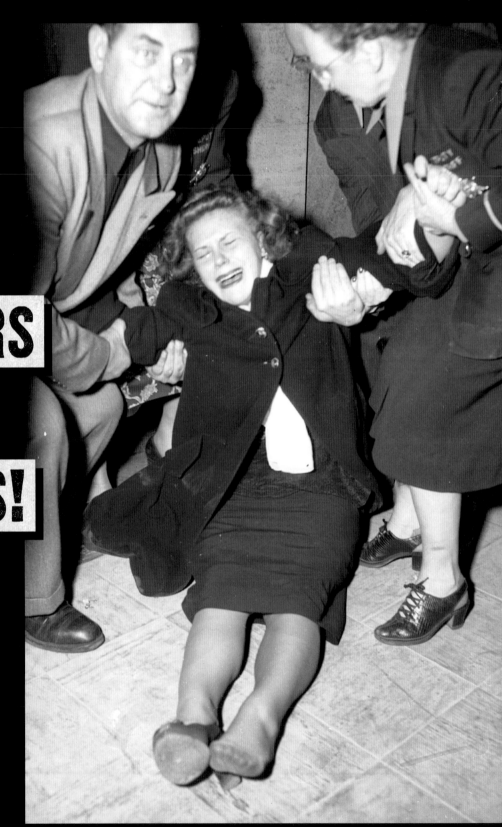

199 YEARS FOR 2 KILLERS!

◄ CONTINUED Margaret Ann "Peggy" Fentress, 17, the wife of Lowell Fentress, reacts after hearing that her husband was sentenced to 199 years in prison on Jan. 15, 1949. Lowell Fentress had driven the car during the murder spree, which took place just nine days after the couple married. By confessing and naming names, Fentress avoided the electric chair, unlike his cohort James Morelli.

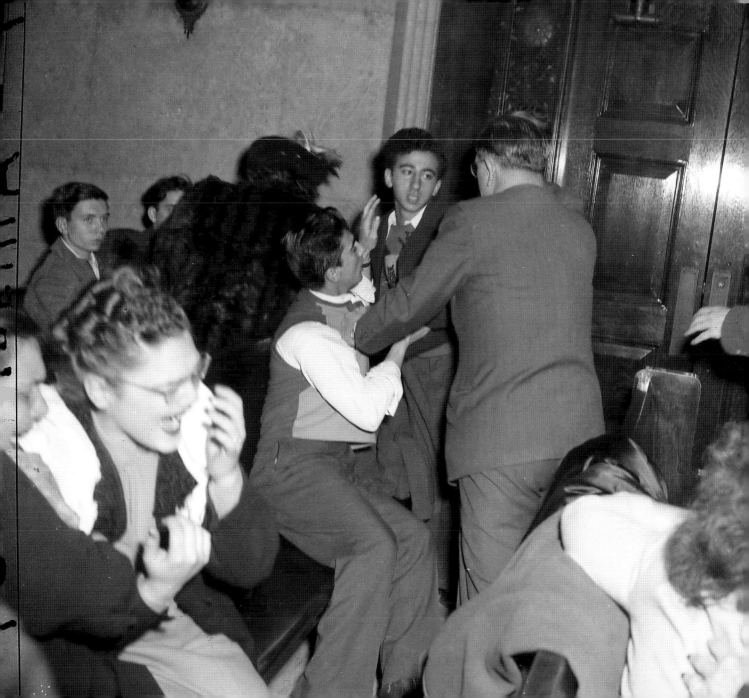

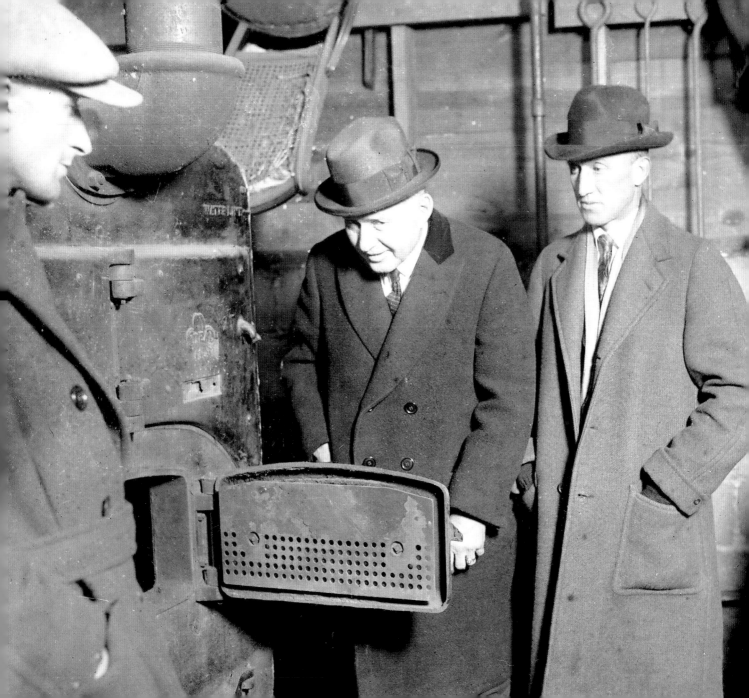

LINCOLN ADMITS KILLING WIFE

The greenhouse furnace where, in 1924, lawyer and horticulturist
Warren J. Lincoln, third from left, burned the headless bodies of
his wife, Lina Lincoln, and her brother, Byron Shoup, in Aurora, Ill.
Lincoln murdered them on Jan. 10, 1923, and then cleverly faked his
own death to make it seem as though they had murdered him and
fled. Lincoln disappeared in April 1923 but reappeared in June telling
a tall tale of abduction and "dope rings" that were forced upon him
by his wife and brother-in-law. Lincoln had simply run out of money.
He then disappeared again in the fall of 1923, but police caught him
in Chicago on Jan. 12, 1924. He confessed to the crime and showed
police where he had encased Lina and Byron's severed heads in a

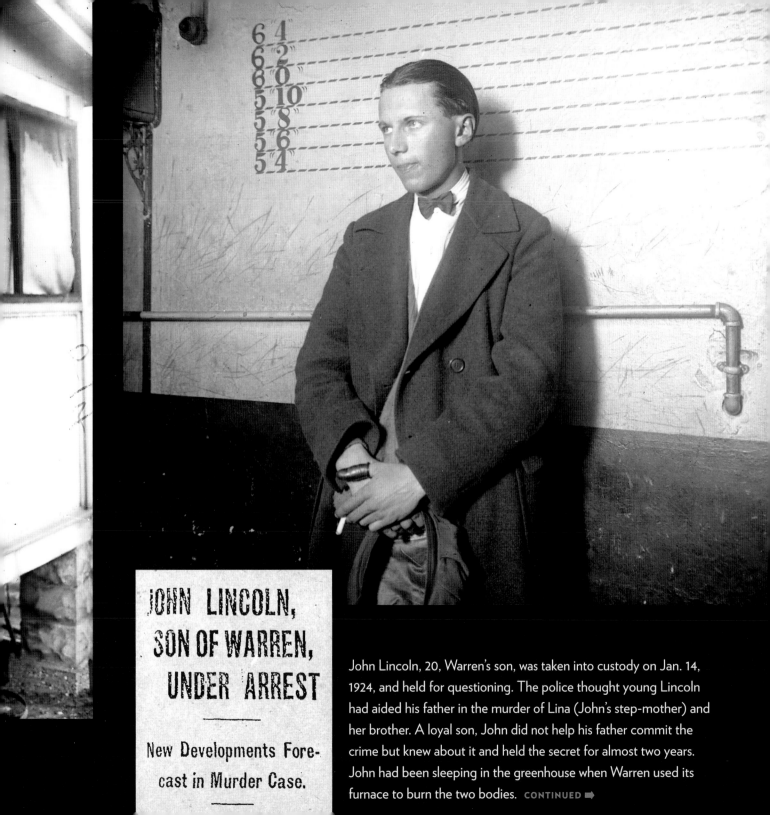

JOHN LINCOLN, SON OF WARREN, UNDER ARREST

New Developments Forecast in Murder Case.

John Lincoln, 20, Warren's son, was taken into custody on Jan. 14, 1924, and held for questioning. The police thought young Lincoln had aided his father in the murder of Lina (John's step-mother) and her brother. A loyal son, John did not help his father commit the crime but knew about it and held the secret for almost two years. John had been sleeping in the greenhouse when Warren used its furnace to burn the two bodies. CONTINUED ➡

◀ CONTINUED Aurora police
Chief Frank Michels, from left,
Warren J. Lincoln and jailor Peter
Fatten in Aurora, Ill., in 1924.

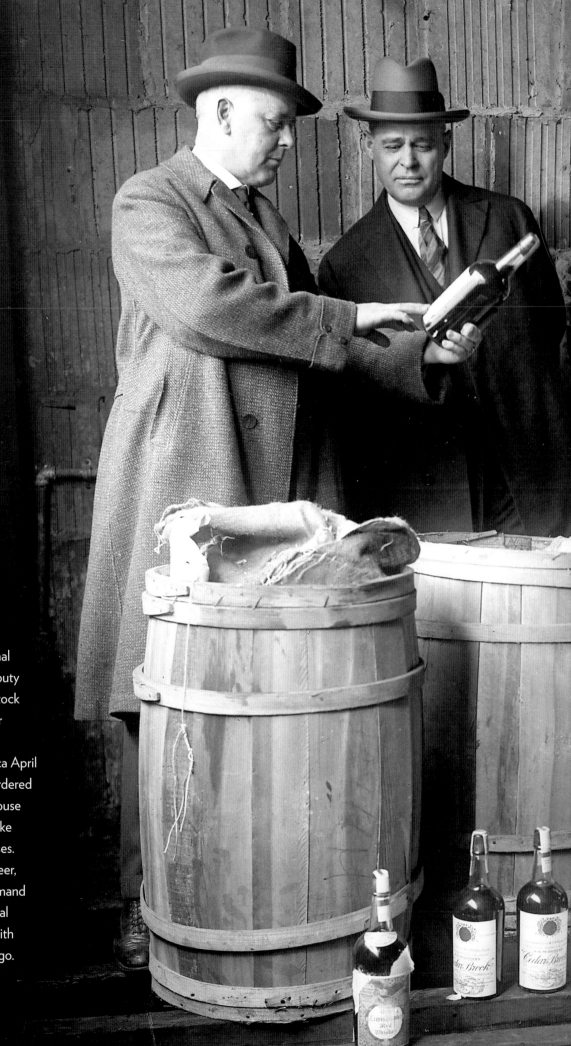

From left, Capt. A. C. Townsend, U. S. Marshal Palmer Anderson, Deputy U.S. Marshal A. J. Jostock and a laborer look over confiscated liquor at a federal warehouse, circa April 1925. The men were ordered to clear out the warehouse for seized liquor to make room for Army purposes. At one point in his career, Townsend was in command of the Eleventh General Prohibition Division, with headquarters in Chicago.

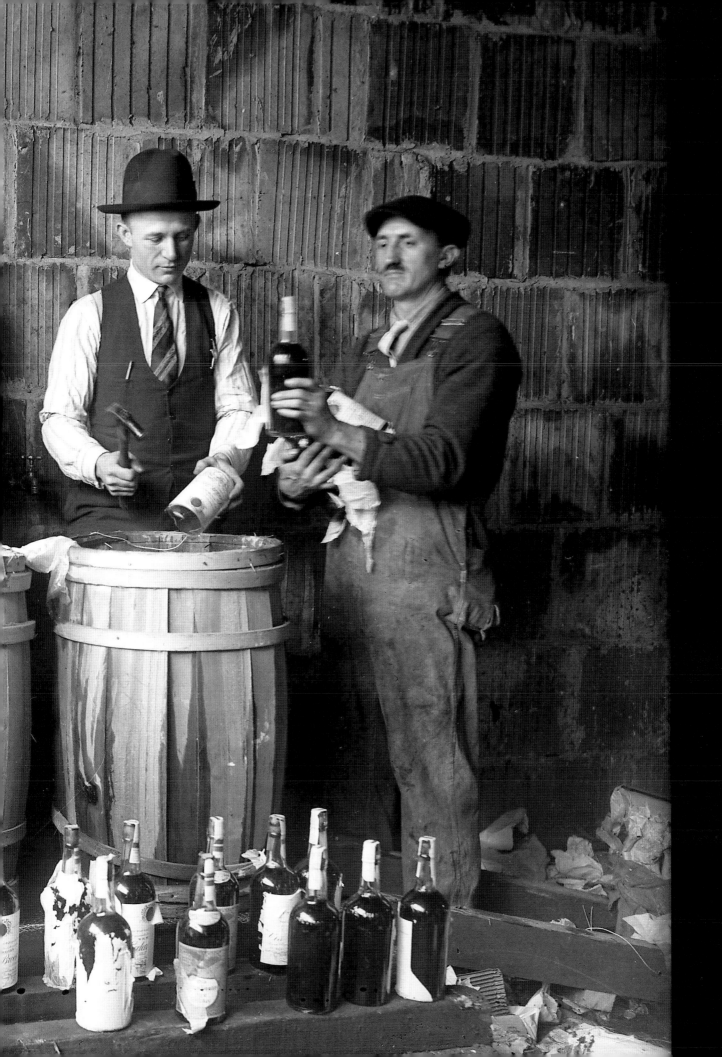

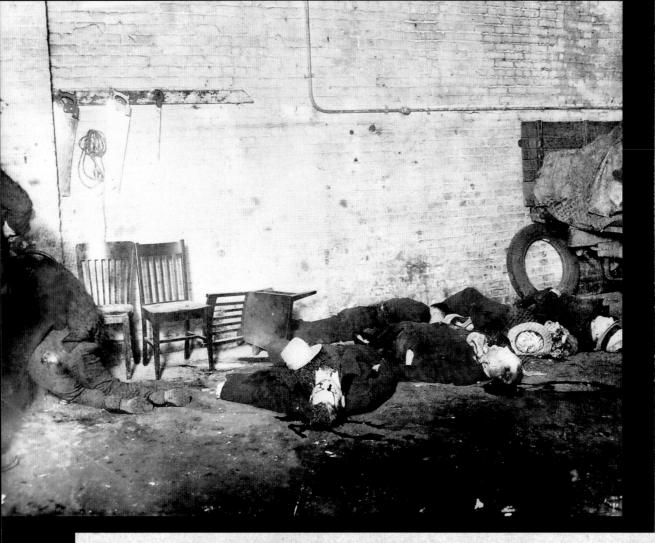

ST. VALENTINE'S DAY MASSACRE!

In what became known as the St. Valentine's Day Massacre, seven men were executed in the SMC Cartage Co. garage in the 2100 block of N. Clark Street on Feb. 14, 1929. Here, six of the bodies lie on the floor of the garage. Most were members of a North Side gang run by George "Bugs" Moran: Peter Gusenberg, 40; his brother Frank Gusenberg, 36; Moran's brother-in-law James Clark, 40; recent gang recruit Albert Weinshank, 26; the renter of the garage, Adam Heyer, 40; and Moran's mechanic and father of seven children, John May, 35. Only one of the seven was not in the Moran gang: Dr. Reinhardt Schwimmer, 29, an optometrist with a hoodlum complex. He liked the thrill of hanging out with gangsters. The murders were said to have been ordered by Moran's rival, Al Capone.

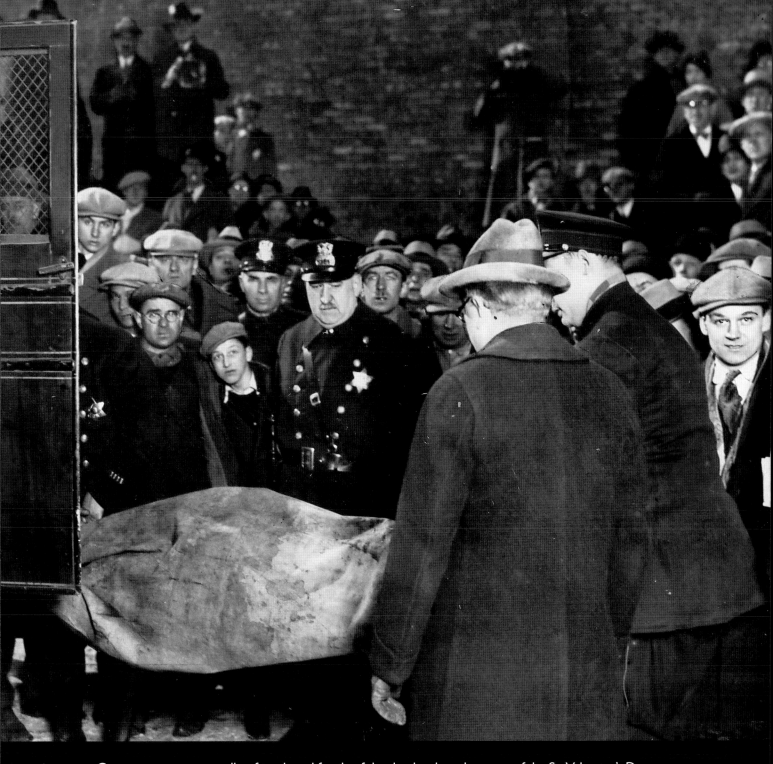

Curious spectators as well as friends and family of the dead rush to the scene of the St. Valentine's Day Massacre to identify the victims. CONTINUED ➡

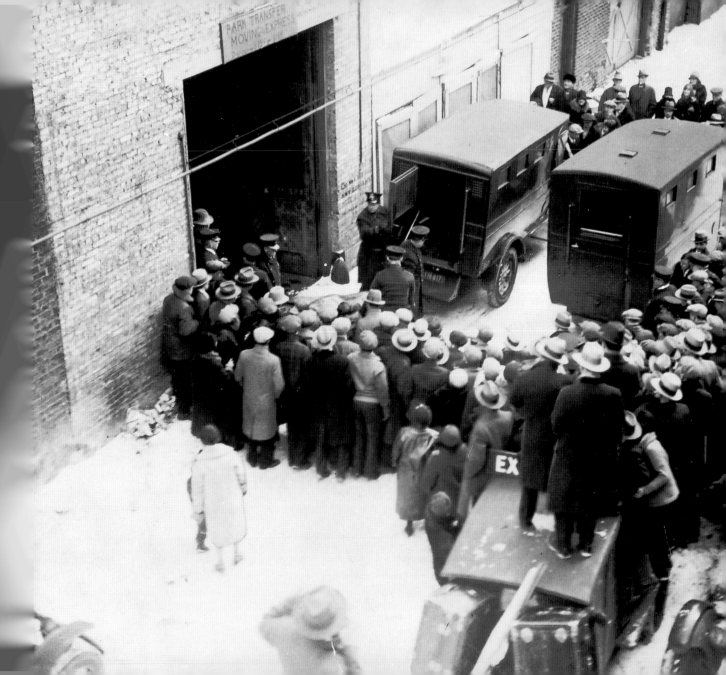

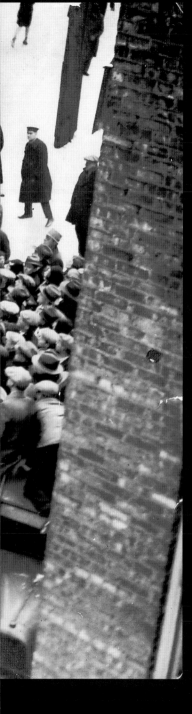

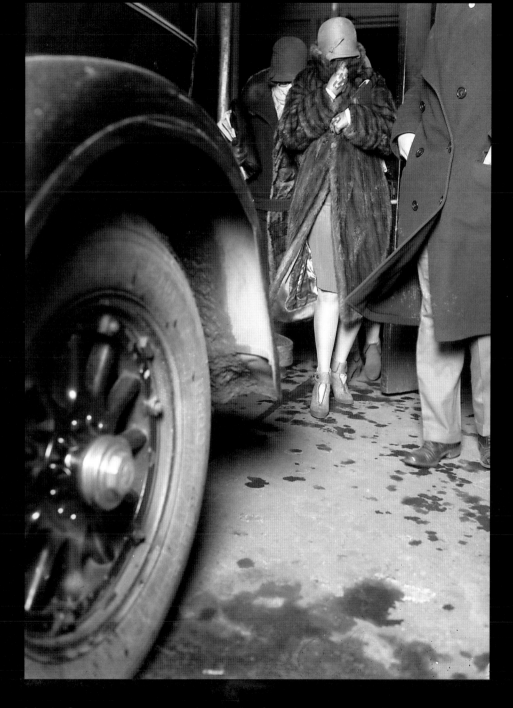

Myrtle Gorman, center, is seen leaving the Gusenberg inquest on Feb. 14, 1929. Gorman, who was Peter Gusenberg's wife, denied all knowledge of her husband's illegal activities. CONTINUED ➡

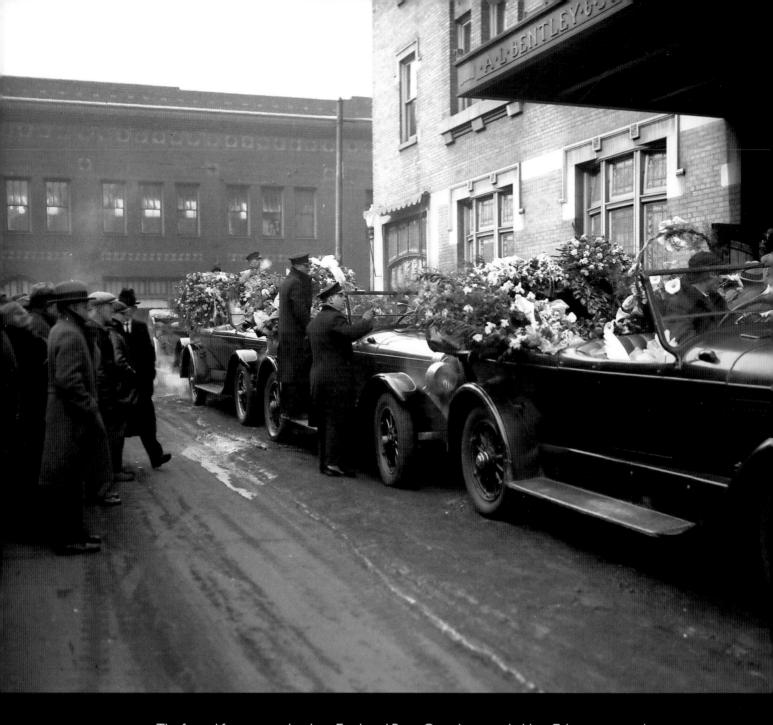

◀ CONTINUED The funeral for gangster brothers Frank and Peter Gusenberg was held on Feb. 18, 1929, and was packed with floral arrangements, including one heart containing 2,500 roses believed to be from gang leader George "Bugs" Moran. Frank Gusenberg is the only one of the seven who survived for a short time, dying several hours later at Alexian Brothers Hospital without giving police any clues to the killers.

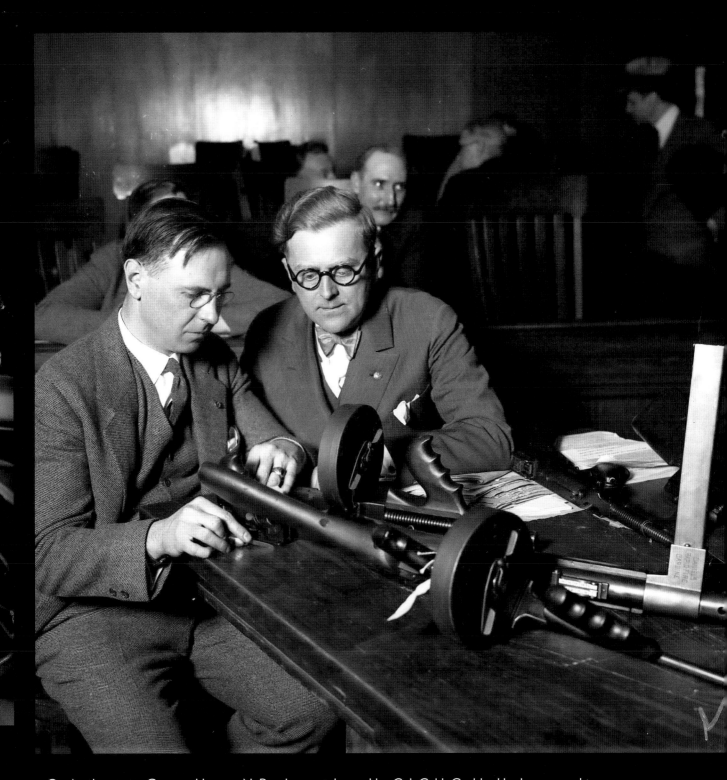

On April 19, 1929, Coroner Herman N. Bundesen, right, and Lt. Col. C. H. Goddard look over machine guns allegedly used in the St. Valentine's Day Massacre. Bundesen had summoned all local firearms dealers to the coroner's jury in Chicago.

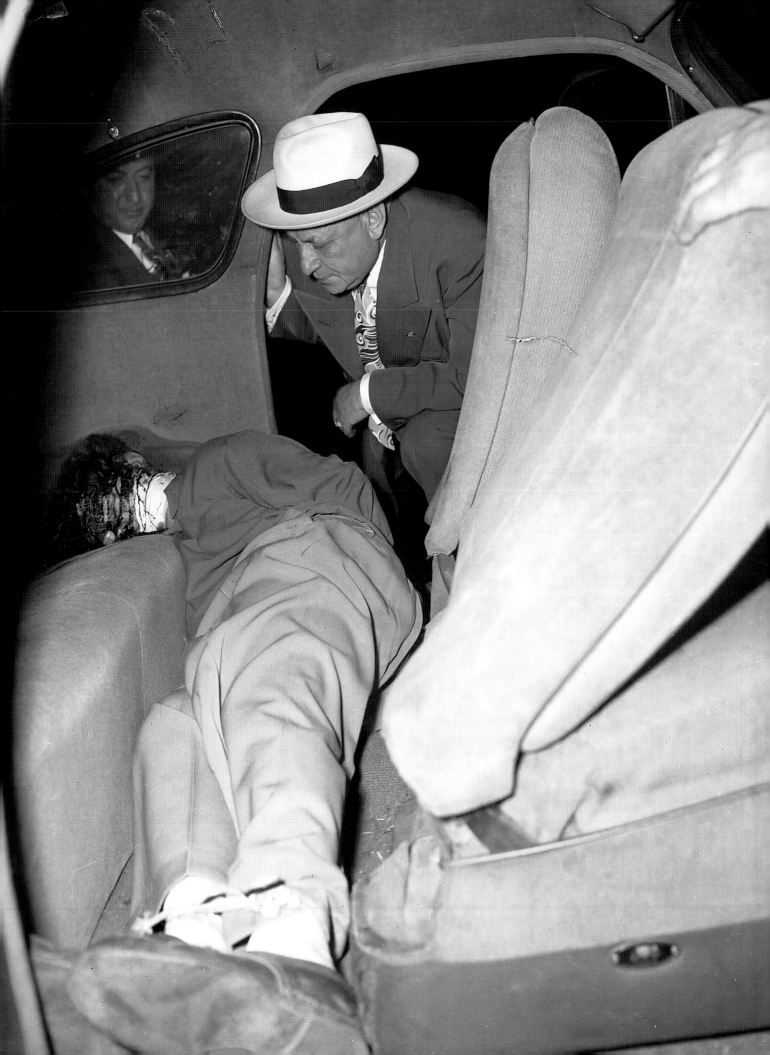

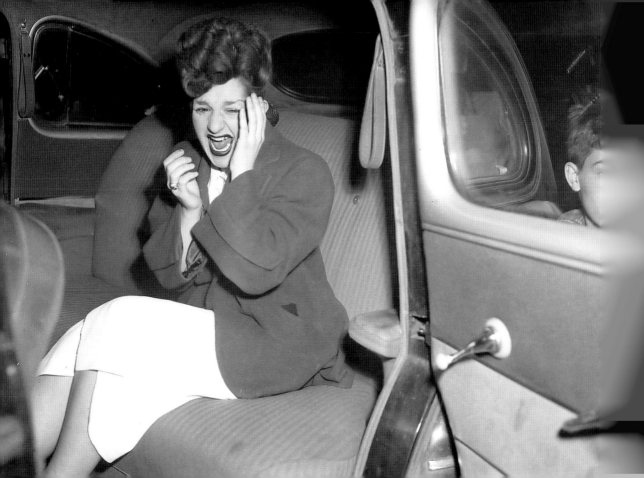

Al Capone, 31, in front of the detective bureau in Chicago, circa March 1930. Capone gave himself up voluntarily after being released three days earlier from a Philadelphia penitentiary for carrying a gun. According to the Tribune, the courts didn't want to detain Capone; Deputy Police Commissioner John Stege wanted only to give him a warning to get out of town. Capone had this to say: "All I ever did is sell beer and whiskey to our best people."

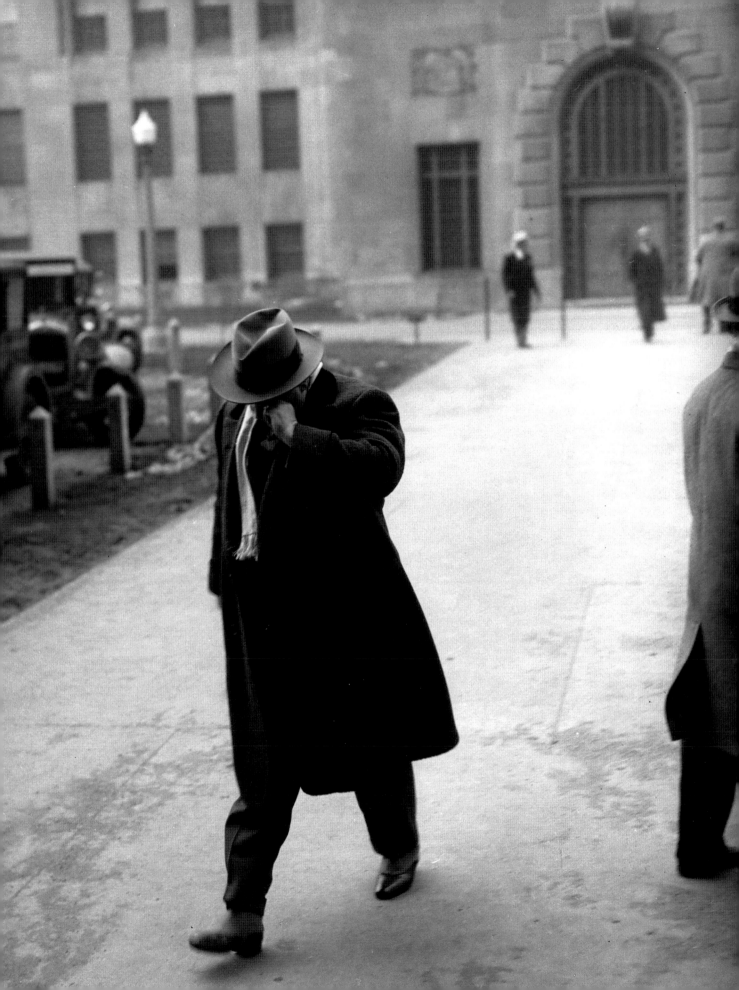

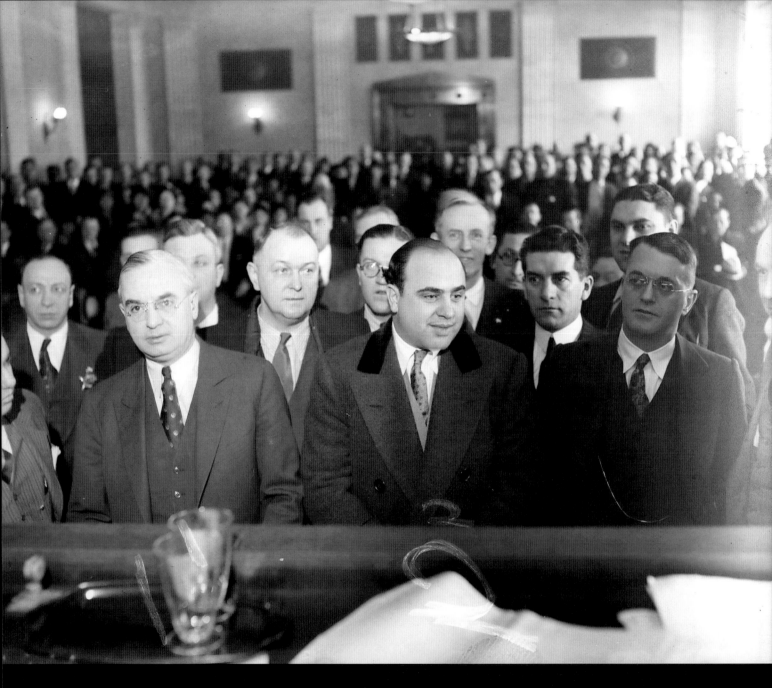

Assistant State's Attorney Harry Ditchburne, left, and Al Capone, center, in a Chicago courtroom in this undated photo.

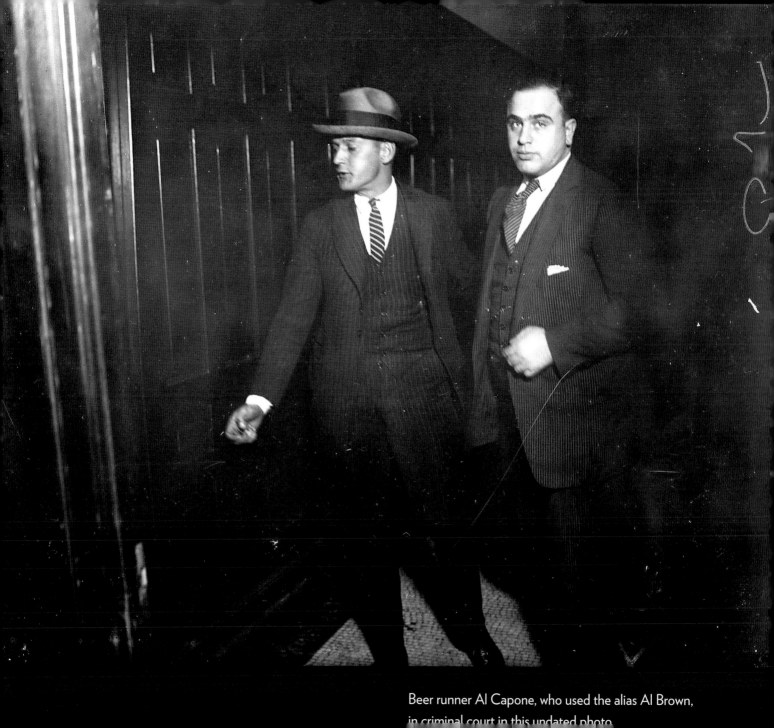

Beer runner Al Capone, who used the alias Al Brown, in criminal court in this undated photo.

WANDA STOPA FOUND—DEAD

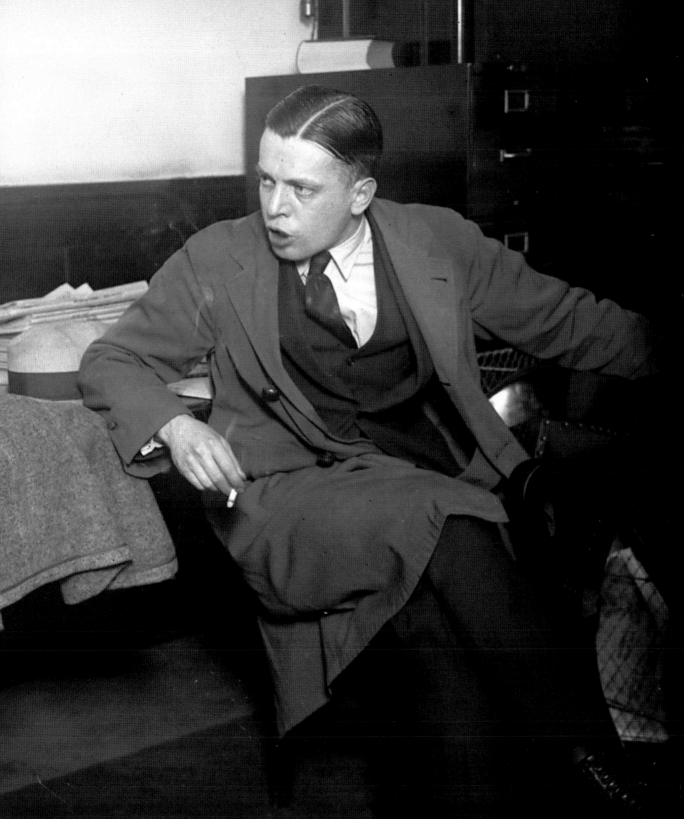

Wanda Stopa's husband, the Russian Count Zdzislaw "Ted" Glasko, right, speaks to Y. Kenley Smith, Stopa's benefactor and supposed lover. On April 24, 1924, Stopa, 24, Chicago's youngest female attorney, went to Smith's house with the intention of shooting him and his wife. She was in love with Smith and upset that he would not marry her. When Stopa found Smith's wife home alone, she shot at her and missed, killing the groundskeeper instead. Stopa then fled to Detroit and committed suicide with arsenic in a hotel room. CONTINUED ➡

Morbid Thousands Assemble at Funeral of Wanda Stopa

CONTINUED "Over 10,000 morbid sensation seekers crowded the streets of Little Poland yesterday afternoon to see the body of Wanda Stopa, young slayer of Howard Manning," reported the Tribune. Stopa's wake and funeral were held in the 1500 block of W. Augusta Boulevard on April 28 and 29, 1924.

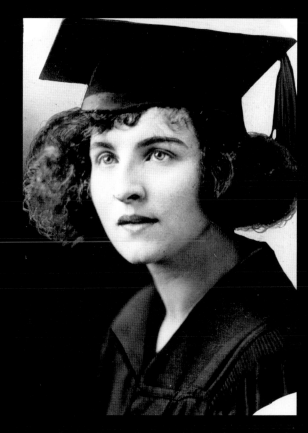

An undated photo of Wanda Stopa. She is buried at the Bohemian National Cemetery in Chicago.

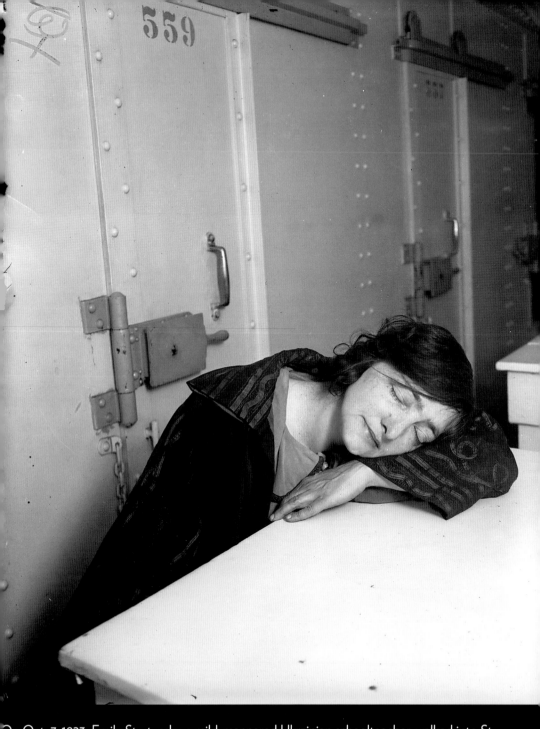

On Oct. 7, 1923, Emily Strutynsky, a mild-mannered Ukrainian schoolteacher, walked into St. Michael the Archangel Church, pulled a gun from her dress and killed the Rev. Basil Stetsuk. She claimed she had to kill the priest because he was a "such a bad leader of the Ukrainians." Strutynsky's husband, the Rev. Nicholas Strutynsky, was the former priest of the CONTINUED ▶

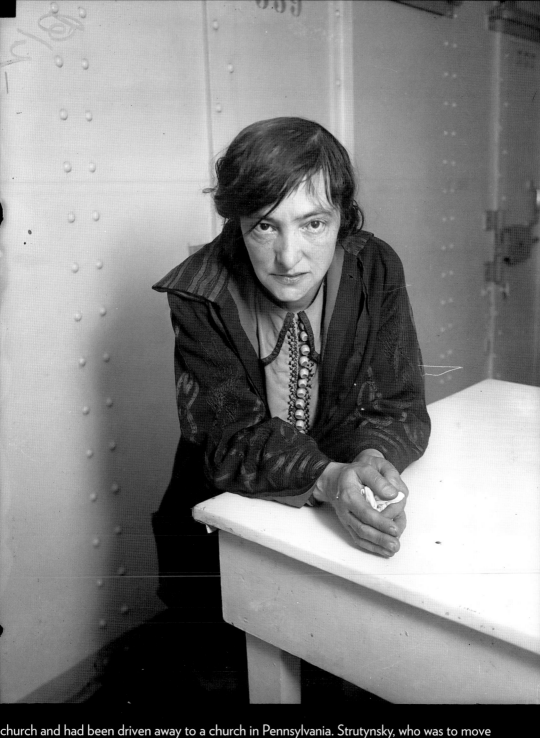

church and had been driven away to a church in Pennsylvania. Strutynsky, who was to move with her husband, planned the murder for weeks. She spent four years at Illinois' Kankakee State Hospital Department of the Criminally Insane before she slipped away on July 9, 1927, and jumped to her death in the Kankakee River.

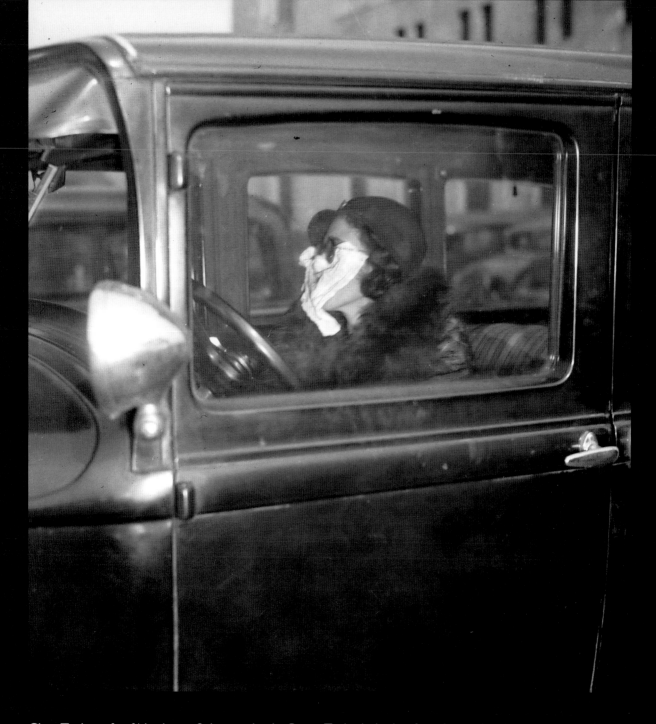

Clara Touhy, wife of Northwest Side gang leader Roger Touhy, hides her face during the closing session of her husband's trial for the kidnapping of John "Jake the Barber" Factor, circa February 1934. Touhy and two others were convicted of the kidnapping and sentenced to 99 years apiece at the Stateville Prison in Joliet, Ill. Touhy had been framed for the kidnapping by Al Capone's gang in order for Capone to get rid of the powerful mob boss.

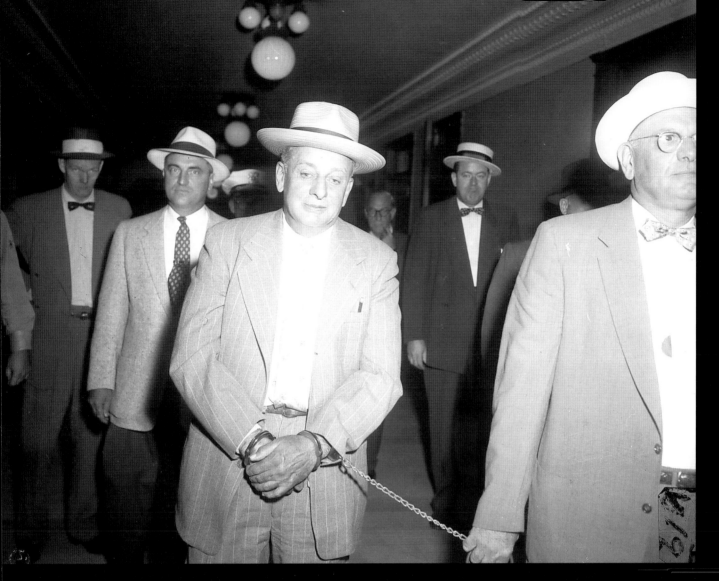

APPEALS COURT DENIES MOTION TO FREE TOUHY

Continues in Prison; State Plea Next

Roger Touhy is released on Aug. 9, 1954, after serving 20 years in Stateville Prison for a kidnapping he did not commit. Touhy told Tribune reporters he planned "to leave Chicago and start a manufacturing business." Unfortunately, Touhy headed back to prison 48 hours later, when the federal court of appeals ruled that the district court lacked jurisdiction to hear Touhy's original case.

Touhy's attorneys eventually convinced an appeals court that the kidnapping was a hoax, and he was released for good in 1959. About three weeks later, he was murdered by mob hit men. CONTINUED ➡

TOUHY SLAIN IN AMBUSH!
Shotgun Blasts Fell Freed Gangster

TOUHY BURIED AT A LONELY, QUIET SERVICE

No Floral Wreaths; Few Mourners

◀ CONTINUED A hearse carries Roger Touhy to Mount Carmel Cemetery in Chicago on Dec. 18, 1959. Touhy, 61, was killed on Dec. 16 after two gunmen ambushed him outside his sister's home in the 100 block of N. Lotus Avenue.

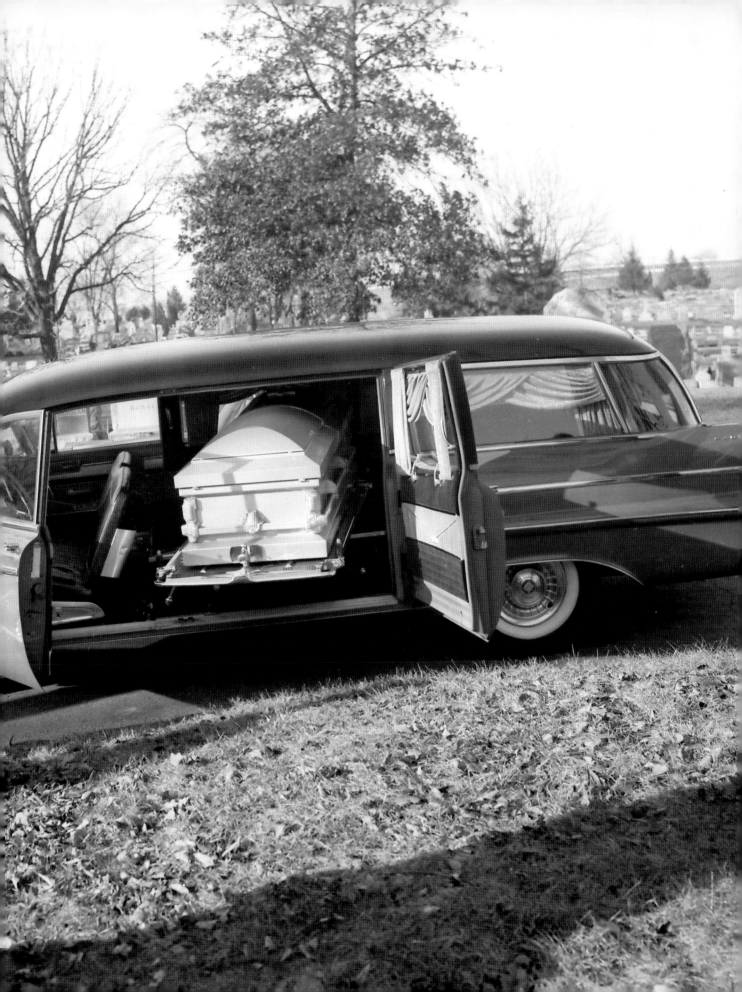

The FBI credited Joseph "Diamond Joe" Esposito, the beloved Republican boss of the 19th Ward, as being one of the first known Sicilian mafia members to immigrate to the United States. He was involved in bootlegging, extortion, prostitution and labor racketeering, and he was a prime rival of Al Capone before being murdered in 1928. Undated photo. CONTINUED ➡

SHOTGUN VOLLEY KILLS CHICAGO ITALIAN LEADER

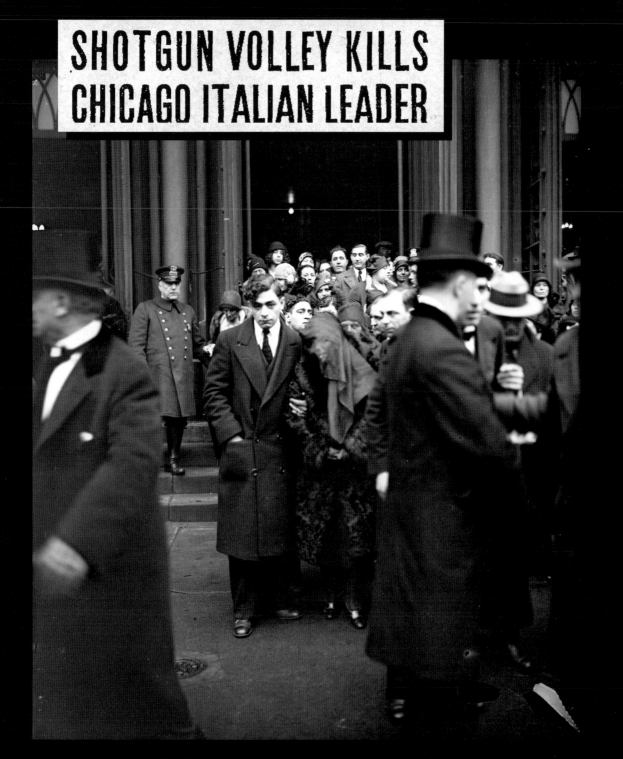

◀ CONTINUED Mourners leave Holy Family Church after Joseph "Diamond Joe" Esposito's funeral on March 26, 1928. More than 8,000 people attended the politician's funeral, including men high in authority and Italian mothers and their babies, according to the Tribune. Esposito was killed while walking home between two bodyguards on March 21, 1928. He was shot 58 times from two double-barreled shotguns and a revolver; his bodyguards were left unscathed.

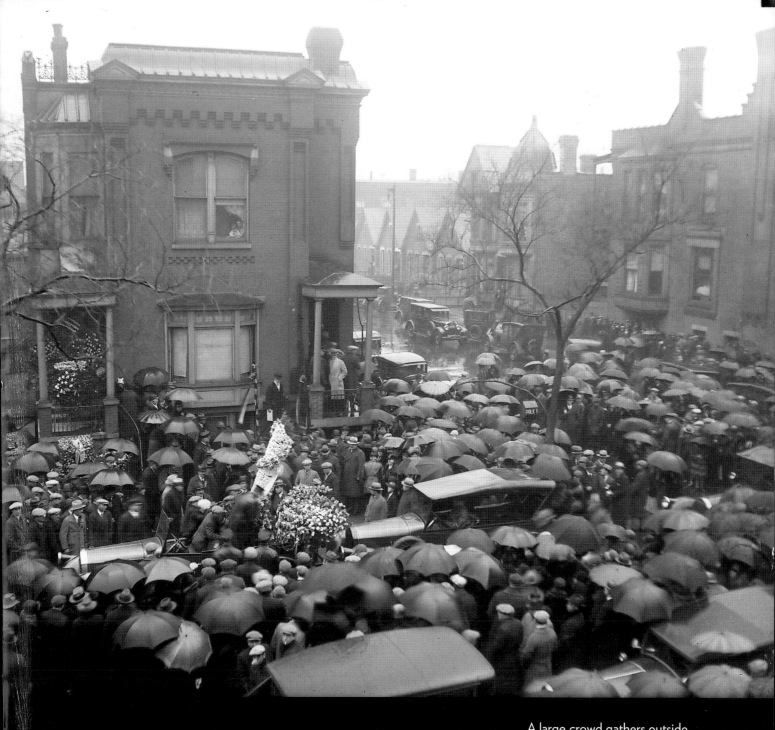

A large crowd gathers outside
Esposito's home in the 800